Musical Instruments

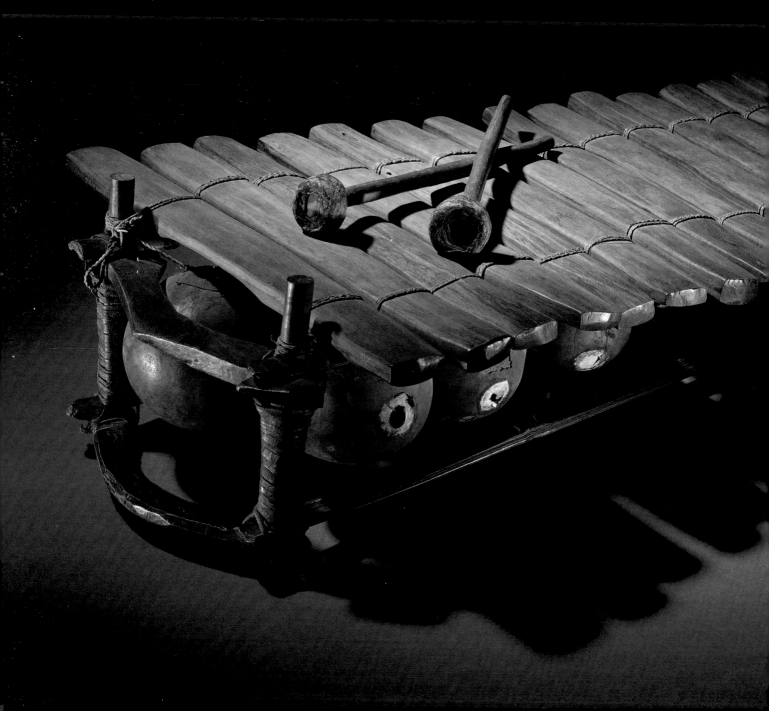

MUSICAL

INSTRUMENTS

Highlights of The Metropolitan Museum of Art

J. Kenneth Moore, Jayson Kerr Dobney,
and E. Bradley Strauchen-Scherer

The Metropolitan Museum of Art, New York

Distributed by Yale University Press, New Haven and London

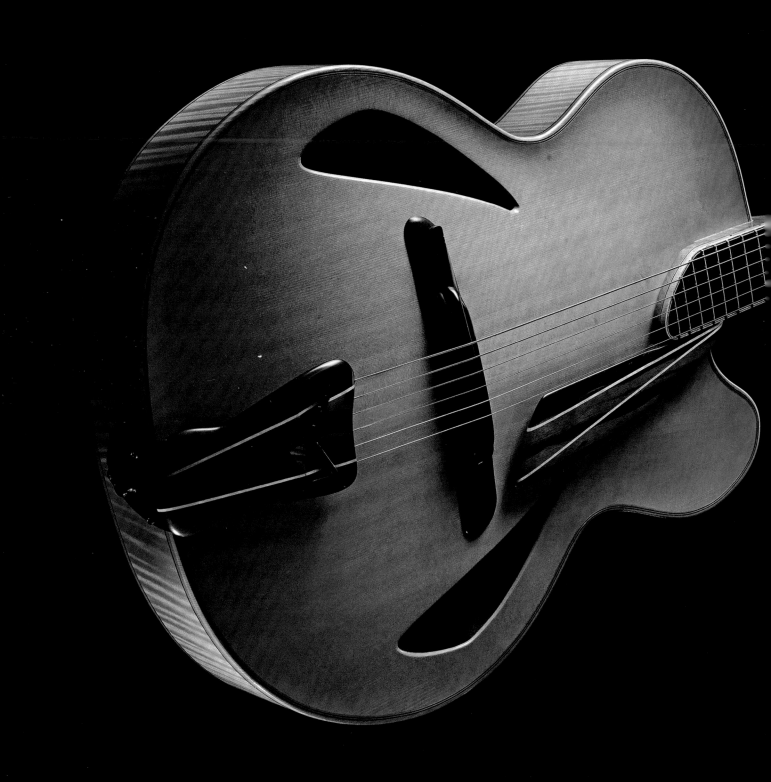

Contents

DIRECTOR'S FOREWORD 6

ACKNOWLEDGMENTS 8

Introduction

11

Highlights from the
Collection

21

About the Musical
Instruments Collection

180

GLOSSARY 182

SUGGESTED READINGS 186

INDEX 189

PHOTOGRAPHY CREDITS 192

Director's Foreword

The Metropolitan Museum of Art's musical instruments collection is a celebrated resource for musical exploration. It inspires new ways of thinking about the significance of instruments and augments the appreciation of other works of art on display in the Museum's galleries. For more than 125 years, the Museum's instruments collection has illustrated and documented the creativity and technical ingenuity of diverse cultures, presenting a comprehensive historical record of music's changing aesthetics, materials, and traditions. The first encyclopedic assemblage of music's material culture in the United States, it is among the most extensive and important in the world. Today, examples dating from the third millennium B.C. to works created within the last decade may be found in our galleries.

The collection is especially rich in instruments from non-Western cultures, such as monumental slit drums from Oceania, African trumpets made of horn, Persian fiddles, and Mayan pottery whistles. Also among the treasures are rare Asian instruments made of precious materials and some of the greatest achievements in Western music: the oldest existing piano, by Bartolomeo Cristofori; an important American pipe organ, by Thomas Appleton; violins by Antonio Stradivari; and exquisite instruments from the Renaissance and Baroque eras. While remarkable for their visual beauty, the instruments are functional objects, inseparable from the purpose of making music. They serve an intangible and immaterial art that variously accompanies ritual, battle, and work; entertains; and expresses emotions.

The Department of Musical Instruments uniquely contributes an acoustic dimension to the Museum's collection of visual arts; it is distinguished not only by its impressive holdings but by its unceasing efforts to demonstrate and document the music they produce. The department was integral in the early years of presenting concerts at the Museum; in the late 1940s it began recording its instruments, creating an invaluable archive. It has also continuously adopted

the newest technologies, from headphones in the 1970s to online videos today, to enable visitors to experience instruments in performance.

This beautifully illustrated volume highlights the musical masterpieces—instruments as well as their depictions—found throughout the Museum. The instruments selected for this book are just a small portion of the Met's collection, but they represent a cross section of the world. Together they tell the tales of instrument makers and players, of traditions and technologies, of artists and their times.

We are grateful to the Diane W. and James E. Burke Fund for making this publication possible.

Thomas P. Campbell
DIRECTOR
THE METROPOLITAN MUSEUM OF ART

6/25/2022

Dear John:
Happy Retirement!.
We expect you to learn to play at least half of these instruments.

Love
Rob & Joyce

Acknowledgments

Most of the instruments shown in this book are from the collection housed in the Museum's Department of Musical Instruments. However, instruments are also collected and displayed by other departments at the Met, and it has been a great pleasure to work interdepartmentally with our colleagues. They not only furnished important information on their holdings but also provided objects for photography, thereby permitting images of instruments that are ordinarily dispersed across the Museum to be grouped together for the first time. The cooperative effort has helped show the vast richness of the Museum's collection of instruments. Joan Aruz and Tim Healing in the Department of Ancient Near Eastern Art furnished the oldest instruments shown here. Diana Craig Patch, Lila Acheson Wallace Curator in Charge, and Isabel Stuenkel of the Department of Egyptian Art; C. Griffith Mann, Michel David-Weill Curator in Charge, and Helen C. Evans, Mary and Michael Jaharis Curator of Byzantine Art, in the Department of Medieval Art and The Cloisters; Maxwell K. Hearn, Douglas Dillon Chairman, Department of Asian Art; Rebecca Tilghman, Collections Management Associate, Department of Modern and Contemporary Art; and Alisa LaGamma, Ceil and Michael E. Pulitzer Curator in Charge, Eric Kjellgren, formerly Evelyn A. J. Hall and John A. Friede Associate Curator, Yaëlle Biro, and Matthew A. Noiseux in the Department of the Arts of Africa, Oceania, and the Americas all helped to enhance this work and make it truly comprehensive culturally and chronologically. Special recognition goes to Susana Caldeira, former Associate Conservator, and Tim Caster, Principal Departmental Technician, for their invaluable assistance.

A key element of this book is the images of instruments depicted in artworks. We are indebted to the Departments of European Paintings; European Sculpture and Decorative Arts; Egyptian Art; Islamic Art; Asian Art; Greek and Roman Art; Arts of Africa, Oceania, and the Americas; Medieval Art; Photographs; and Drawings and Prints, as well as to The American Wing for

sharing their musical iconography with us. A whole book could be devoted to images of musical instruments in art, and this publication only hints at the Metropolitan Museum's wide range of musical representations.

Many talented and wise individuals have given this work its form and design. In the Museum's Editorial Department, Mark Polizzotti, Publisher and Editor in Chief, Peter Antony, Chief Production Manager, and Michael Sittenfeld, Managing Editor, have guided this project from first discussions to the final product. Many thanks to Nancy E. Cohen, our enthusiastic editor, counsel, and arbiter, for her gentle persuasion that kept us on track, meeting deadlines and turning specialized language into readable yet substantive text. We are immensely grateful to Joan Sommers for her design, which beautifully illuminates our words and images. Not least and perhaps most important, thanks to the Museum's Senior Photographer Paul H. Lachenauer, whose specially commisioned photography has provided new ways of looking at the art of musical instruments.

The Diane W. and James E. Burke Fund has our sincere gratitude for generously supporting this publication.

Introduction

The story of music probably begins with slaps on the body and stomps on the ground, followed closely by the voice, the most readily accessible and personal vehicle for music making. Musical instruments—objects that are used or created to produce sound—quickly joined in. Able to convey sound and emotion that exceeded the limits of vocal production, they became a vital means of expression and communication. As the essential mediators between players, composers, and their audience, be it human or divine, musical instruments soon assumed extramusical qualities, functioning as symbols of prestige or disrepute, identity, godly attributions, or technological wonder.

From the beginning, musical instruments have accompanied daily life in work, worship, celebration, and war, while the music they produce has sparked controversy and theories about its potent effect on listeners. Early civilizations—Mesopotamia, Egypt and Greece, India and China—associated musical sounds with mathematics and deemed some types of music as beneficial and others harmful to the body and mind. Pythagoras, Plato, and others warned about music's impact upon human behavior and the social order. As Confucius asserted, "If one should wish to know whether a kingdom is well governed, if its morals are good or bad, the quality of its music will furnish the answer." Today, neurologists study music's influence on the brain's emotional, auditory, contextual, and conceptual centers. Its ability to evoke states of mind, jar the memory, and calm or stimulate is exploited in films, waiting rooms, elevators, and shops. Listeners are now able to tailor personal soundtracks to any need or occasion, and to access them through mobile devices. Music permeates modern life.

Traditionally, loud instruments like conch shell trumpets, bells, and struck hollowed logs were used to warn, welcome, or intimidate people as well as to petition gods. Trumpets and drums once signaled commands during skirmishes, and they still motivate feet to march and instill courage before battle. Percussive instruments like tambourines and clappers have long been used

throughout North Africa and the Middle East to accompany dance. Penetrating double-reed pipes, frame drums, and castanets helped induce the Maenads' trance during their Dionysian revels. Metal horns originally had utilitarian purposes: to communicate among hunters scattered widely in the field and to signal the mail's arrival. Animal horns like those whose blowing is said to have destroyed ancient Jericho are used worldwide to call the attention of gods. Bell towers summon the devout to prayer, strike the time, and serve as alarms. The sounds that developed around instruments' functional and ceremonial uses were eventually absorbed into the more abstract compositions, forms, and genres of so-called art and popular music traditions.

Instruments' sounds, the type of music played upon them, and their very form were and are directly influenced by the availability of materials at any given time. Across the ages, natural materials like wood, reeds, and gourds have proved durable staples for wind and stringed instruments, while large conch shells, animal horns, and ivory tusks have made excellent trumpets. Animal skins serve well for drumheads and the bellies of some types of lutes, harps, and lyres. A few traditional materials—like the rams' horns used for Jewish shofars—are closely connected to ritual and remain in use, but as new, sturdier, or more easily accessible materials are introduced, some instruments have been modified. Although synthetic materials may change the instrument's sound, often making it louder and perhaps less subtle or nuanced, makers and players usually prefer the synthetics' greater durability and lower cost, replacing gut strings with nylon and hide drumheads with plastic. Ecological factors and regulations also influence the makers' choices: traditional sources of materials may become endangered, like the elephants that supplied the ivory for African horns and piano key veneers, or depleted, like Pernambuco wood, long used for violin bows. Now plastic stands in for ivory keys, and other woods, carbon, and graphite fiber are used instead of Pernambuco.

Early tools and techniques to craft materials into instruments were borrowed from a wide variety of trades, including tanning, carpentry, metalworking, and pottery making. In some parts of the world performers still make their own instruments, often incorporating rituals to sanctify the instrument and placate the spirits of the materials used; certain African ceremonies are intended to appease the trees cut down for drums. Elsewhere, as instrument designs became more complex, instrument making developed into a specialized art with its own practitioners. That facilitated the consistency and standardization needed when instruments are played in large ensembles,

like bands or orchestras, which require uniform pitch. Function drove form: acoustical parameters—such as the sounding length of piano strings, the thickness and width of xylophone bars, and the length of wind instrument tubing—determined each instrument's distinctive shape and configuration. In designing instruments, makers had to solve problems of physics, mechanics, and metallurgy to configure instruments ergonomically, ensuring that keys were easily reached, piano pedals were centered in front of the player, and trombone slides did not exceed the length of the performer's arms. Instruments—and music—changed as the makers sought to manipulate basic acoustical principles efficiently and deploy technological innovations to produce even-sounding scales and uniform tone color across the range of the instrument. For example, the mid-eighteenth-century development of keys for wind instruments enabled instrument makers simultaneously to experiment with their structure and to improve their performance.

Although created primarily as tools for making music, instruments often are functioning visual artworks. Some were made to be "pleasing to ear and eye alike," as mottoes painted on Renaissance keyboards proclaim. Certain instruments possess a simple elegance, like the violin or the Indonesian sesando (see page 149); others are embellished with beautiful surface decoration, exuberant carving, or painting. Sometimes an instrument is principally a visual artwork that also makes sound, as are pre-Columbian figural pottery whistles (see page 38) and the ō-daiko (see page 141), a drum that signifies peace. An instrument often represents an interface among art, design, and technology, as does a musical mechanical clock with moving figures, or a beautifully ornamented piano case (see pages 64 and 124).

Instruments as works of art are produced for wealthy or royal clients to impress and to send other nonmusical messages. These embellished instruments serve as symbols of the prestige and power of the ruling and religious establishment. The remarkable silver kettle drums that served at the Hanover court of King George III (see page 100) were royal regalia that doubled as art objects. Highly decorative instruments may include specific motifs and designs that identify individuals, families, or groups that hold instruments as communal property. They often require collaboration between an artist and an instrument maker to produce a work of visual beauty while maintaining the instrument's functional integrity.

Within each culture, certain instruments bear special status or symbolic weight. Some are associated with specific ceremonies, like African caryatid

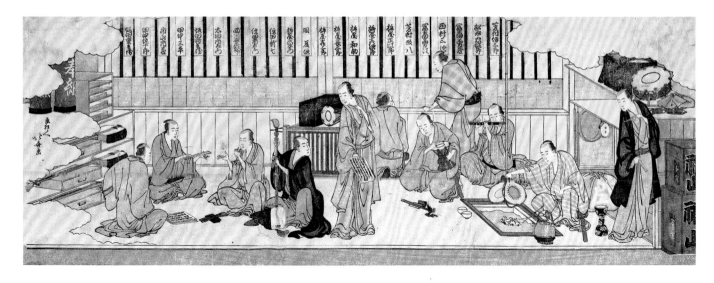

FIGURE 1

Katsushika Hokusai (Japanese, 1760–1849). *Dressing Room for Musicians at a Theater* (*Shitakubeya*), Edo period, early 19th century. Ink and color on paper, 7 ⅞ x 21 ⅞ in. (20 x 55.6 cm). H. O. Havemeyer Collection, Bequest of Mrs. H. O. Havemeyer, 1929 (JP1857)

drums (see page 137) or the kagura suzu, bells associated with Shinto rituals (see page 78); sometimes only designated individuals or groups may touch and use them. In some cultures an instrument is thought to possess a soul or, like the saùng-gauk (see page 122), to be home to spirits that command respect and sometimes dictate a prescribed behavior.

Some instruments serve as national symbols, as do the Irish harp, Norwegian hardingfele (see page 94), and Armenian duduk, instilling pride in their countrymen when seen or heard. In immigrant communities, musical instruments help maintain cultural identity, as the Italian mandolin did in the United States in the late nineteenth century, before it was appropriated into the broader culture. When absorbed into the mainstream, an instrument may evoke various responses and levels of meaning, as does the bagpipe, which is nationally associated with Scots-Irish traditions but also resonates broadly as an instrument of mourning.

A more personal, rather than cultural, attachment frequently forms between instrument and performer. Over years of practicing and performing with an instrument, learning and fully exploiting its idiosyncrasies, the musician develops an intimate connection with it. Musicians establish rituals of maintenance, preparing their reeds, warming up the instrument before a performance, and tuning and retuning (fig. 1). The instrument ultimately becomes an extension of the musician's body—even of his or her persona—as well as a means of expression that can be transformative for performer and audience alike. In many cultures, the instrument seemingly takes control of the

performance, binding the musician in an all-absorbing union with the music—a heightened state of performance psychologists refer to as "flow" or "being in the zone." The experience can sometimes be spiritual, as if the player is a medium through which music communicates. This phenomenon reinforces the belief, as in some African and Asian traditions, that an instrument possesses a spirit or soul that must be honored and nourished.

Beyond their value as a means of transcendence, as art objects, and as technical masterpieces, musical instruments serve as documents of music history and performance. Studying old instruments yields important clues to faded musical traditions. Their construction, form, decoration, and wear patterns reveal information about the type of music they played, who played them, and how they were played. Perhaps most important, they provide tangible evidence of an ephemeral art and of distant, sometimes lost, musical cultures. For example, the zhong (see page 25), a bell that produces two pitches, attests to a keen understanding of metal casting and acoustics in ancient China. Almost three thousand years ago, Chinese bell makers discovered that a bronze bell designed with an elliptical mouth, precise thicknesses, and a symmetrical arrangement of studs or nipples decorating its surface produced two tones: one when struck on the bell's narrow side and another if struck in the center. Sets of as many as sixty-five two-toned bells, each sounding an interval of either a major or minor third, were hung from frames and played by several musicians. In other cases, modifications made to instruments by successive generations of owners chronicle changing styles and tastes, both musical and visual, with the addition of up-to-date mechanisms (such as keys and strings) or revisions to the decoration.

An instrument's form, its most conspicuous feature, can tell us much about its maker, the culture from which it arose, and its owner. Connoisseurship enables us to ascertain the distinguishing traits of a master's hand, a school, a style, or a region, as we can see in a cittern whose shape is typical of Hamburg, Germany, and whose decoration exemplifies its maker's work (see page 75). In some instances, decorative preferences, use of particular materials, and construction details are telltale traits that identify a specific group, as with the distinctively carved drums that are unique to the indigenous people of New Guinea (see page 175).

Decoration may also hint at individual ownership, such as the crowned mermaid—symbol of Rome's wealthy Colonna family—beneath a seventeenth-century harpsichord (see page 73). Similarly, the profusion of emblematic

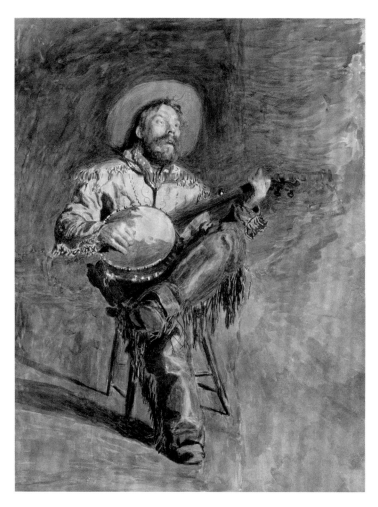

FIGURE 2
Thomas Eakins (American, 1844–1916).
Cowboy Singing, ca. 1892. Watercolor and
graphite on off-white wove paper, 18 ⅞ x 15 in.
(47.9 x 37.9 cm). Fletcher Fund, 1925 (25.97.5)

cranes inlaid on a Japanese koto identifies it with the crest of the Karasumaru clan (see page 61). An instrument's decoration and materials may convey certain powers, whether courtly, political, martial, or ritual, as does the carving on a shaman's rattle used in healing ceremonies (see page 126). Objects made of precious materials like ivory, jade, gold, or porcelain universally denote the owners' elevated social status; lavish instruments also would be commissioned as gifts of recognition, like the virginal displaying the medallions of Spain's Philip II (the presumed benefactor) and his wife, Anne of Austria (see page 58).

Through gifts, war, trade, religion, or migration, various types of instruments, musical ideas, and technological innovations have been and continue to be spread across the globe. Foreign musicians—from hired entertainers at court to slaves who accompanied their work and ritual with music—brought unfamiliar sounds to new cultures. When instruments migrate they often adopt different forms while retaining some original characteristics; they may bear names that echo or derive from the original. These physical similarities and recurring names reveal the relationships among objects that are distributed across great distances or separated through time. Within the internal construction of a Japanese shō are the Asian roots of a much later English instrument, the symphonium (see pages 120 and 121). The Philippine dadabuan (see page 147), a goblet drum, takes decorative elements and its overall shape from Arabic forebears. Another Arabic instrument, the oud (al-'ūd), migrated through trade to China, Japan, and Indonesia. When it reached Europe, it became the lute, an instrument almost identical in appearance and similar in name.

Instruments often bring distinctive rhythms and musical traditions with them as they travel to new locations, as did African drums. Others remain emblematic of their original place and time even as they are recast by the musicians who compose for and play them in a different sonic world. Although the widespread short-necked lute looks and sounds similar from one place to another, in Europe the Arabic model acquired frets, to orient the player's

fingering, and its strings were plucked by fingers instead of a plectrum. Another example is the banjo, which descends from ancient African lutes made from gourds and skins. It was brought to the United States by enslaved Africans but had entered the mainstream by the mid-nineteenth century (fig. 2) and today is closely associated with American bluegrass and folk music.

Instruments fundamentally shape, and are shaped by, the music they produce. Before the advent of valve systems in 1814, composers who used brass instruments to play melodies were largely limited to the instruments' upper octaves, where the notes of the harmonic series lie close enough to string together scales and melodic lines. That resulted in the characteristic high passagework of trumpets and horns in Baroque music—just one example of how different types of instruments, their technical and tonal characteristics, and the way in which they were employed are hallmarks of different repertoires, genres, styles, and periods. Some instruments have had such an impact on a type of music that they became a defining element and symbol of the genre, as the saxophone is to jazz and the electric guitar is to rock and roll. Yet the saxophone was conceived as a concert and military band instrument in the 1840s, when jazz was unknown, and the guitar had been a favorite folk instrument for centuries before electricity and audio amplification.

From ancient times to the present, people have rendered images of instruments, singers, dancers, musicians, and audiences in paint, pottery, woodwork, textile, and other media, underscoring the centrality of music to the human experience in its vast variety. In an Egyptian relief, a female string ensemble performs at the pharaoh Akhenaten's court (fig. 3); in a scene from a Ming dynasty hand scroll suggesting quietude, a scholar contemplates the perfect

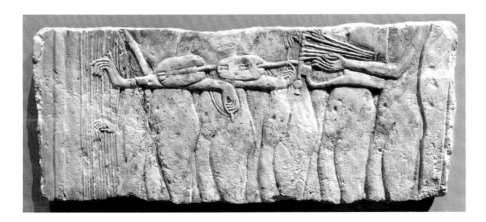

FIGURE 3
Female musicians. Egypt, New Kingdom, Amarna period, Dynasty 18, reign of Akhenaten, ca. 1353–1336 B.C. Limestone and paint, 8 ¼ x 20 ⅞ x 1 ¼ in. (21 x 53 x 3.2 cm). Gift of Norbert Schimmel, 1985 (1985.328.12)

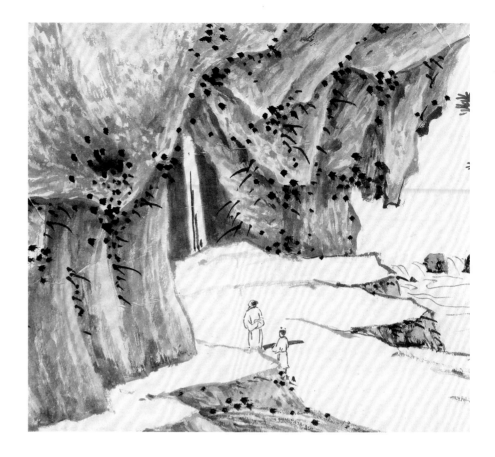

FIGURE 4
Shen Zhou (Chinese, 1427–1509) and
Wen Zhengming (Chinese, 1470–1559).
Joint landscape (detail), Ming dynasty,
ca. 1509 and 1546. Ink on paper, overall
14 ½ in. x 56 ft. 8 ⅞ in. (36.8 x 1729.3 cm).
Purchase, The Dillon Fund Gift, 1990
(1990.54)

location to play the zither his attendant carries in his arms (fig. 4). In contrast, a flute and cittern provide raucous entertainment for a bawdy party in one of Jan Steen's allegorical paintings, in which the artist depicts himself and his wife as an inebriated innkeeper and provocative hostess (fig. 5).

Musical iconography such as those examples tells us about people's day-to-day lives and offers clues about how instruments were played and by whom, documenting gender restrictions and social status. Harps, for example, may be associated with players of a particular gender in different contexts and periods. In the Middle Ages, Gothic harps were associated with men; they were played by bards and at court events. Five hundred years later, women played the harp, but only in domestic settings (fig. 6). The harp stood alongside the piano as the most popular and prestigious instrument for nineteenth-century women to cultivate in the home, but, as women then rarely performed in public, professional harp playing was dominated by men.

Thus shedding light on the people who owned, played, and made them, musical instruments come to life at The Metropolitan Museum of Art, the

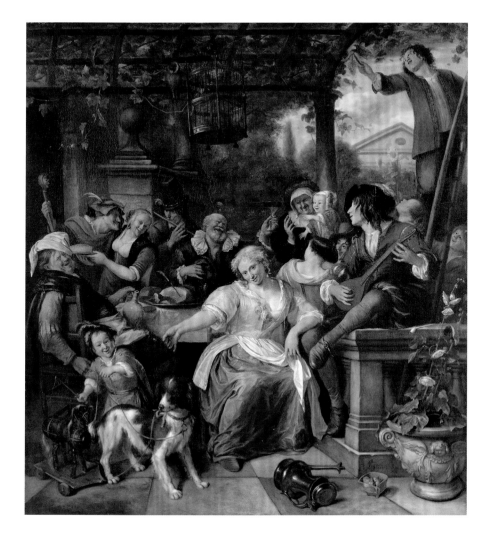

FIGURE 5

Jan Steen (Dutch, 1626–1679). *Merry Company on a Terrace*, ca. 1670. Oil on canvas, 55 ½ x 51 ¾ in. (141 x 131.4 cm). Fletcher Fund, 1958 (58.89)

world's greatest repository of musical instruments and related art. The wealth of musical iconography that virtually rings from the Museum's walls and corridors complements and contextualizes its encyclopedic collection of more than five thousand musical instruments.

This book mirrors that rich, interdisciplinary approach. Here, more than one hundred of the finest musical instruments from the Met's collection are accompanied and illuminated by depictions of instruments and music making drawn from the Museum's masterpieces. Whether created to entertain a royal court, provide personal solace, or aid in rites and rituals, these remarkable instruments make manifest music's universal resonance—and the ingenuity various cultures, with distinct sonic traditions and access to varying resources, deployed to achieve some means of musical expression.

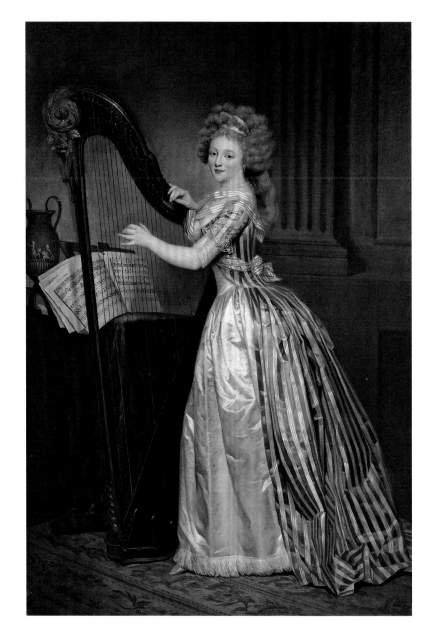

Reflecting the Museum's unique ability to present musical instruments in a relatively unbroken continuum, spanning all cultures and eras, the objects are arranged more or less chronologically rather than by the traditional categories of typology or geography, demonstrating how musical creativity and expression have unfolded across the globe over time. The following pages are replete with marvels of technology, masterpieces of design, and fascinating stories of individual people, cultures, and our eternal connection with music.

Sistrum

Central Anatolia, ca. 2300–2000 B.C.
Copper alloy, H. 13 in. (33 cm)
Purchase, Joseph Pulitzer Bequest, 1955 (55.137.1)

Sistrum

Egypt, Memphite region, Old Kingdom,
Dynasty 6, reign of Teti, ca. 2323–2291 B.C.
Travertine, pigment, and resin, H. 10¾ in.
(27.3 cm)
Purchase, Edward S. Harkness Gift, 1926
(26.7.1450)

Sistrum

Egypt, Ptolemaic Dynasty, reign of
Ptolemy X, 107–88 B.C.
Silver, H. 11¾ in. (29.8 cm)
Rogers Fund, 1958 (58.5a)

Jingling sistra were frequently heard in ancient Egypt and throughout the Near East, the rattles ritually warding off evil or providing rhythmic accompaniment for dancing, as well as for processions like the one depicted on the relief shown below. The music evoked an ancient rite—the "shaking of the papyrus"—meant to deflect dangerous deities.

The sistrum has sliding disks threaded on fixed horizontal rods that are held by a frame that could be configured in different ways, as seen in these ancient examples. The striking U-shaped version (shown at near right) is one of three known Early Bronze Age sistra from central Anatolia. Its upright arms are decorated with bulls' horns, and

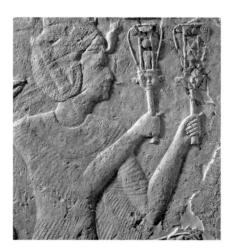

Relief on the south wall of a chapel of Ramesses I (detail). Egypt, New Kingdom, Ramesside period, Dynasty 19, reign of Seti I, ca. 1295–1294 B.C. Limestone, overall 43¾ x 74⅞ in. (111 x 190 cm). Gift of J. Pierpont Morgan, 1911 (11.155.3c)

the crossbar features plants and a bird with a curved beak that suggests a bird of prey. The symbols, whose meaning eludes us today, are reminiscent of those on copper alloy standards from tombs of the period at the Anatolian archaeological site of Alaca Höyük.

Egyptians used two types of sistra: one with a horseshoe-shaped frame and another, like the two pictured here, with a naos (a small shrine); rods were inserted through the holes, holding the disks on either side. The white travertine sistrum (center) had an emblematic purpose but was nevertheless a functional instrument. Its handle is in the shape of a papyrus stalk; the naos is inscribed with the names of King Teti and topped with a falcon and a rearing cobra. The sistrum as a whole may be read as a rebus of the name of the goddess Hathor, who is closely associated with Egyptian sistra. Hathor, whose attributes include music, dance, and fertility and whose animal manifestation is the cow, is often depicted with bovine ears, as in the silver version on the far right.

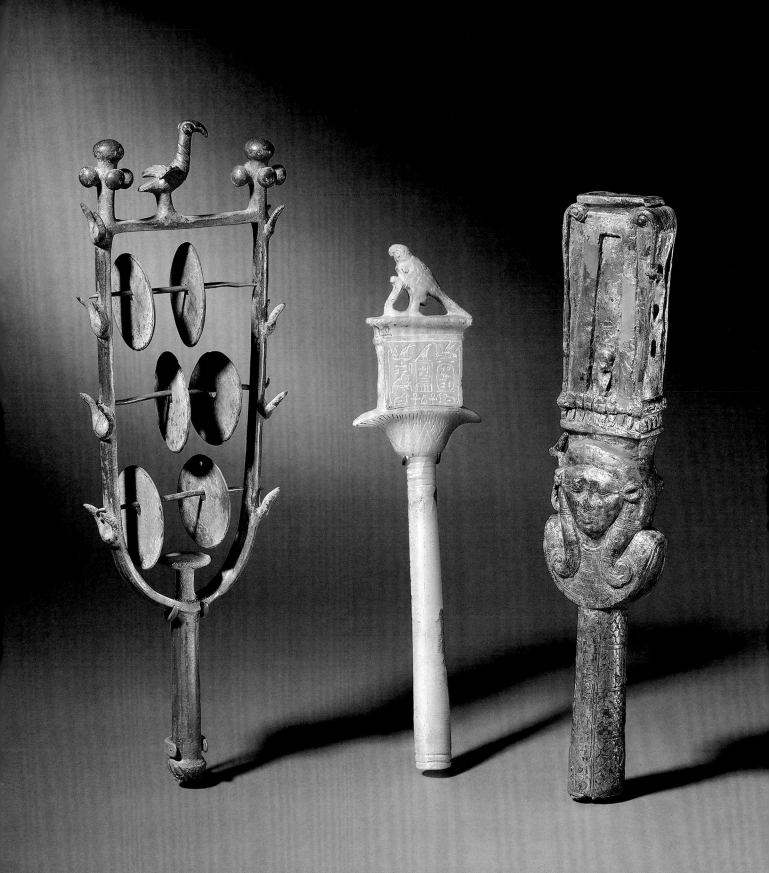

Arched Harp
(Shoulder Harp)

Egypt, New Kingdom, late Dynasty 18,
ca. 1390–1295 B.C.
Wood, rope tuning rings, and strings,
L. (diagonally) 32 ⅜ in. (82 cm)
Rogers Fund, 1943 (43.2.1)

Domu (Harp)

Mangbetu people
Democratic Republic of the Congo,
19th–20th century
Wood body with skin belly, H. 26 ½ in. (67.3 cm)
The Michael C. Rockefeller Memorial Collection,
Purchase, Nelson A. Rockefeller Gift, 1960
(1978.412.412)

Two arched harps in the Museum's collection provide a striking example of the continuity in instrument design that sometimes prevails, notwithstanding manufacturing innovations sparked by musical, societal, economic, or commercial demands. Made more than three thousand years apart, they feature the same construction.

Open harps (those without a European-style forepillar to brace them; see page 163) may be assembled with arched or angled necks that hold strings at one end and connect to an interior bar concealed under the belly at the other. They have existed practically unchanged for thousands of years. The Burmese saùng-gauk (see page 122) is another example, but similarities between an ancient Egyptian harp and a more contemporary one from the Democratic Republic of the Congo are notable. Both have arching necks that are fitted at one end of a waisted body with a skin belly (missing on the Egyptian harp, at near right) and terminate with a sculpted head. The Egyptian example has twelve strings, while the Mangbetu has five, similar to older Egyptian harps.

An interesting difference between the two is the way the strings are attached along the neck. The domu has rotating tuning pegs that resemble traditional Mangbetu hairpins, while the Egyptian harp has stationary pegs and tuning rings (similar to the saùng-gauk's) positioned beneath the strings so that plucking produces a buzzing sound, an aesthetic typical of many sub-Saharan instruments today.

The Egyptians used harps for group entertainment and ritual events. By contrast, the domu arose in the nineteenth century for personal entertainment, a use that declined in the twentieth century, when the instrument became more valued as an art object than for its music.

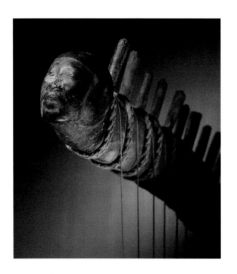

Detail of the Egyptian arched harp

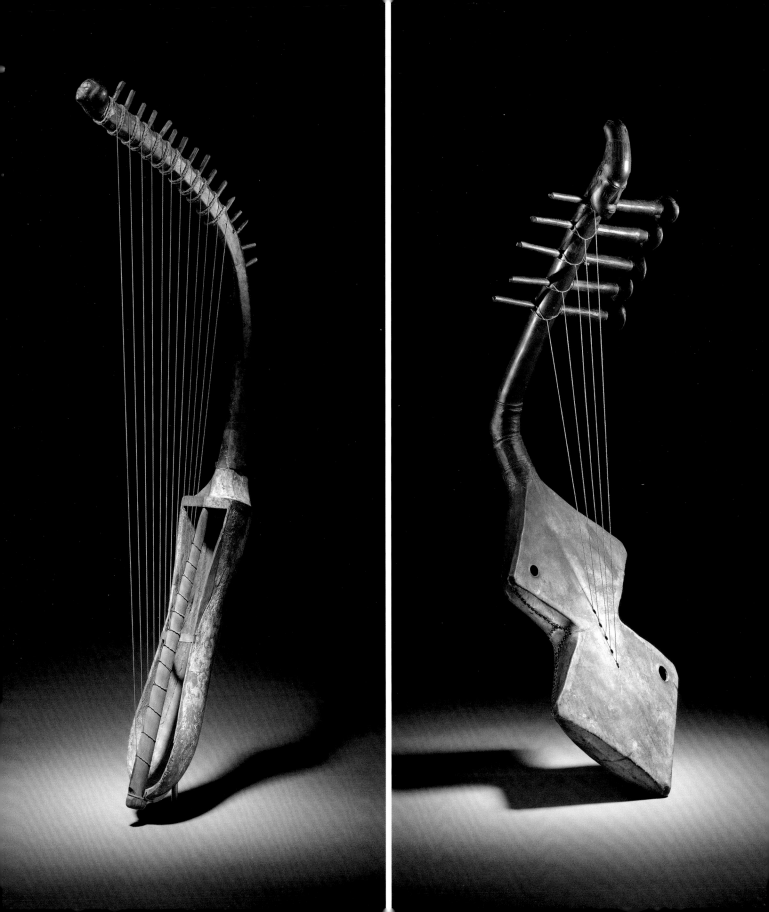

Clappers

Middle Egypt, el-Amarna (Akhetaten),
New Kingdom, Amarna period, Dynasty 18,
ca. 1353–1336 B.C.
Ivory, L. 8 ½ in. (21.5 cm)
Gift of Mrs. John Hubbard and Egypt Exploration
Society, 1932 (32.5.2a, b)

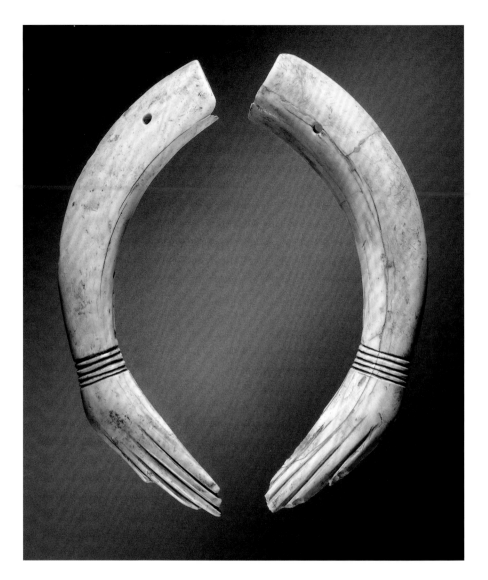

The earliest musical instrument was the human body, which can be used to create a wide variety of sounds, including singing, clapping, patting, slapping, stomping, and whistling. The relationship between the human body and a musical instrument is evident in many of the terms used to describe the latter's parts, such as the belly or neck of many stringed instruments, the drumhead, and the foot and butt joints of many woodwinds. Some instruments are anthropomorphized, given engraved or painted faces or made to resemble other body parts. The Egyptians commonly shaped their clappers in the form of hands; this pair in carved ivory is complete with incised lines depicting fingers and bracelets.

Clappers are made from wood, bone, metal, or other hard material and struck together to produce a percussive sound. In Egypt they provided percussion in musical ensembles with instruments such as sistra, harps, and flutes, and were used to keep time for dancing. This pair is made from a single hippopotamus tusk that was split in half and carved.

The hole in each clapper suggests that they were tied together, perhaps to enable certain performance techniques or to keep the set intact.

Zhong (Bell)

China, Eastern Zhou dynasty, Warring States
period, 5th–3rd century B.C.
Bronze, H. 24 in. (61 cm)
John Stewart Kennedy Fund, 1913 (13.220.86)

Bo (Bell)

China, Qing dynasty, Kangxi period, 1715
Gilded bronze, H. 12 in. (30.5 cm)
Gift of J. Pierpont Morgan, 1917 (17.190.2056)

Bells have been part of life in China for millennia. The earliest known bronze examples date from the Shang dynasty (ca. 1600–1046 B.C.). After the tenth century B.C., during the Zhou dynasty (ca. 1046–256 B.C.), graduated sets of bells of the type known as zhong were suspended from a wood frame and struck with a long-stemmed, T-shaped beater. The bianzhong, or bell set, featured prominently in ritual and domestic music making. Those early bells were expertly cast, with sides that flare from the crown to the mouth, which has an elliptical opening and arching sides. That unusual shape allowed the bell to sound two tones, one pitch when struck in the center and a second when struck on the side.

After the Zhou dynasty, the technology that allowed for the production of two-tone bells seems to have been lost. Bells from later periods are barrel shaped and produce a single tone when struck. One of this type, the bo, is formed with a suspension loop on the top and hung on a stand. A detail common to all zhong and bo bells is the presence of nine *mei,* or nipples, grouped in three rows of three. The *mei* likely had symbolic meaning; the number nine is auspicious in Chinese cosmology and frequently signified the emperor. The *mei* also appear to play an important part in the acoustics of zhong bells. Experiments suggest that they clarify the tone by shaping the vibratory patterns of the bell's surface, helping to stabilize and define the bell's two distinct fundamental pitches.

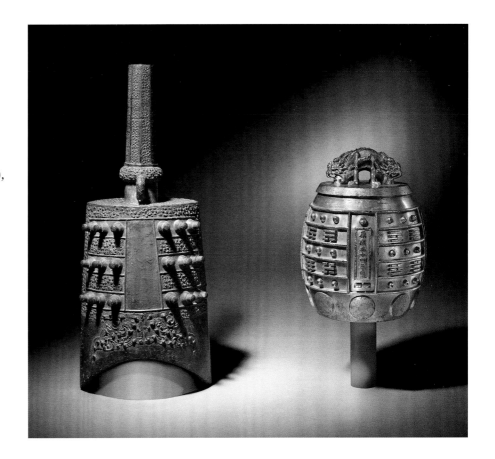

Tympanum

Vietnam, 500 B.C.–A.D. 300
Bronze, Diam. 24 ⅜ in. (61.9 cm)
Samuel Eilenberg Collection, Bequest of Samuel
Eilenberg, 1998 (2001.433.98)

Mahōra Thuk (Drum)

Laos or Thailand, 14th–17th century
Bronze, Diam. 18 ½ in. (47 cm)
Gift of Dr. Thongphet Phetsiriseng, 1966 (66.38)

Bronze drums, which have been unearthed throughout Southeast Asia and parts of southern China, represent one of the oldest continuous musical traditions. These beautifully decorated instruments are made in sections by the lost-wax casting method and topped by a bronze tympanum instead of a skin head. The most ancient examples date from the Bronze Age Đông Sơn culture (late fourth century B.C.) in present-day northern Vietnam; they were used in and buried during funerary rituals. It is believed that some were tuned and used in ensembles. Even today the drums, known by various names, play an important role in the cultural life of the Karen in Burma and Thailand and of other groups in Guangxi and Yunnan, China.

The drum's flat tympanum is commonly decorated with a central star encircled by concentric bands filled with stylized animals, domestic scenes, or geometric motifs. The Karen are animists and believe that the drums' sound placates mountain spirits (nats), who then bring good fortune. The drums are also used to summon ancestors to aid the living, as well as to bring rain, as indicated by the frogs depicted on the cardinal points of many tympana. Scholars debate the drums' significance and importance but agree that they provide a window into the technology, customs, and beliefs of ancient Southeast Asia.

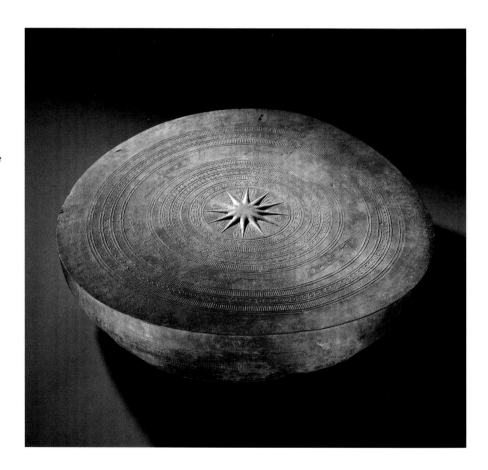

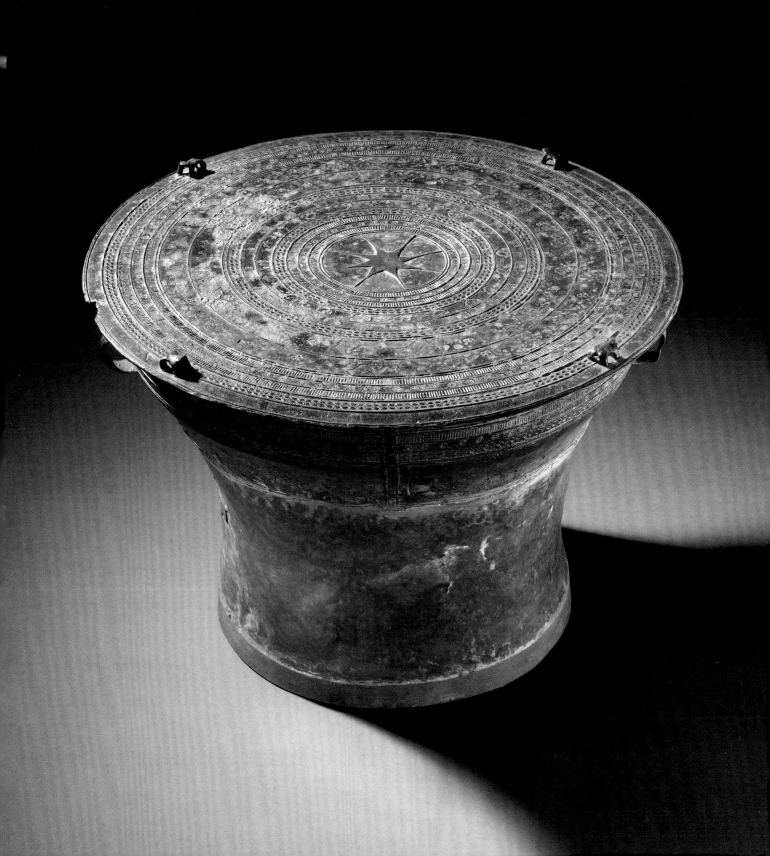

Drum

Nazca culture
Peru, 1st century
Ceramic, H. 17 ¾ in. (45.1 cm)
The Michael C. Rockefeller Memorial Collection,
Gift of Mr. and Mrs. Raymond Wielgus, 1964
(1978.412.111)

Pair of Drums

Paracas culture
Peru, 300–200 B.C.
Ceramic, H. 9 ⅞ in. (24.9 cm)
Purchase, Frederick M. Lehman Bequest, 2010
(2010.172.1, .2)

The Paracas (700 B.C. to A.D. 100) and Nazca (100 B.C. to A.D. 600) were civilizations on the southern coast of Peru. The river valleys were rich in clay deposits of exceptional quality, and the Paracas people and the subsequent Nazca culture, which was heavily influenced by it, developed a vibrant tradition of ceramic work, including the manufacture of ceramic drums. The Museum has drums from both cultures, all of which are missing the stretched skin heads that would have covered the opening in the hollow body of the drum. The pair of drums from the Paracas may have been worn on a belt at the player's waist. The larger Nazca drum was perhaps held under the player's arm or, if the player was seated, on the lap or between the legs. The instruments were probably important ritual objects used during ceremonies.

The drums are decorated with motifs that correlate to designs found on other artwork of the two related cultures: zigzags and birds reminiscent of the famous Nazca geoglyphs on the Paracas drums and an anthropomorphic shape for the Nazca drum. The earlier drums have incised outlines that were executed when the clay was dry, and the color was added after firing, with paint made of plant resin. The later, richly colored Nazca drum was painted before the pot was fired.

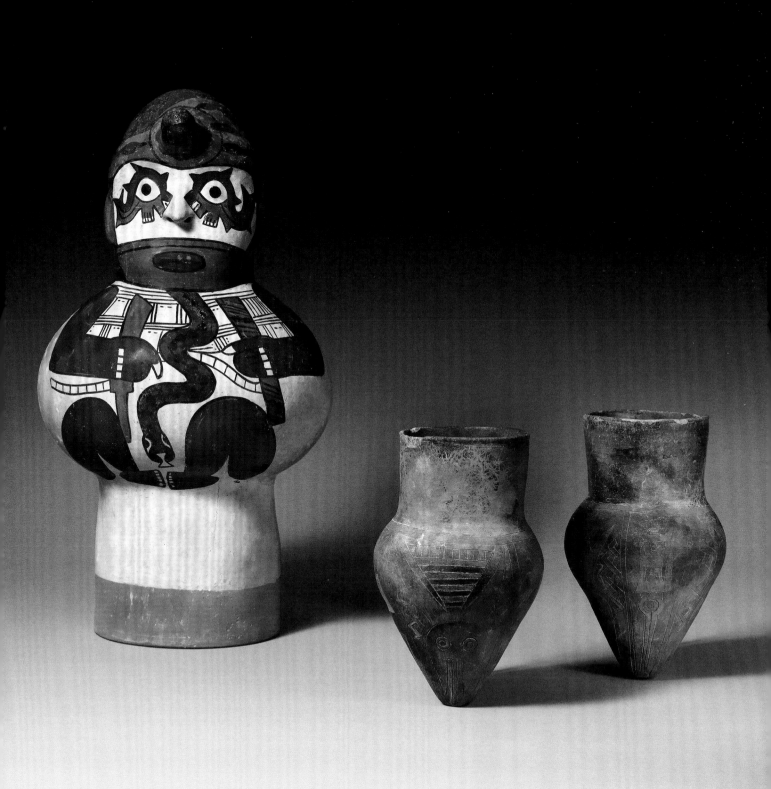

Tibia

Syria, ca. 1–500
Bone with bronze and silver facing and
decorative chalcedony bulb, L. 23 ⅛ in. (58.6 cm)
Rogers Fund, 1958 (58.40)

The tibia, an ancient double-reed instrument, accompanied many events in Etruscan and Roman daily life. Ubiquitous depictions in mosaics, pottery, and sarcophagi portray tibia players in wedding processions, entertaining at formal meals, and providing music for laborers. Ovid wrote that the tibia "sang" in temples, at the games, and at funeral rites. Both Ovid and Livy recounted a legendary strike by tibia players, underscoring the instrument's importance.

Tibia design, acoustics, and performance technique were highly sophisticated, as can be seen in this example from Syria, then a province annexed to the Roman Republic. The tibia was sounded with a double reed, and two pipes would have been played simultaneously. The small tubes or chimneys projecting from the side of this instrument and the bands of metal encircling its body were likely part of a complex mechanical system designed to increase the number of notes and scales that could be played on a single instrument.

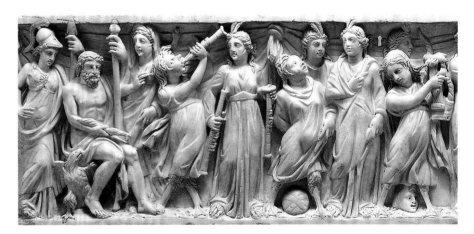

Sarcophagus (detail) with the contest between the Muses and the Sirens. Roman, Late Imperial period, Gallienic era, third quarter of the 3rd century A.D. Marble, overall 21 ¾ x 77 ¼ x 22 ½ in. (55.3 x 196.2 x 57.2 cm). Rogers Fund, 1910 (10.104)

Dōtaku (Bronze Bell)

Japan, Yayoi period, 1st–2nd century
Bronze, H. 43½ in. (110.5 cm)
Rogers Fund, 1918 (18.68)

According to musical archaeologists, Japan's first instruments were of stone and clay and appeared during the early and middle Jōmon period (4000–2000 B.C.). By the middle Yayoi period (100 B.C.–A.D. 100) bronze technology had developed, as did the cast dōtaku, a conical clapper bell with an elliptical mouth. About 470 have been excavated from remote hillsides, where they had been buried in what may have been a ritual act. The earliest forms, cast in sandstone molds, seem to derive from smaller Korean animal bells. Later ones, like this example, were cast in clay molds that furnished finer decorative detail. They are larger than their predecessors, with thinner walls and without an interior rim where the internal clapper struck, resulting in a brighter, less powerful sound. The refined decoration suggests that their role as musical objects was superseded by their ritual function.

Besides the geometric patterns seen on this example, bell decoration

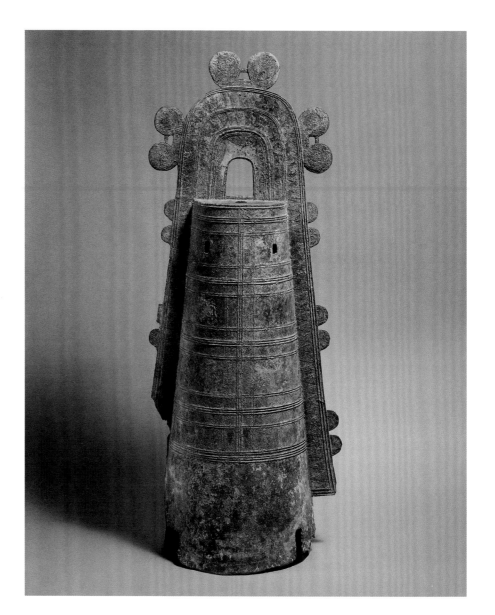

included flowing water patterns, animals such as herons, deer, and cranes, and depictions of granaries and rice pounding, suggesting an association with rice cultivation and agriculture. The bells may have been used in sowing and harvesting celebrations, but reasons for their

burial, their distribution mostly on the western half of Honshu, Japan's main island, and their disuse after the Yayoi period remain unclear.

Lute

Roman/Byzantine
Egypt, 200–500
Wood with traces of paint, L. 28 ⅞ in. (73.2 cm)
Rogers Fund, 1912 (12.182.44)

"Lute" is a general term for stringed instruments that have a neck and resonator with strings running parallel to the soundboard. A wide variety of long-necked and short-necked lutes can be found all over the world. The oldest examples are believed to have been used in ancient Syria, from which they disseminated to Egypt.

An ancient lute in the Museum's Byzantine collection is one of only seven surviving examples that are associated with Coptic monasteries in Egypt and date from the first millennium. It is the earliest instrument to have features like a guitar's. The body is waisted, with a flat top that is punctuated by clusters of small piercings that function as sound holes, and the back is carved into a bowl shape. The neck is rounded on the back, for a comfortable fit in the hand, and the flat front has indentations that indicate where frets were once placed. At the top of the neck are an integrally carved nut, indicating the string positions, and four angled holes that would have held pegs. There is no surviving bridge, but the strings probably were secured to a spike at the bottom of the instrument, as on later spiked fiddles throughout Asia (see page 129).

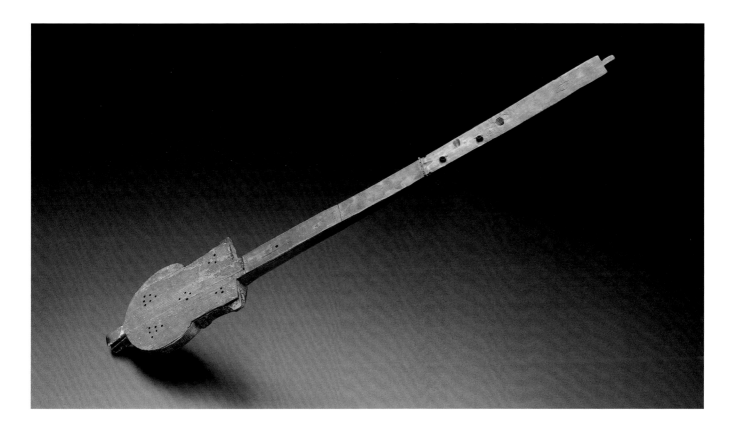

Bone Trumpet

Calima (Malagana) culture
Colombia, Yotoco period, 2nd–5th century
Condor bone, L. 12 in. (30.5 cm)
Purchase, Frederick M. Lehman Bequest, 2004
(2004.284)

Pottery Trumpet

Teotihuacan culture
Mexico, ca. 400–700
Pottery, L. 11¾ in. (29.8 cm)
Purchase, Gift of Elizabeth M. Riley, by exchange,
Eugene M. Grant Gift, and funds from various
donors, 2002 (2002.186)

Prior to the introduction of ceramic technology in Central and South America, bones—from deer, llamas, pelicans, condors, and even humans—served as natural tubes for flutes, panpipes, and small trumpets. Bone instruments may have been thought to imbue the player and listener with the deceased's power or other attributes. The first New World bone flutes and trumpets date from about 2170 B.C.; they were found at Caral, a large settlement in the Supe Valley of central Peru.

The much later and extremely rare condor-bone trumpet (at near right) may have been covered with gold, as is a similar bone trumpet in the Museo del Oro del Banco de la República in Bogota, Colombia; the incised surface would have shown through the gold sheet. Made in sections, it may have been modeled on larger trumpets that were constructed from horn or gourds, such as the trumpet pictured on a Mayan plate (below).

Trumpets of pottery are more numerous and widely distributed than those of bone, probably because they were simpler to source and process. They often take zoomorphic forms, but this example (at far right) has the familiar tube shape flaring into a bell incised at the rim. The mouthpiece flares to facilitate the proper embouchure, the formation of the player's lips.

Pre-Columbian musical instruments reveal a high degree of technological sophistication in their production and decoration. The purpose of these rare trumpets and the status they held in their cultures are not known, but trumpets are depicted in pre-Columbian art in the context of celebrations or rituals for kings and gods.

Plate with trumpeter. Guatemala or Mexico, Mayan, 8th century. Ceramic, Diam. 12¾ in. (32.4 cm). Gift of Eugene and Ina Schnell, 1989 (1989.110)

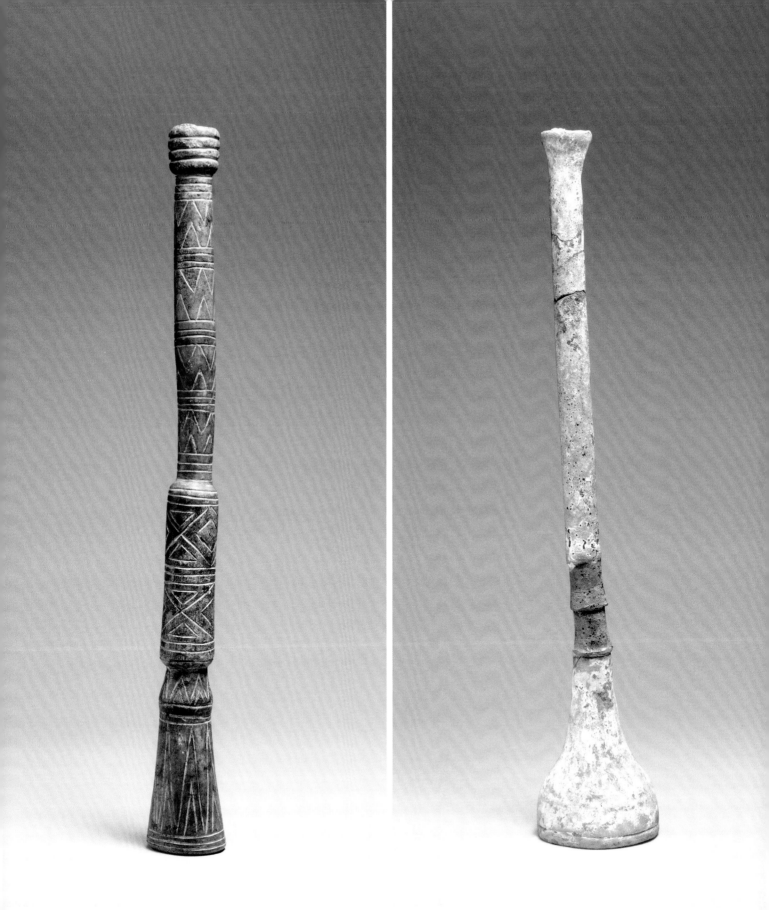

Double Whistle

Mayan
Mexico, 7th–9th century
Pottery, H. 8 ½ in. (21.6 cm)
Purchase, Gift of Elizabeth M. Riley, by exchange
2000 (2000.44)

Bird-Headed Figure Whistle

Veracruz culture
Mexico, 8th–9th century
Ceramic, H. 20 ¼ in. (51.4 cm)
The Michael C. Rockefeller Memorial
Collection, Gift of Nelson A. Rockefeller, 1963
(1978.412.80)

The production of anthropomorphic and zoomorphic ceramic figures in Central and South America originated about 6,500 years ago in the Andes region of Colombia, then spread along the west coast, from Ecuador to northern Chile and Argentina, and finally farther north. Rattles and whistles, made in a variety of sizes and forms, sometimes imitated the sounds of the creature represented. These two beautiful freestanding whistles are both held erect on three supports. The one at far right, a masterwork of Veracruz ceramics, portrays a large, imposing, and powerful masked or bird-headed figure with a fantastical horned and feathered serpent atop its head. The refined and detailed incising represents scrollwork, fringe, and interlacing motifs on the face, collar, loincloth, and headpiece. The double whistle is in the shape of a colorful Mayan bird and has two separate internal sound chambers. The bird's body forms the lower chamber, which is sounded through a mouthpiece in the tail. Two low, owl-like pitches can be produced from that chamber by use of the finger hole on the bird's breast. The smaller upper chamber, in the bird's head, is activated through a mouthpiece behind its protruding ears, producing a high screak.

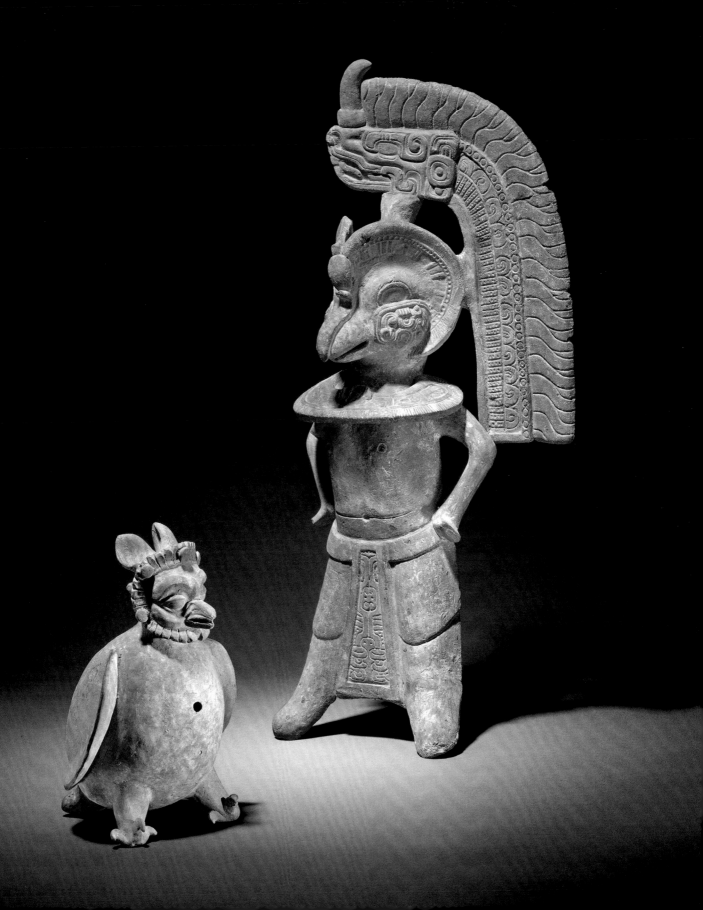

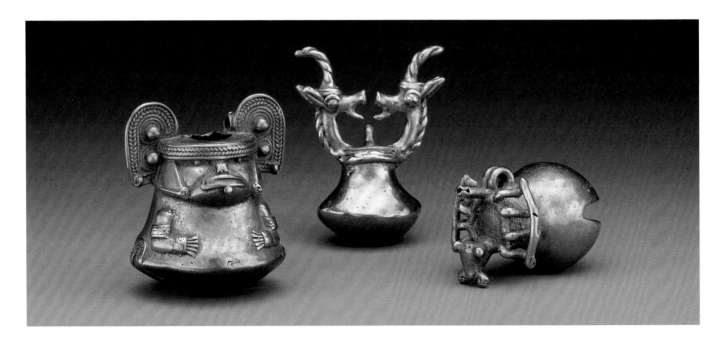

Figural Bell

Tairona people
Colombia, 1000–1500
Gold and copper alloy, H. 1¾ in. (4.3 cm)
Purchase, Clara Mertens Bequest, in memory of
André Mertens, 2004 (2004.49)

Deer-Head Bell

Chiriqui people
Costa Rica, 11th–16th century
Gold, H. 1¾ in. (4.4 cm)
Jan Mitchell and Sons Collection, Gift of Jan
Mitchell, 1991 (1991.419.2)

Spider Bell

Panama, 6th–10th century
Gold, H. 1⅝ in. (4 cm)
Purchase, Clara Mertens Bequest, in memory of
André Mertens, 2004 (2004.48)

Gold was perfect for fashioning small, hollow clapper bells that made an intimate tinkling sound, and the material's prestige suggests the bells' ritual and symbolic use. Many bells of cast gold or *tumbaga* (gold and copper alloy) are decorated with depictions of animals, plants, or mythical beings. These small instruments could be worn as pendants, strung with beads as necklaces, or sewn to fabric. Especially skilled metalworkers may have held high status for their ability to produce these diminutive symbols of power, perhaps supernatural.

Smelting and alloying metals in the Americas began in the Andean region, with evidence dating to about 2100 B.C. The technology gradually moved northward through Colombia,

Panama, and Costa Rica (A.D. 300–500) to arrive in Mesoamerica by A.D. 800. It seems to have spread through trade and travel, overland as well as by sea.

The lost-wax casting technique produced complicated decorations such as the elaborately costumed figure seen on the Tairona bell (at left), who confronts the viewer with beady eyes. He may be a leader and is adorned with a lip plug, bracelets, cuffs, earrings, and a headpiece with braided strands of gold. Less ostentatious but simply elegant are the Chiriqui deer-head bell and the Panamanian bell topped by a spider. Each has a single slit and interior ball and once had an integral loop from which it could be suspended.

Rattle

Taino culture
Hispaniola, 900–1500
Wood, L 12 ⅝ in. (32 cm)
Purchase, Amati Gifts, 2008 (2008.104)

The Taino people inhabited the northern islands of the Caribbean, including present-day Cuba, Hispaniola (Dominican Republic and Haiti), and Puerto Rico. Columbus made contact when he voyaged there in 1492. The introduction of European diseases, as well as the enslavement of a large part of the population, led to the decimation of the Taino in the sixteenth century. Most of what is known of Taino culture, including its music and musical instruments, was recorded by Spanish colonists.

This rattle is one of a handful of surviving instruments that are the only tangible pieces of Taino musical culture. Such rattles are believed to have had a ceremonial purpose. The Museum's example is carved in the form of a rodent and has a hollow body with four slits. Inside are four large wooden pellets that sound when the instrument is shaken.

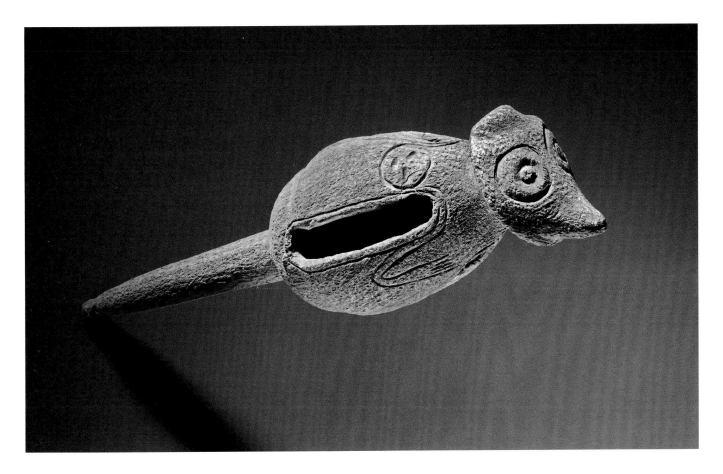

Oliphant

Italy, Amalfi, 12th century
Ivory with metal mounts, L. 17 in. (43 cm)
Gift of J. Pierpont Morgan, 1917 (17.190.218)

The movement of people through migration, pilgrimage, and trade disseminated musical instruments over great distances. The origins of the oliphant—so called because it is made from elephant tusk—can be traced to the Byzantine Empire in the tenth century. Europeans may have first encountered the instrument during the Crusades, contributing to the instrument's popularity on the Continent during the eleventh and twelfth centuries. Many oliphants from that period, including this one, were made by Muslim craftsmen accomplished in ivory work who had settled in Southern Italy and Sicily.

Oliphants could be used as hunting horns but were probably most important as badges of status. Emblematic of the prestige attached to the hunt, they were also used to signify land tenure or feudal rights. As such, they are frequently depicted in heraldic devices or coats of arms. Some oliphants were used as drinking vessels and reliquaries. The carvings on this example, which include depictions of Christ as the Lamb of God, suggest that it was made for a Christian patron and possibly for use in a church. Manuscript illuminations, like the one shown at left, often featured angel musicians playing oliphants.

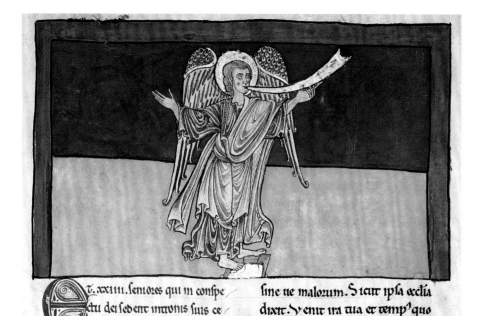

Detail from a Beatus manuscript: The Seventh Angel Proclaims the Reign of the Lord. Spain, from the Benedictine monastery of San Pedro de Cardeña, Burgos, ca. 1180. Tempera, gold, and ink on parchment, leaf overall 17 ½ x 11 ⅞ in. (44.5 x 30 cm). Purchase, The Cloisters Collection, Rogers and Harris Brisbane Dick Funds, and Joseph Pulitzer Bequest, 1991 (1991.232.12)

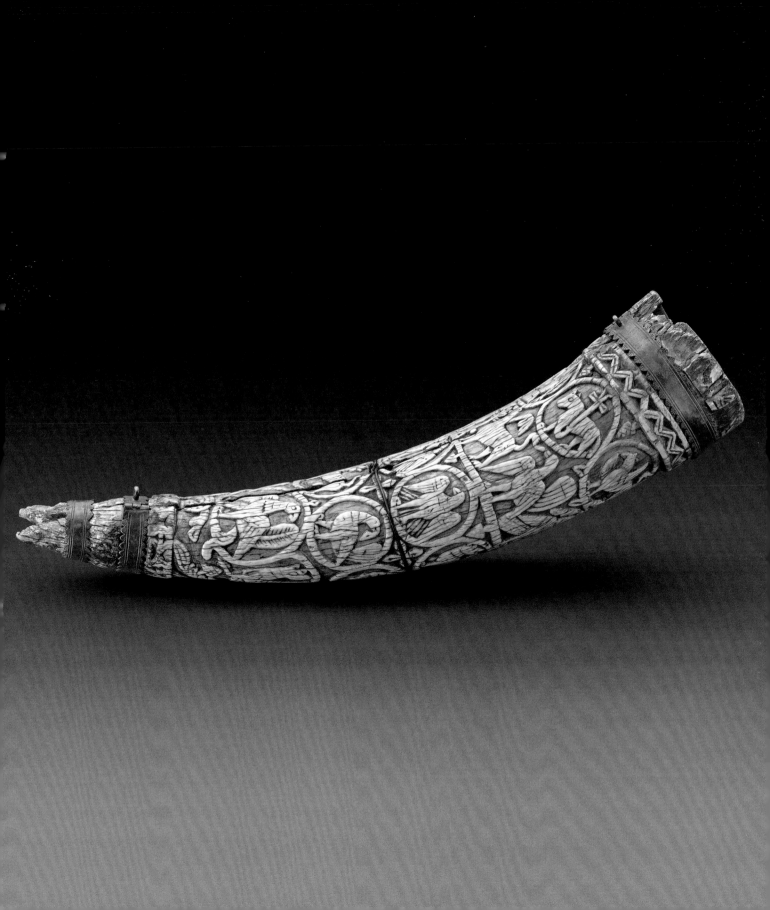

Sgra-Snyan (Lute)

Tibet, 14th–16th century
Wood body with paint on gesso, ivory inlay, gold
and tin leaf, and skin bellies, L. 43 in. (109 cm)
Purchase, Clara Mertens Bequest, in memory of
André Mertens, 1989 (1989.55)

Sometimes older instruments are refurbished to reflect current fashion, as exemplified by this lute. Its double bellies covered in green skin and its portraits of the Buddha and his musicians, rendered on painted ivory with gold leaf, are decorative elements typical of fifteenth-century Tibet. A later layer of decoration on the back, fingerboard, and pegbox displays cartouches and palmettes that are reminiscent of seventeenth-century Persia. These modifications from a Buddhist to a more Islamic aesthetic may suggest a shift in ownership.

Originally six strings were attached to this instrument, but the pegbox was shortened to accommodate five; a hole along the neck was probably provided for a strap. Despite the appearance here of the Buddha and his musicians and the sgra-snyan's occasional depiction in tankas (Tibetan religious paintings), the instrument is not used in religious settings but accompanies secular song and dance.

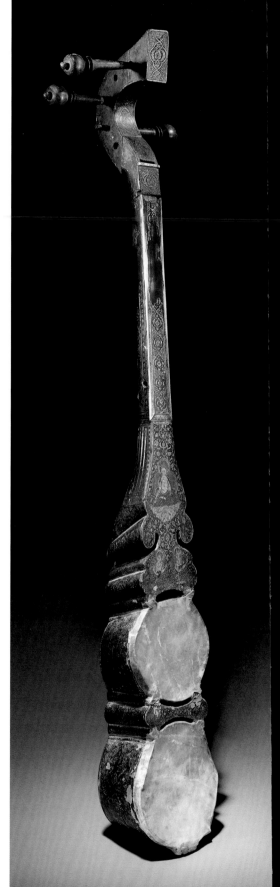

Cog Rattle

France (?), 15th or 16th century
Wood, L. 10 ¾ in. (27.3 cm)
Gift of Blumka Gallery, 1954 (54.160)

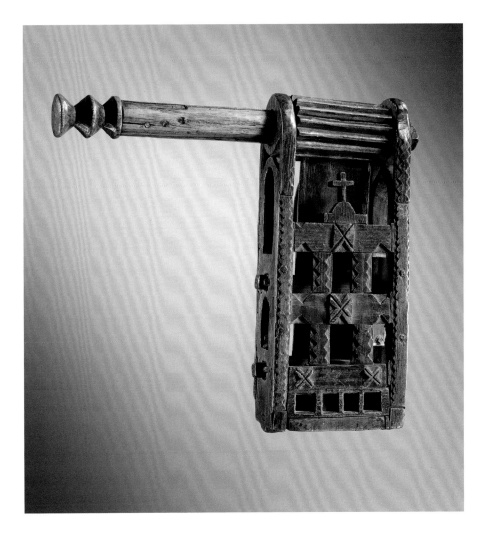

Bells have been used in the Latin Mass of the Roman Catholic Church since at least the eighth century. A tradition developed of setting aside the bells during Holy Week. Their ringing was considered too joyous for that somber time of year, and the bells were said to have flown to Rome. While the bells were not in use, they were replaced by a cog rattle, a noisemaker that produces a loud, rattling sound when whirled around by its handle. The tradition continues in some Latin American countries.

A cog rattle is a relatively simple musical instrument, with a handle that incorporates a fluted cogwheel, and a box that encloses a wooden tongue. When the rattle is spun, the tongue catches on the sharp edges of the cogwheel, producing a raucous sound. In addition to its service in the Mass, this type of instrument historically was used in processions and on naval vessels, where it functioned as an alarm. Today it is most commonly found at parties and carnivals. This extraordinary example has survived since the Renaissance. The box, or cage, that holds the wooden tongue is decorated with rough carvings, including a Roman cross.

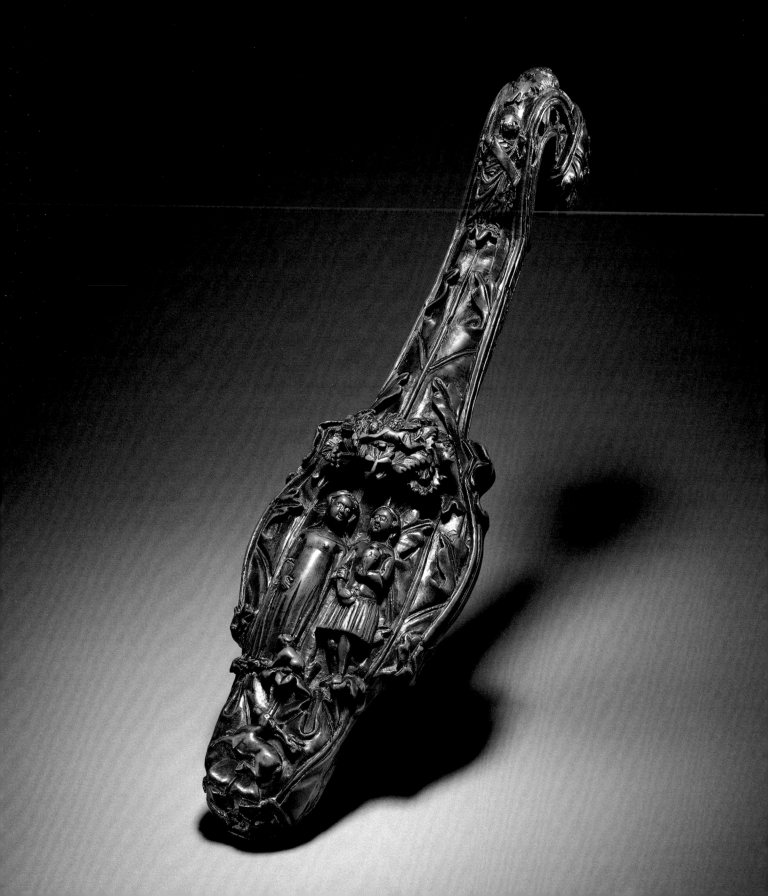

Mandora or Chitarrino

Northern Italy, Milan (?), ca. 1420
Boxwood body and stained rosewood fingerboard,
L. 14 ¼ in. (36 cm)
Gift of Irwin Untermyer, 1964 (64.101.1409)

This small, strangely shaped box-wood instrument recalls stringed instruments seen in Renaissance paintings by Fra Angelico and Agostino di Duccio, but scholars debate what it was, how it was played, and even what to call it: mandora, mandola, chitarrino, or rebecchino. Those who maintain that it was played with a bow cite its overall form, the sickle-shaped peg-box, and the extended lower section, features that link it with two bowed instruments, the medieval European rebec and its North African pre-decessor the rebab. Unlike those instruments, this mandora also has a rose (a decoration in the sound

hole). The bowed hypothesis is sup-ported by two related instruments in Vienna (Kunsthistorisches Museum) and Bologna (the Violeta of Santa Caterina de' Vigri in the Monastery of Corpus Domini) and by several images, including Gerard David's *The Virgin Among the Virgins* (Musée des Beaux-Arts, Rouen).

Other scholars believe the instrument was plucked, like a lute. Most bowed instruments have an arched top to facilitate bowing, but recent scholarship suggests that this instrument's flat top and rose are original. Moreover, a small carved figure on the pegbox is plucking a small lutelike instrument, and the carvings on the back relate to roman-tic love and fidelity, long associated with plucked instruments like the guitar and lute.

Regardless of how it was played, it is evident that much care was given to its opulent carvings and fine relief work. A maiden, her hair falling to her shoulders, gazes at her betrothed; her hand folds over his arm, and a dog, a symbol of fidel-ity, sits at her feet. A falcon perches on the young man's hand. Cupid is in the tree above, and a leaping stag is below. A robed figure on the neck points to a threatening dragon above, introducing a perhaps more ominous theme.

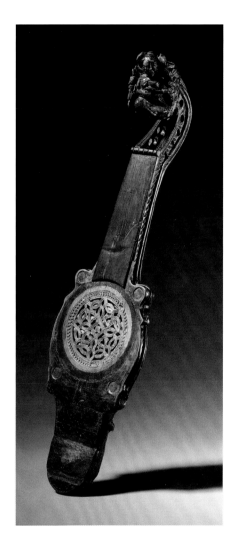

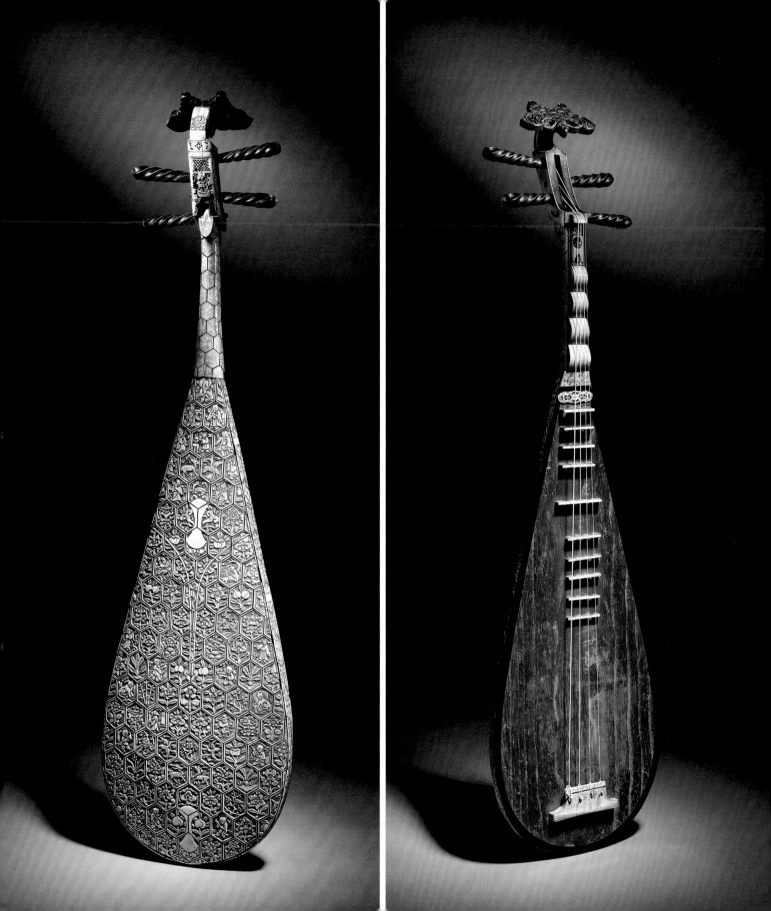

Pipa

China, Ming dynasty, late 15th–early 16th century
Wood top with ivory decorative plates on back,
bone plaques on neck, and silk strings,
L. 37 in. (94 cm)
Bequest of Mary Stillman Harkness, 1950
(50.145.74)

Many instruments migrated across the Silk Road, including the pear-shaped lute, which traveled both east and west from Central and Western Asia. (The European lute gets its name from a linguistic corruption of the Arabic al-'ūd [the oud].) The instrument appeared during the Han and Sui dynasties (first century to 618) in China, where it eventually became the pipa. The pipa originally was held horizontally, like a guitar (as seen in the Tang dynasty earthenware figure shown at right), and its twisted silk strings were plucked with a large triangular plectrum, or pick—a style still used for Japan's version of the instrument, the biwa. The Chinese name describes the down-up motion of the plectrum, held in the performer's right hand: *pi*, "to play forward," and *pa*, "to play backward."

In the mid-tenth century musicians in China began using their fingernails to execute the exuberant programmatic repertoire (music associated with a story or other extramusical idea) that was gaining popularity and ultimately became the national style. (Fittingly, the ivory bridge of the pipa shown here is engraved with a pivotal scene from the Chinese opera *Romance of the Western Chamber*.) To facilitate the use of the fingers, the instrument was held in a more upright position. In addition to its use in the opera and in storytelling ensembles, the pipa has a solo repertory of virtuosic music.

This unique Ming dynasty example features spectacular ivory decoration on the back and sides; atypically, the expert workmanship faces the player and is unseen by listeners. Each of the more than 110 hexagonal ivory plaques is carved with Taoist, Confucian, or Buddhist figures and symbols signifying prosperity, happiness, and good luck.

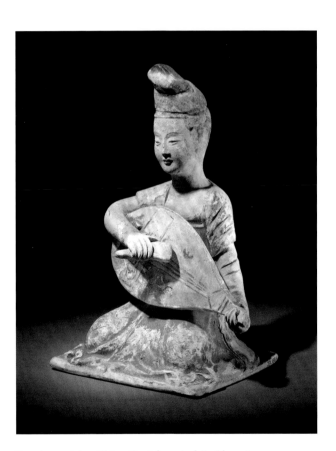

Female musician. China, Tang dynasty, late 7th century.
Earthenware with pigment, H. 5¾ in. (14.6 cm). Rogers Fund, 1923
(23.180.4)

Spinetta (Virginal)

Venice, 1540
Wood case with colored wood and ivory inlay,
cypress soundboard, and parchment rose,
L. 57¼ in. (145.4 cm)
Purchase, Joseph Pulitzer Bequest, 1953 (53.6a, b)

This small, elegant virginal is one of the oldest surviving keyboard instruments. According to an Italian inscription found inside, it was made for the duchess of Urbino, Eleonora della Rovere, who was the daughter of the great arts patron Isabella d'Este. The case is inlaid with different colored woods in floral and geometric designs. Mother-of-pearl is inlaid in gilt squares that alternate with floral carvings above the keys. Fantastical creatures top panels flanking the keyboard. The pentagonal case shape was common in Italian instruments of the period, and the projecting keyboard was characteristic of instruments made in Venice.

In Italy the instrument was commonly used in outdoor performances, because it was easier to move than the larger harpsichord. On a thin strip above the keyboard is an Italian verse that translates: "I am rich in gold and rich in tone; if you lack virtue, leave me alone."

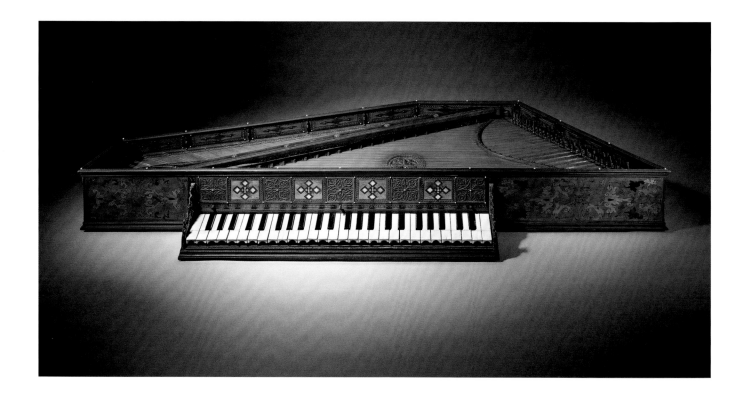

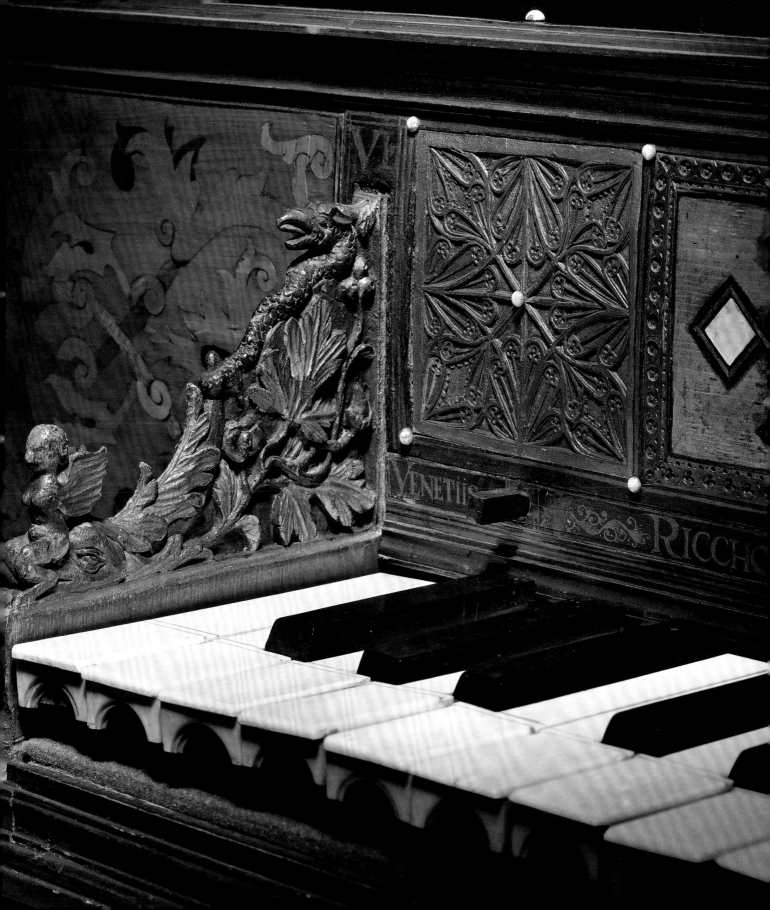

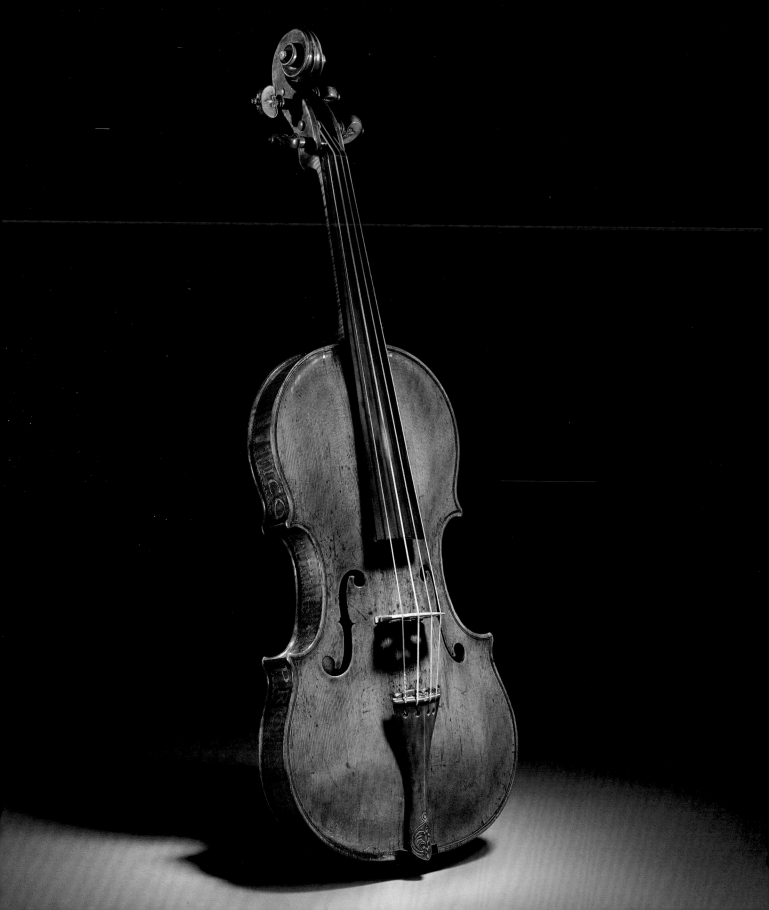

Violin "ex Kurtz"

Andrea Amati (ca. 1505–1578)
Italy, Cremona, ca. 1560
Spruce top, maple sides and back, ebony
fingerboard, and gut strings, L. 22 ⅝ in. (57.4 cm)
Purchase, Robert Alonzo Lehman Bequest, 1999
(1999.26)

Royal patrons were crucial to establishing the reputations of musical instrument makers, as they were to other artists and artisans. The instruments resulting from royal commissions, like the virginal for Eleonora della Rovere (see page 50) or this violin, were often more decorative than other instruments by the same makers. This violin bears on its ribs a painted motto in Latin that translates as "by this bulwark alone religion stands and will stand." The motto is associated with the marriage of Philip II of Spain to Elisabeth of Valois in 1559 and the union of their Catholic countries against Protestantism. The back has additional painted decoration, including fleurs-de-lis in the corners, a geometric design with floral ornamentation between the upper bouts (the curves forming the violin's shoulders), and a few traces presumed to have been a central coat of arms.

It was made by Andrea Amati, who lived and worked in the city of Cremona and is credited with standardizing the instrument in its modern form, with four strings. Amati's method for building his instruments, shaping the ribs around an internal form, would be used by generations of Cremonese makers, including subsequent members of the Amati family, the Guarneri and Ruggieri families, and Antonio Stradivari. It is one of the defining characteristics of instruments from Cremona, which became the violin-making center of the world.

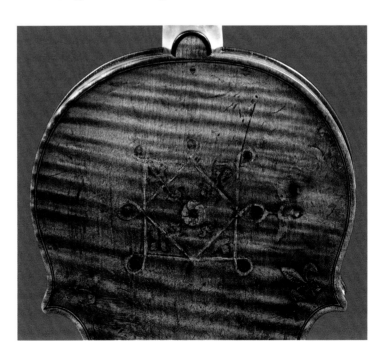

Regal

Attributed to Georg Voll (active ca. 1540–75)
Germany, Nuremberg, ca. 1575
Painted wood case, hide-bound bellows, boxwood
keys, and brass reeds, L. 27 in. (68.6 cm)
The Crosby Brown Collection of Musical
Instruments, 1889 (89.4.2883)

The regal is a small pipe organ with a single rank of pipes. Inside each pipe is a thin metal (usually brass) tongue, or reed, that produces a loud, nasal sound when air produced by pumping the bellows rushes around the reed, causing it to vibrate. The pipes function as resonators but, because they are very short, do little to moderate the reeds' aggressive tone. Usually used as a continuo instrument, the regal's long, sustained tone distinguished it from the plucked sound of the harpsichord, and its loud volume made it of greater use with large groups of musicians than a chamber organ. Composers occasionally specified it, as Monteverdi did in *Orfeo*'s scenes of the underworld.

This example follows an innovative design by the sixteenth-century Nuremberg instrument maker Georg Voll, with a keyboard and pipes that can be stored inside the bellows for easy transport.

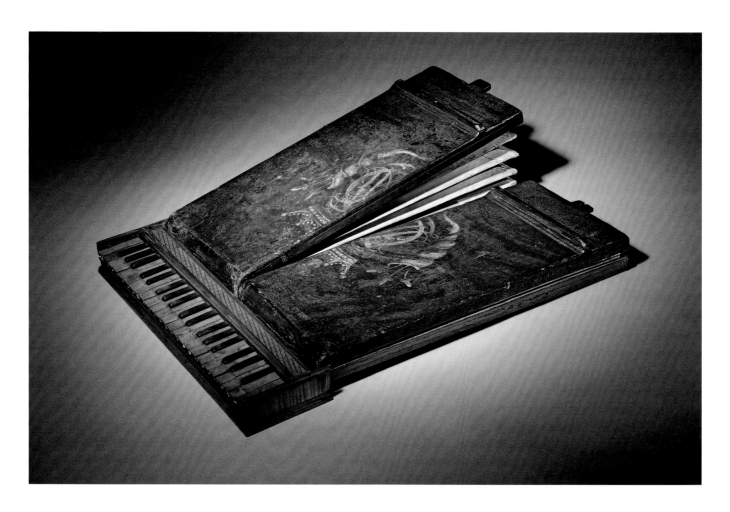

Bajón (Bass Dulcian)

Possibly Spain, 17th century
Tropical hardwood, L. 35 ⅞ in. (91 cm)
Purchase, Amati Gifts, 2010 (2010.204)

Bajoncillo (Soprano Dulcian)

Southern Europe or Spain, early 17th century
Boxwood body with brass keys and bocal,
L. 14 ⅛ in. (35.8 cm)
The Crosby Brown Collection of Musical
Instruments, 1889 (89.4.3479)

The rich and dark double-reed sound of the dulcian family would have been familiar to seventeenth-century European ears in many different contexts. In mixed consorts, dulcians were often used as a robust low voice with or in lieu of trombones and were favored bass instruments in trio sonatas with violins.

In seventeenth-century Spain, the bajón and the smaller, higher-pitched bajoncillo were prominent and important instruments in the church. *Bajonistas*, who included nuns, accompanied the sung liturgy and performed the large body of sacred repertoire written for the instrument. In the eighteenth century, dulcians throughout Europe were gradually supplanted by the bassoon.

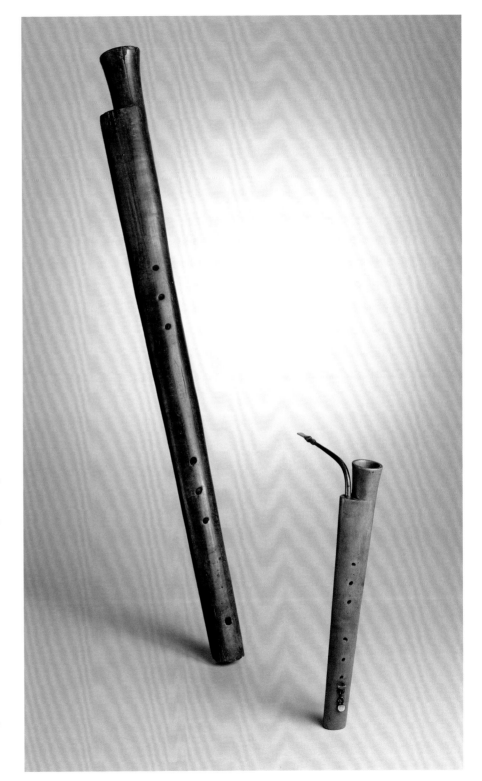

Cornett

Germany or Italy, ca. 1575
Ivory body and gilded ferrule, L. 22 ⅝ in. (57.5 cm)
Funds from various donors, 1952 (52.96.1)

The cornett was the most important soprano wind instrument during the Renaissance. A tradition of intricate, florid playing flourished in ecclesiastical and secular settings, particularly in Italy, Austria, and southern Germany. Leading virtuosi were celebrated and often lavishly remunerated. The instrument's prominence made it popular in visual representations of music. The intarsia panel (shown below) from a study in the ducal palace in Gubbio, Italy, is one of the earliest depictions of the cornett in its characteristic octagonal form.

Typically cornetts were fashioned from wood that was covered with black leather. This cornett's design and faceted carving mirror those of wooden examples, but the use of ivory and the finely detailed and gilded decorative metal ferrule are exceptional. They suggest that this cornett may have been commissioned by a wealthy patron, perhaps for a favored virtuoso. Horns made of ivory are precious symbols of status around the world. Not only is the material rare, but the process of crafting an instrument from ivory, which includes delicately boring out the curved tusk, is exacting. Ornate ivory cornetts were popular additions to aristocratic art collections and were sometimes made primarily as decorative objects, but the careful placement and undercutting of the finger holes on this instrument indicate that it was intended for the hands of a musician.

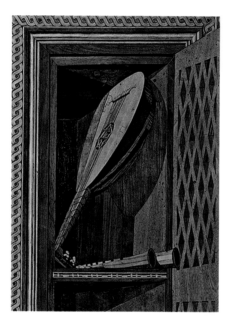

Francesco di Giorgio Martini (Italian, 1439–1501). Lute and two cornetts; detail from the studiolo from the ducal palace in Gubbio, ca. 1478–82. Walnut, beech, rosewood, oak, and fruitwoods in walnut base, 27 ½ x 18 ½ in. (69.9 x 47 cm). Rogers Fund, 1939 (39.153)

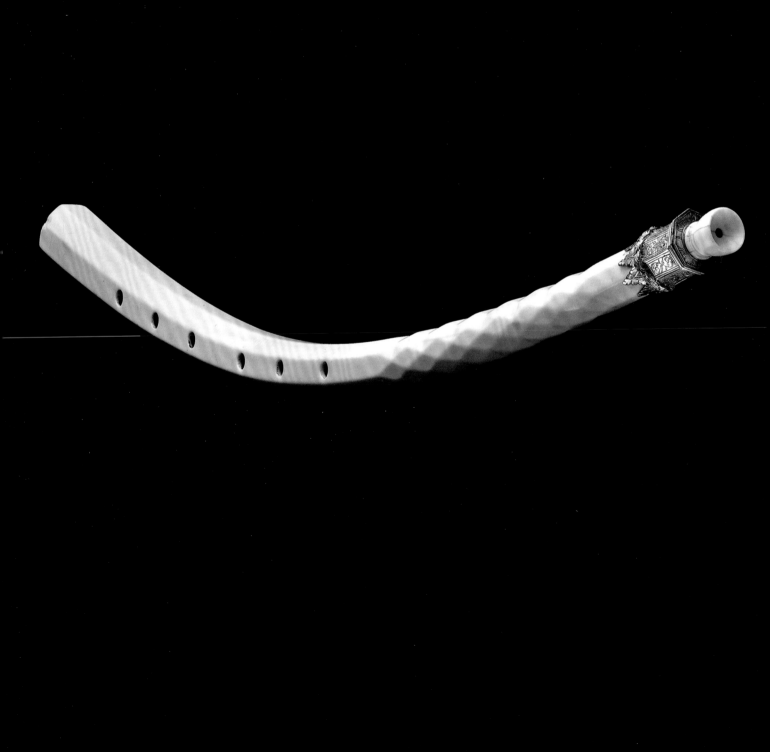

Double Virginal

Hans Ruckers the Elder (ca. 1540s–1598)
Belgium, Antwerp, 1581
Painted pinewood case, W. 71 ¾ in. (182.2 cm)
Gift of B. H. Homan, 1929 (29.90)

Hans Ruckers was the first of a family dynasty that dominated harpsichord building for more than a century and profoundly influenced northern European instrument building in the sixteenth and seventeenth centuries. This exquisite instrument is the oldest known work by this maker and was built two years after Ruckers joined the Guild of Saint Luke, a trade organization for artists in Antwerp that included the city's great painters, such as Jan Brueghel the Elder and Peter Paul Rubens.

The word "virginal" probably came to be associated with such instruments in the sixteenth century because young women would play them for domestic entertainment. The double virginal is sometimes referred to as a "mother and child" because its main instrument—in this example, with its keyboard on the right—is accompanied by a smaller virginal (called an ottavino, seen on the left) that plays an octave higher than the larger keyboard.

The smaller instrument fits into a compartment and can be removed to be played by itself. When the child is properly positioned above the mother, an ingenious mechanism allows both keyboards and their corresponding sets of strings to be coupled, or played simultaneously.

Medallions with the profiles of King Philip II of Spain and his fourth wife, Anne of Austria, are set above the large keyboard. Spain controlled Antwerp in the late sixteenth century, and the instrument is thought to have been built as a royal gift to the viceroy of Peru. It was found in Cuzco, Peru, in the twentieth century.

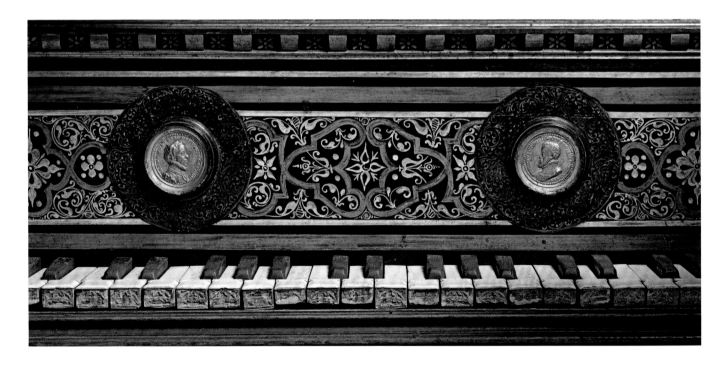

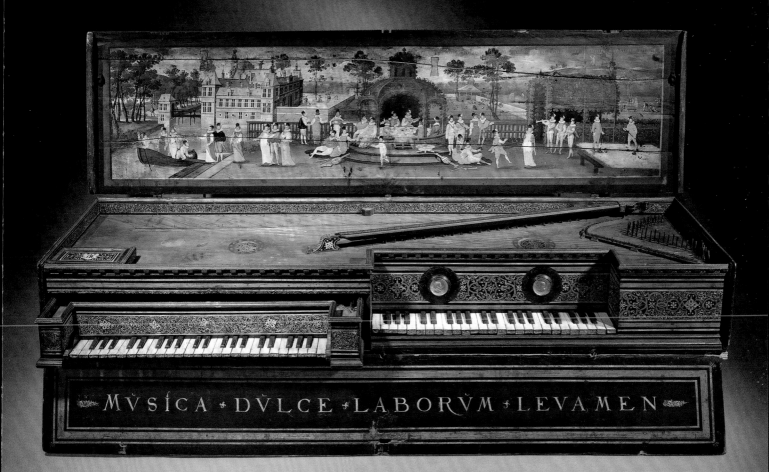

MVSICA · DVLCE · LABORVM · LEVAMEN

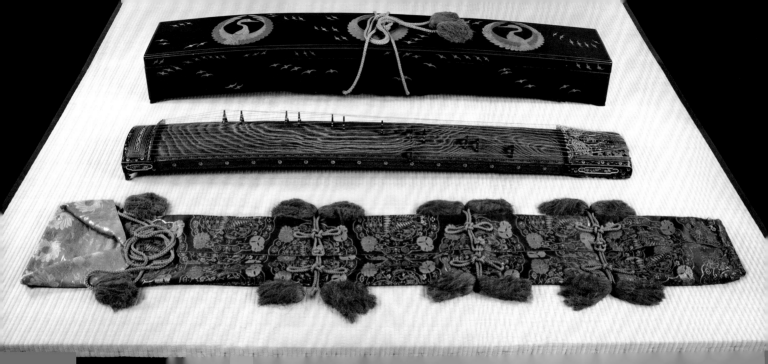

Koto (Long Zither)

Workshop of Gotō Yūjō; metalwork by
Gotō Teijo (1603–1673)
Japan, early 17th century
Paulownia wood body with ebony, metalwork,
and inlay of colored woods, ivory, tortoiseshell,
silver, and gold; silk strings; silk brocade wrap;
lacquered box,
L. of koto 74 ⅝ in. (189.5 cm)
Purchase, Amati Gifts, 2007 (2007.194a–f)

This exquisite koto is a tour de force of Japanese decorative and musical arts. The circumstances of its conception are as extraordinary as the object itself. In the first third of the seventeenth century, during a series of battles that led to the unification of Japan, Tanabe Castle was under siege by fifteen thousand men. Holding the castle was Hosokawa Yūsai, military commander and sole keeper of the secret interpretive traditions of a tenth-century imperial anthology of Japanese poems (*Kokin Wakashū*). To save him, the shogun dispatched three poet-warriors, including Yūsai's son-in-law, Karasumaru Mitsuhiro. Yūsai's son, the daimyo Hosokawa Tadaoki (Sansai), is said to have presented

the instrument to Mitsuhiro in gratitude for the rescue. According to tradition, its completion took one thousand days.

Befitting the nobleman who owned it, each component of the koto is of the highest quality. Accompanying this exceptional instrument are its original traveling crate (not pictured), an early nineteenth-century lacquered storage box decorated with gold cranes (symbol of the Karasumaru family), eighteenth- and nineteenth-century silk brocade wrapping, and thirteen silver-tipped and -lined bridges, one for each silk string. Every part of the koto is decorated. Its soundboard has a swirling grain pattern that evokes flowing water and an elegant border of geometric inlay. Roundels of cranes are set against a carved diaper pattern along the sides. Gold cranes and flying geese appear on both ends, which also feature intricate metalwork by Gotō Teijo depicting facing dragons and a drum-playing *apsara*, a female spirit of the clouds and waters.

The koto tradition dates to the twelfth century; its harplike sound was featured in solo or ensemble performance in court, ritual, and popular music. The koto's classical repertoire as we know it today, as well as its use by women (as shown above right), arose shortly after this instrument was made.

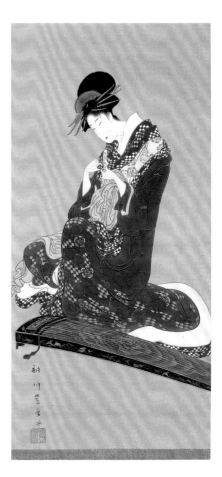

Utagawa Toyohiro (Japanese, 1763–1828). *Woman Putting on Finger Plectrums to Play the Koto*, Edo period, early 19th century. Ink and color on silk, 31 ⅜ x 10 ¼ in. (79.6 x 26 cm). Charles Stewart Smith Collection, Gift of Mrs. Charles Stewart Smith, Charles Stewart Smith Jr., and Howard Caswell Smith, in memory of Charles Stewart Smith, 1914 (14.76.43)

Tenor Recorder

Member of the Bassano family
Venice or London, ca. 1600
Boxwood, L. 24 ⅝ in. (62.5 cm)
Purchase, Amati Gifts, 2010 (2010.205)

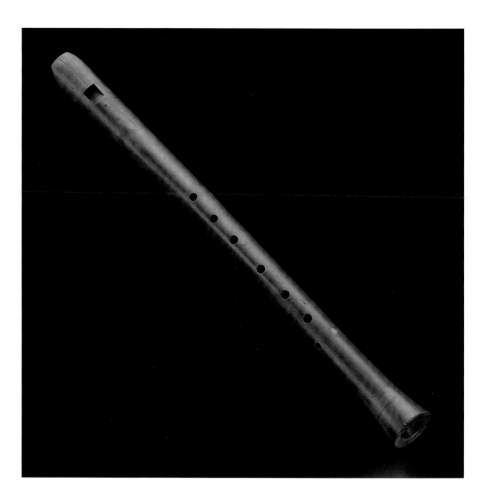

The Bassano family of instrument makers and musicians took its name from the city of Bassano del Grappa in the Veneto but had relocated by the early sixteenth century. Although only circumstantial evidence exists about the family's religion, Bassano was a well-known Jewish surname, and the family may have fled Bassano in 1516, when Jewish residents of the town were expelled. The Bassanos' coat of arms featured three silkworm moths and a mulberry tree, suggesting that the family was involved at some point in the silk farming trade. This recorder bears on the rim of its bell the Bassanos' moth stamp.

During the sixteenth and early seventeenth centuries the Bassanos were active in music circles in Venice and London, where in the late 1530s several Bassano brothers established themselves as musicians at the court of Henry VIII. Members of the family were part of Shakespeare's circle, and one of the brothers, Baptista, had a daughter Emilia, who may have been the "Dark Lady" of Shakespeare's sonnets. Shakespeare may also have based the character Bassanio from *The Merchant of Venice* on a member of the family.

Part of the flute family, the recorder has been used in art music in Western Europe since the fifteenth century. Makers constructed matched consorts of various sizes of recorders, from soprano to bass, to play polyphonic repertory, including secular songs, motets, and dance music.

Qin (Zither)

Prince of Lu (1608–1646)
China, Ming dynasty, 1634
Wood, lacquer, and silk strings,
L. 46⅝ in. (118.4 cm)
Purchase, Clara Mertens Bequest, in memory
of André Mertens, Seymour Fund, The Boston
Foundation Gift, Gift of Elizabeth M. Riley,
by exchange, and funds from various donors,
1999 (1999.93)

The qin is China's quintessential classical instrument. Traditionally a scholar's instrument, its quiet music, played in solitude or for an intimate friend, expressed one's innermost and profound emotions. During the Han dynasty (206 B.C. A.D. 220) writers claimed that playing the qin helped to cultivate character, understand morality, supplicate gods and demons, enhance life, and enrich learning. Literati of the Ming dynasty (1368–1644) suggested that the qin be played outdoors, in a mountain setting, garden, or small pavilion, preferably near an old pine tree with incense perfuming the air. A serene moonlit night was considered an appropriate time for performance. Today the qin's extensive repertoire is played publicly, but the music remains complex and evocative as the player plucks, snaps, and dampens the strings to create embellishments such as slides, bell-like harmonics, ornaments, and vibrato.

The present form, with seven unfretted silk strings and thirteen studs (*hui*) marking finger positions, emerged only in the late Han period (A.D. first century), although, according to legend, the qin was played in the time of Confucius (sixth century B.C.) or even earlier.

Many Ming dynasty princes were accomplished musicians and music scholars. Zhu Changfang, the prince of Lu and nephew of Emperor Wanli (Shenzhong), commissioned hundreds of qins, all bearing the inscription of the Princedom of Lu. Of the ten or so extant instruments, this one, number eighteen, is the earliest. On its back are the maker's seal and date, the words for "Capital Peace," and a poem by Jingyi Zhuren (died 1670) that translates as: "The moonlight is being reflected by the river Yangzi / A light breeze is blowing over clear dewdrops, / Only in a tranquil place / Can one comprehend the feeling of eternity."

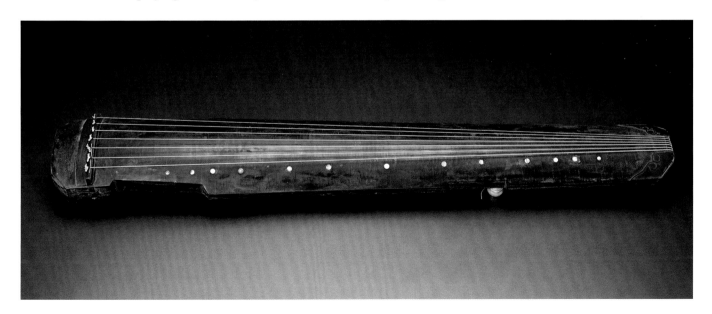

Musical Automata Clock

Samuel Bidermann (1540–1622) and Veit
Langenbucher (ca. 1587–1631)
Germany, Augsburg, ca. 1625–31
Ebony case, H. 30¾ (78.1 cm)
Purchase, Clara Mertens Bequest, in memory of
André Mertens, 2002 (2002.323a–f)

Encased in this ebony table clock
is one of the most complex auto-
matic instruments to have survived
from the early seventeenth century.
Visible from the outside are small
facade pipes and a clock surmounted
by a pavilion housing five carved and
colorful commedia dell'arte charac-
ters who dance, turning and circling,
when the clock strikes the hour.
Within the cabinetry is an extremely
rare and important mechanism that
controls both the dancers and the
musical apparatus, a sixteen-note
pipe organ and a sixteen-string
spinet that may be played separately
or together. The clock's compact

internal design includes a spring
mechanism; organ pipes and bel-
lows; a device that plucks the spinet's
strings; and a pinned, rotating cyl-
inder that activates the instruments
and the motion of the dancers. Three
airs, probably by composer Hans Leo
Hassler, are stored on the original
pinned cylinder. Most cylinders and
their tunes were replaced over the
years, so this one provides the oppor-
tunity to hear the airs as they were
played in the seventeenth century.

This instrument represents a
masterwork of technology that would

have been the pride of an important
family. It was made by the renowned
team of Samuel Bidermann (musical
programmer) and Veit Langenbucher
(clockwork), whose best-known
work was the art cabinet that was
presented to Duke Philip II of
Pomerania and depicted about 1617
in a painting by the German artist
Anton Mozart (Staatliche Museen,
Kunstgewerbemuseum, Berlin); the
cabinet was destroyed in World
War II. Today, this clock offers a
unique glimpse into the music and
technology of a prosperous past.

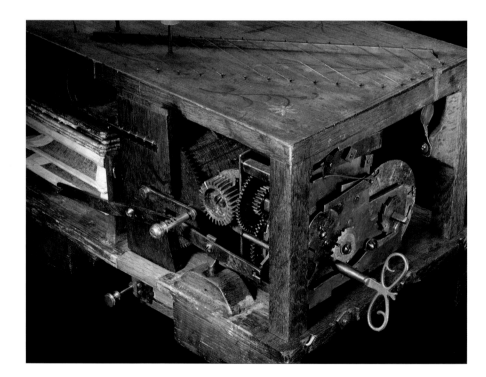

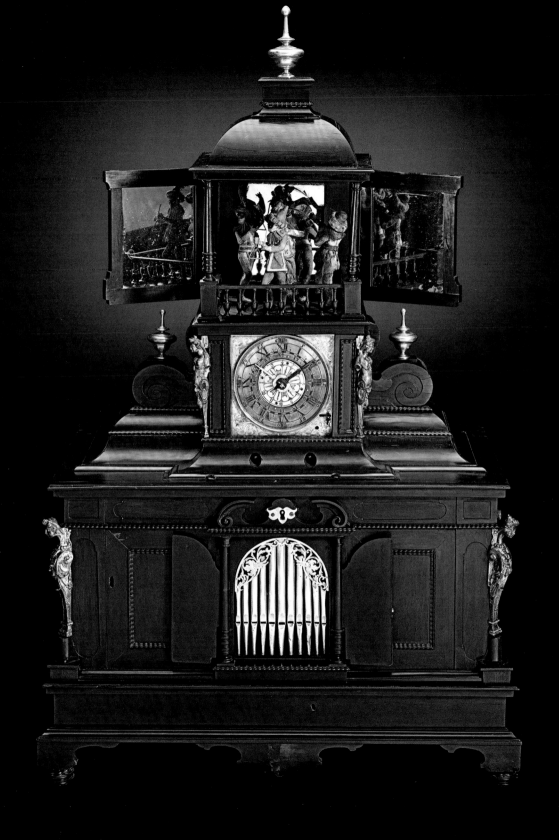

Guitar

Attributed to Matteo Sellas (ca. 1599–1654)
Venice, ca. 1630–50
Spruce top, snakewood and ivory back, parchment
rose, gut strings, and inlay of ivory, mother-of-
pearl, and bone, L. 37⅝ in. (95.6 cm)
Purchase, Clara Mertens Bequest, in memory of
André Mertens, 1990 (1990.103)

The guitar's now widespread popularity first gained momentum in Europe during the Baroque period, eventually eclipsing the lute, which was more difficult to tune and play. In addition to its longtime role accompanying singers, the guitar became a fashionable solo instrument with a large repertoire, much of which was inspired by various dance forms. Contemporary iconography also shows guitars being played in ensembles of mixed instruments. Some of the most celebrated Baroque depictions of the guitar feature it in the theatrical context of commedia dell'arte, where it was often played by the mischievous character Mezzetin, notably in the painting by Antoine Watteau shown at right.

The guitar has long carried with it that whiff of roguish disrepute. The composer and music theorist Michael Praetorius proclaimed in his book *Syntagma Musicum* (ca. 1614) that it was played by "charlatans and saltimbanques who use it for strumming, to which they sing villanelles and other foolish songs." Guitar players, particularly from Spain and Italy, were criticized for their extravagant body movements and gestures, which were regarded as all the more unseemly when indulged in by the northern European aristocrats who increasingly laid aside their lutes for guitars.

Opulently decorated guitars such as this example and others produced by the Sellas family reflect the instrument's growing cachet and appeal to wealthy customers. The use of exotic materials such as snakewood was a hallmark of Venetian makers, whose famed port provided access to resources from around the globe. The intricate parchment rose of this guitar is tiered like an inverted wedding cake and recedes into the sound hole to stunning effect. Below the mustachioed bridge is an inlaid bouquet of bone hearts. The headstock, which has been restored and may not be original, features the name Matteo Sellas, one of the best in a large family of luthiers.

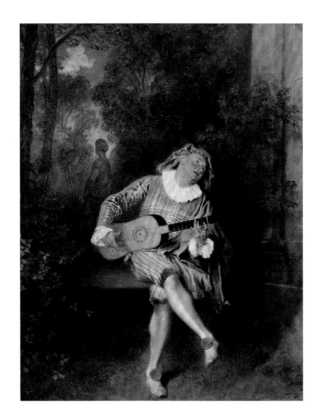

Antoine Watteau (French, 1684–1721). *Mezzetin*, ca. 1718–20. Oil on canvas, 21¾ x 17 in. (55.2 x 43.2 cm). Munsey Fund, 1934 (34.138)

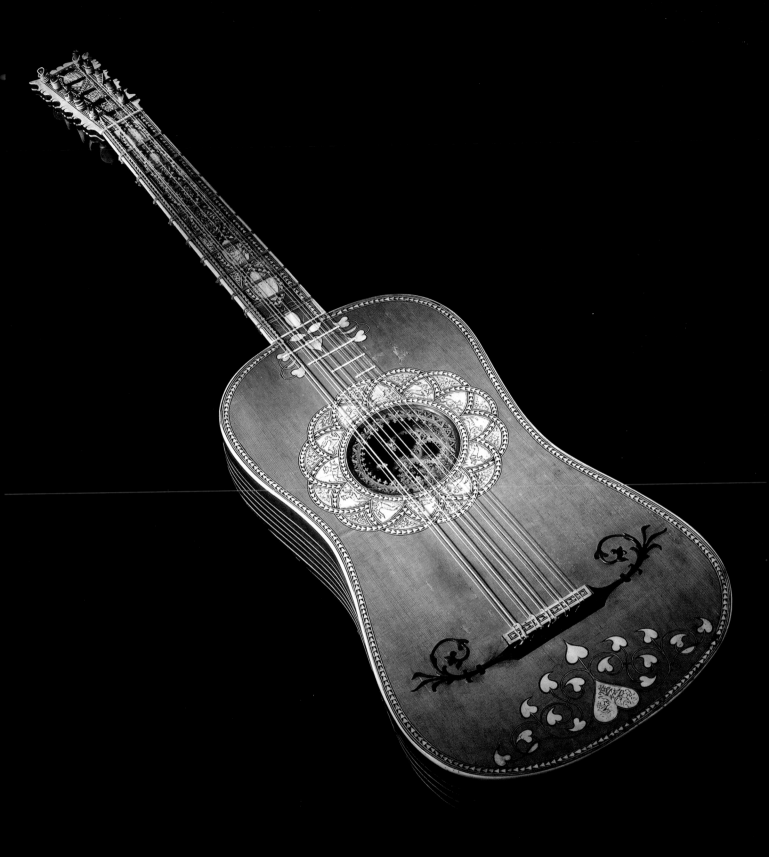

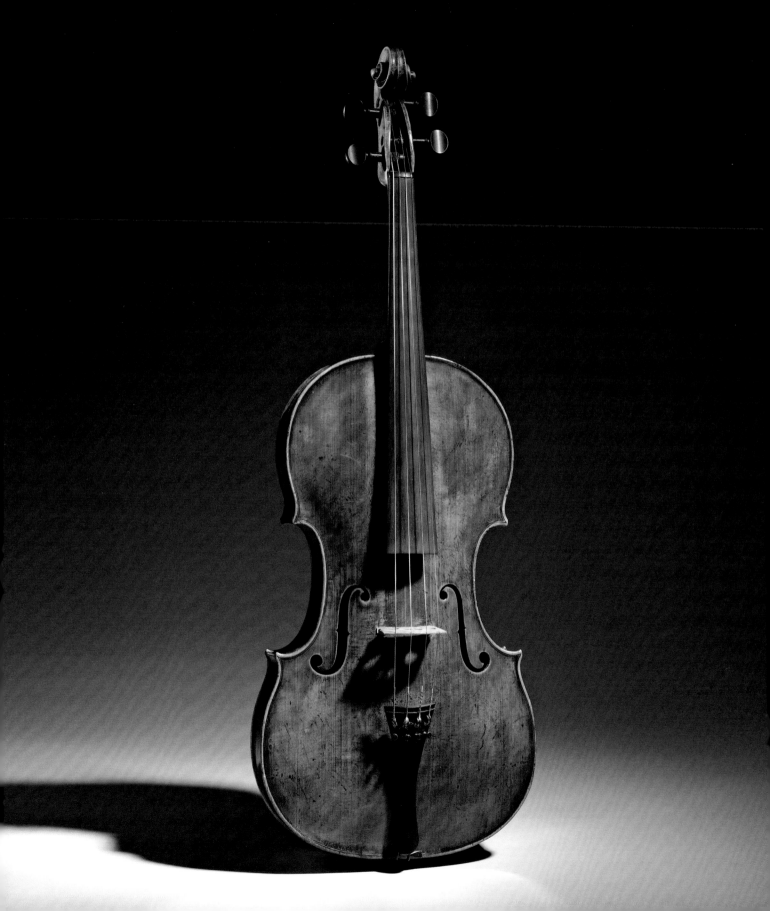

Viola

Jacob Stainer (ca. 1617–1683)
Austria, Absam, ca. 1660
Spruce top, maple back and sides, and blackwood
fingerboard, L. 27⅞ in. (70.8 cm)
Purchase, Robert Alonzo Lehman Bequest,
Fletcher Fund, 2012 Benefit Fund and Beatrice
Francais Gift, 2013 (2013.910)

Fitting between the violin and the cello in both pitch and tone color, the viola is the middle voice of the violin family. During the seventeenth century violas were true tenor instruments with large bodies, often with tall ribs joining their tops and backs. As repertoire became more technically demanding, makers built smaller violas that were easier for players to handle. Prized old violas were literally cut down to adapt to changing performance techniques, losing their original proportions and sound in the process. This viola is one of the very few from the seventeenth century that has not been reduced in size. An abundance of the original varnish, which gives this instrument its distinctive caramel color, is also a rare survival.

Jacob Stainer is known as *der Vater der deutschen Geige* (the father of the German violin), and his instruments were favorites of the Bach and Mozart families. This viola was made at the height of Stainer's powers and is an expression of his mature style. The very full arching, or voluptuous curvature, of its top and back is a Stainer hallmark that was vital to producing the so-called *voce argentina* (silver tone) for which his violins and violas were famed. His instruments are also identifiable by their vertical f-holes (sound holes), which are punctuated on each end by well-proportioned "eyes," or circular openings, and by their meticulous workmanship. They remained the world's most sought-after instruments in the violin family until the beginning of the nineteenth century, when performers striving to be heard in increasingly loud orchestras and larger concert halls came to prefer the brighter sound of Antonio Stradivari's instruments.

Harpsichord

Designed by Michele Todini (1616–1690);
carving by Jacob Reiff; gilding by Basilio Onofri
Rome, 1672
Cypress soundboard and gilded wood case,
L. of case 9 ft. 10 in. (299.7 cm)
The Crosby Brown Collection of Musical
Instruments, 1889 (89.4.2929)

This magnificent harpsichord was originally part of Rome's Galleria Armonica, a private museum of unusual mathematical and musical machines created by Michele Todini, an inventor. Todini may have conceived the harpsichord's design as early as 1665 but took several years to fully realize it. The gilded case is decorated with a frieze depicting the Triumph of Galatea and is supported by three tritons rising from a rough sea. The case houses a large harpsichord of the Italian style with two sets of unison strings. The instrument and case are flanked by gilded statues of Galatea and the Cyclops Polyphemus, who plays a sordellina, a type of bagpipe. It is thought that the Polyphemus statue originally sat on a much taller rock that concealed a small pipe organ.

The entire assemblage was set before a backdrop with a pastoral landscape painted by Gaspard Dughet.

Todini described these three pieces, now the only surviving parts of the Galleria Armonica, in a catalogue published in 1676. He had intended his Galleria as a profit-making venture and charged an entry fee. Although it became a popular stop on the Grand Tour, described by luminaries such as the musicologist Charles Burney, it led to Todini's financial ruin. The Galleria remained open for more than a century after its founder's death, until 1796.

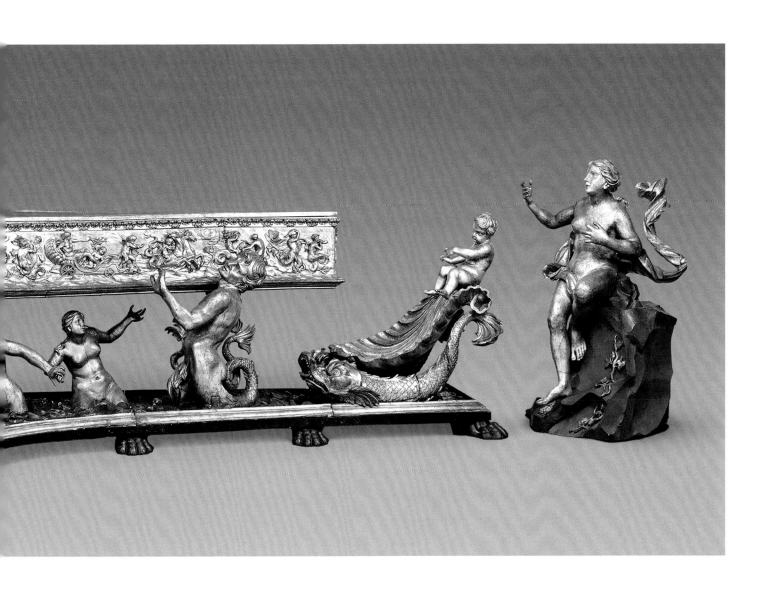

Bass Viol

Labeled Richard Meares; attributed to
Edward Lewis (1651–1717)
London, ca. 1680
Spruce top, maple back and sides, and
gut strings, L. 46 ⅛ in. (117 cm)
Purchase, Louis V. Bell Fund, Mrs. Vincent Astor
Gift, and funds from various donors,
1982 (1982.324)

The viol was one of the most popular
and versatile instruments of the
seventeenth century. An ideal
continuo instrument, it was fre-
quently used to accompany singers
and, like the lute, was fashionable
among amateur players. The viol
was perhaps most characteristi-
cally played in consorts that were
made up of matched viols in differ-
ent sizes—a so-called chest of viols.
As the orchestra developed in the
mid-seventeenth century, the louder
violin family grew in favor, but the
bass viol remained a popular solo
instrument through the eighteenth
century, particularly in England. The
division viol, the type shown here,
was a slightly smaller form of bass
viol designed to facilitate the play-
ing of virtuosic solo variations called
divisions.

This instrument was made in
London, a renowned center for viol
making and home to the workshops
of the celebrated Richard Meares
and his son of the same name. The
label, which bears the name Richard
Meares, is in Latin, a convention the
younger Meares used to differentiate
his work from his father's. However,
the instrument's stylistic and struc-
tural features, such as its thin
purfling (the decorative edge inlaid
into the top and back that protects
against cracking) and geometrically
patterned ribs, suggest that it was
made in the workshop of Edward
Lewis, who died before the instru-
ment was completed. It is likely that
Richard Meares II, the son, pur-
chased the unfinished instrument at
a sale of Lewis's effects, completed
it, and marked it with his own label.
That possible narrative illustrates
the intricacies of trade and suc-
cession in the business of musical
instrument making. Scholarship has
demonstrated that it is an important
example of English viol making,
despite the ambiguity surrounding its
manufacture.

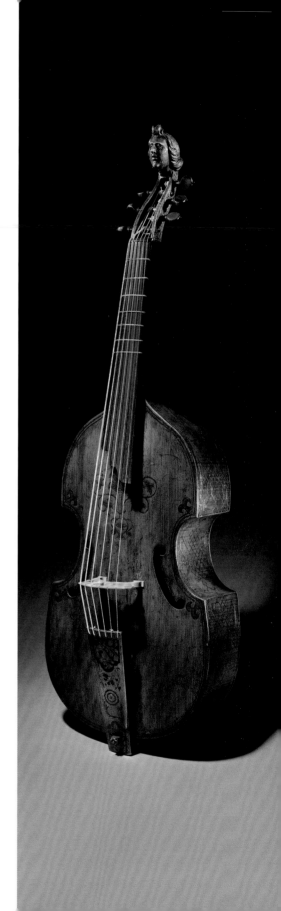

Harpsichord

Italy, late 17th century
Painted wood outer case, cypress or cedar
inner case, and pine soundboard, L. of inner
case 94 ¼ in. (239.4 cm)
Gift of Susan Dwight Bliss, 1945 (45.41)

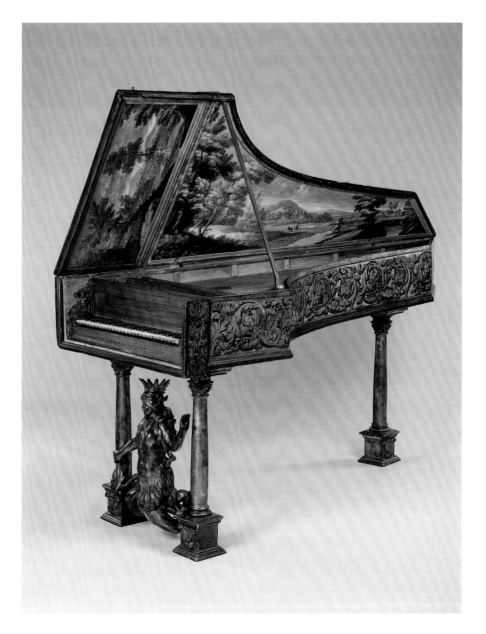

Large instruments such as harpsichords were expensive pieces of high-status furniture that were often elaborately decorated. The decoration was frequently matched to the lavish rooms in which the harpsichords were kept and updated as tastes and furnishings changed.

This remarkable instrument is believed to have been owned by and decorated for the Colonna family, powerful Italian nobles based in Rome. The harpsichord rests on a stand that features a gilded siren between two columns, a symbol of the Colonnas. The inside of the case lid is adorned by two landscape paintings, which Lorenzo Onofrio Colonna, the head of the family in the late seventeenth century, favored. They are probably the work of a follower of Gaspard Dughet. (Dughet, a French artist active in Rome, painted the backdrops for Michele Todini's harpsichord and figures on page 70.) This harpsichord is of a typical Italian construction, with both inner and outer cases, allowing the instrument to be removed from the decorative outer case and easily transported to be played in another room. The instrument is unusual for an Italian harpsichord because it has three sets of unison strings (instead of the typical two) that are simultaneously plucked when a key is played.

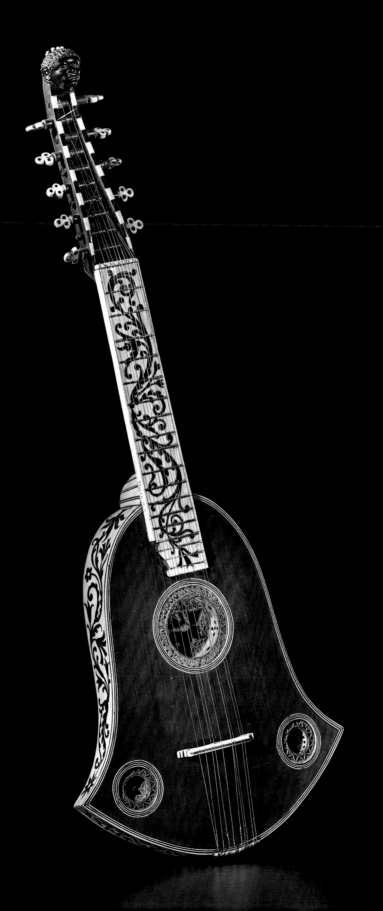

Hamburger Cithrinchen (Cittern)

Joachim Tielke (1641–1719)
Germany, Hamburg, ca. 1685
Cypress top, parchment rose, steel strings, and ivory back, sides, and fingerboard with ebony inlay, L. 24 ⅞ in. (63.2 cm)
Purchase, The Vincent Astor Foundation Gift and Rogers Fund, 1985 (1985.124)

Primarily a folk instrument that continues to be used in traditional music, the cittern was elevated to the position of an art music instrument by sixteenth- and seventeenth-century aristocrats, one of whom was probably this extravagant instrument's original owner.

Citterns are plucked stringed instruments, related to lutes and guitars but with five or six courses of metal strings, which produce a brighter and louder sound than gut strings. The cittern also has inlaid metal frets, whereas lutes and early guitars had movable, tied gut frets that accommodated different tuning for particular compositions. Baroque guitar repertoire may have been performed on five-course citterns like this one.

The bell-shaped cittern was fashionable from about 1650 to 1740; it was a specialty of the city of Hamburg, where Joachim Tielke made the earliest known example. Tielke's workshop also produced a wide range of string instruments for wealthy clients, including lutes, guitars, violins, viols, and pochettes, small fiddles for dancing masters. All featured elaborate inlay and carving and costly materials such as ivory, ebony, and tortoiseshell. The ebony foliate decoration and figural scroll on this cittern are typical of Tielke's workshop. A counterpart to this instrument in the Museum für Kunst und Gewerbe in Hamburg is decorated with the reverse inlay: ivory on a dark ground. The inlay decorations were cut from stacks of multiple sheets of material, producing two sets of perfectly matched, mirror-image inlay at the same time.

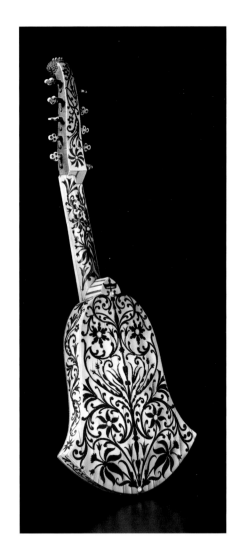

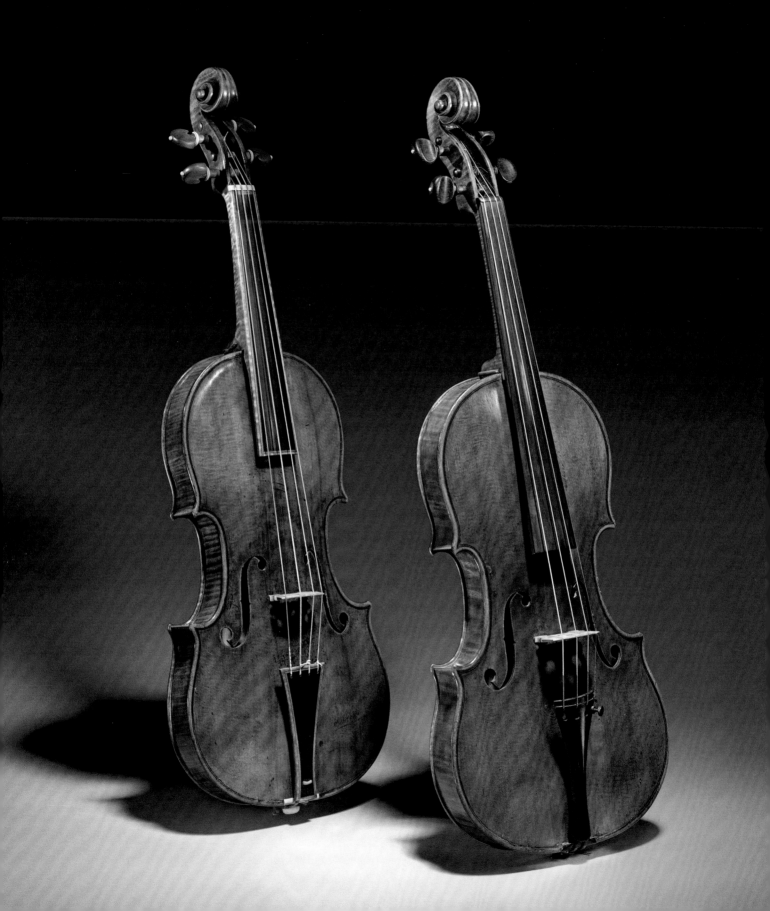

Violin, "The Gould"

Antonio Stradivari (1644–1737)
Italy, Cremona, 1693
Spruce top, maple sides and back, ebony
fingerboard, and gut strings, L. 23¼ in. (59 cm)
Gift of George Gould, 1955 (55.86a–c)

Violin, "The Francesca"

Antonio Stradivari (1644–1737)
Italy, Cremona, 1694
Spruce top, maple sides and back, ebony
fingerboard, and metal strings, L. 23 in. (58.4 cm)
Bequest of Annie Bolton Matthews Bryant, 1933
(34.86.2)

In the modern orchestra, most wind instruments made before the twentieth century are considered outmoded and unusable. Technical developments, including valves and keys, were so fundamental that nearly all were replaced by newer models. By contrast, seventeenth- and eighteenth-century violins, particularly those of Antonio Stradivari, remain sought after by leading performers. Subtle alterations have enabled these violins to stay in use, even as performance spaces grew larger and compositions pushed instruments to their technical capacity, demanding a bigger sound and a greater compass of notes.

A comparison of two Stradivari violins, "The Gould" and "The Francesca," reveals some of the subtle changes that brought violins in line with modern performance expectations. "The Gould" (shown at far left) is a rare example of a Stradivari violin that has been returned to its Baroque configuration, reflecting how it left the maker's workshop, whereas "The Francesca" displays its modifications: the lengthening of the fingerboard and increase of the angle of the neck to extend the left-hand technique to higher positions; the addition of a chin rest (not present in this photo); the use of mostly wire strings instead of gut to produce a more brilliant tone; and the replacement of the sound post and bass bar with larger ones that increase the instrument's volume and strengthen its structure. As a result of such alterations, the character of the violin's sound has changed dramatically since Stradivari's lifetime. Period performance orchestras use violins in the Baroque configuration and corresponding bows to explore historic soundscapes.

Stradivari experimented with the violin's shape and arching and in 1690 devised a slightly longer and narrower body referred to as his "long pattern." Both instruments shown here were built to that design, and their backs may even be of wood from the same tree. By 1700 Stradivari had abandoned the long pattern and reverted to the broader shape typical of his earlier violins.

Kagura Suzu (Bells)

Japan, Nara Prefecture, Miwa, 1699
Wood and metal, L. 13 ½ in. (34.3 cm)
The Crosby Brown Collection of Musical
Instruments, 1889 (89.4.94)

The kagura suzu is a Japanese instrument associated with Shinto ritual; it is used by female shrine attendants (*miko*) during the theatrical and stately kagura dances. It comprises a set of crotal bells (which are spherical, with a slit on one side, similar to sleigh bells) strung atop a wooden handle. Each of the hollow bells has a small pellet inside that rattles when the handle is moved. The bell's shape is said to resemble the fruit of the *ogatama* tree, a species of magnolia that is often found near Shinto shrines because it is thought to summon the kami, or spirits. The kagura suzu is used for a similar purpose: to draw the attention of or wake up the kami.

This example contains twelve crotal bells, each of which has a slit that terminates with heart-shaped cutouts. A five-lobed metal handguard with flower motifs bears an inscription on its underside. Dated 1699, it states that the Shinto priestess Kuriyama Kamiko used the suzu for the worship of the Miwa Miyojin deity at Miwa, a town in Soe County, Nara Prefecture.

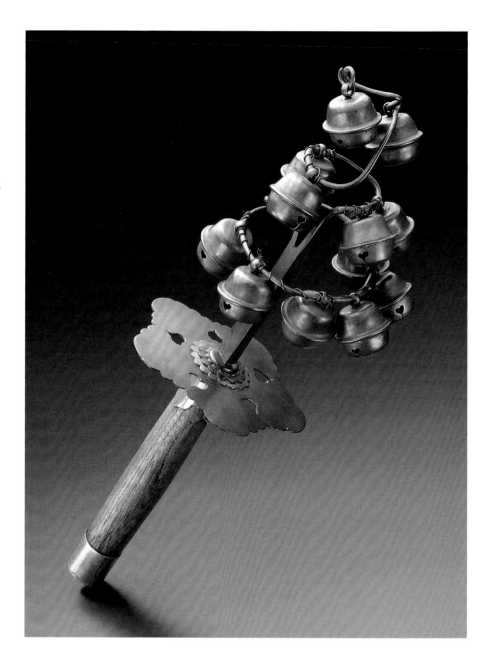

Musette de Cour (Bagpipe)

France, ca. 1700–1750
Silk brocade bag, paper lined leather bellows with wood ends, ebony bourdon, and ivory chanter with silver keys, W. (across bag) 11½ in. (29 cm)
Purchase, Clara Mertens Bequest, in memory of André Mertens, 2003 (2003.63a–d)

The musette is a refined bagpipe designed with a soft sound for genteel entertainment. It was popular with the French aristocracy and those aspiring to upward social mobility from about 1650 to 1750. The instrument conformed to a fashion for idealized rusticity, epitomized by Marie-Antoinette's retreat at Versailles, Le Hameau, where the queen played at being a shepherdess among the carefully groomed sheep that dotted its meadows.

Its sophisticated design, expert workmanship, and valuable materials made the musette a costly instrument. This example's pipes are turned from ivory and delicately inlaid with ebony dots; the keys are silver. Its leather inner bag, now contained in a simple silk cover, would originally have been enrobed in an opulent *couverture* fashioned from fabric and trim that emulated fashionable clothing of the day. While other woodwind instruments of the period had at most three or four keys, musettes had upward of eleven keys on their chanters, the pipes used to play the melody. Further refinements include the bourdon or shuttle drone, which contains the pipes that produce the low, sustained tone and harmonic structure beneath the melody. Its intricate construction includes an ebony body with ivory sliders that can be adjusted to set the pitch of the drone pipes. The handsomely papered bellows are a more seemly way to supply the instrument with air—by manual pumping—than the blow pipe found on more rustic bagpipes.

Trumpet

Johann Wilhelm Haas the Elder (1649–1723)
Germany, Nuremberg, ca. 1700
Silver, L. 28 in. (71.1 cm)
Funds from various donors, 1954 (54.32.1)

The loud and far-carrying sounds of trumpets, drums, and horns made them ideal signal instruments on battlefields and hunting grounds. The wealth and power associated with success in those spheres also made the instruments important symbols of status. While all three instruments went on to become full-fledged members of the orchestra, their original functions are often referenced in the music written for them.

Trumpets have historically been associated with military and royal pageantry and ceremony. The trumpet's sound and appearance—often augmented with tassels and banners—remain prominent features of royal processions, coronations, and other state occasions. In military contexts, fanfare trumpets were often paired with ornate kettle drums (see page 100). Both were highly sought-after war spoils.

The decoration of this example suggests a military context. The bell is engraved with the coat of arms of the electors of Saxony, and the cord that embellishes the instrument displays the Saxon state colors, white and green. The four cast-metal ornaments adorning the bell garland feature canons, armor, and side drums; one ornament (shown below) depicts a pair of banner-draped kettle drums and trumpets.

The guild system in Nuremberg, one of the most celebrated centers of trumpet making in the seventeenth and early eighteenth centuries, ensured the instrument's exclusivity by limiting trumpet playing as well as production to groups of tightly regulated specialists.

Trumpet players were often called upon to perform sonatas, concerti, and church music with the court orchestra. In this indoor context, they cultivated the art of clarino playing, which uses the upper register, where the trumpet's natural notes lie close enough together to perform melodies and scales. The most celebrated exponents of the technique were noted for their subtle and agile playing; in their hands, the trumpet took on a more prominent role in the orchestra.

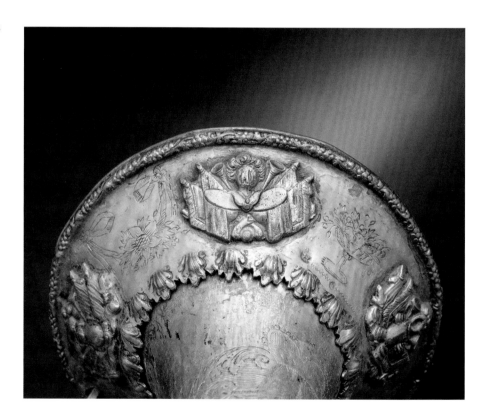

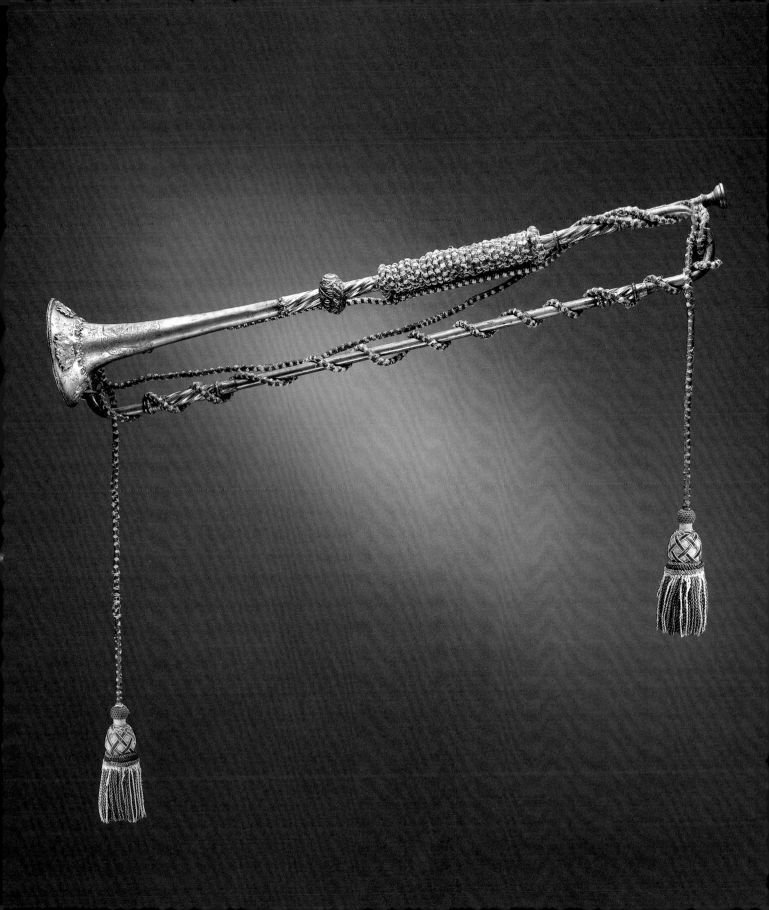

Side Drum

Attributed to Ernest Vogt (ca. 1825–1898)
Philadelphia, ca. 1864
Painted hardwood shell and rims, calfskin heads,
and rope, H. 15 ⅜ in. (39.1 cm)
The Crosby Brown Collection of Musical
Instruments, 1889 (89.4.2162)

Side Drum

Signed Unger
Germany, Saxony, Dresden, reign of Augustus II,
"the Strong," 1694–1733
Brass shell with painted wood rims, calfskin heads,
and rope, H. 23 ⅞ in. (60.4 cm)
Gift of William H. Riggs, 1913 (14.25.1618)

Side Drum

Henry Prentiss (1801–1859)
Boston, ca. 1836
Painted hardwood shell and rims, calfskin heads,
and rope, H. 18 in. (45.7 cm)
Purchase, Amati Gifts, 2008 (2008.239)

The side drum is a military instrument used to accompany infantry troops on the march, whereas the trumpet and kettle drums are symbolic royal instruments used for processions. The side drum was probably first used in Switzerland in the fourteenth century, then spread throughout Europe. The drum provided cadences for marching, signals for battle, and summonses to the routine activities of camp life, such as meals and bedtime. It was often paired with the fife, playing tunes for specific occasions as well as for general entertainment of the troops.

Attributed to Oliver H. Willard (American, active 1850s/70s–died 1875). *Artillery, Musician*, 1866. Albumen silver print from glass negative, applied color, 7 ⅞ x 5 ⅞ in. (19.9 x 14.9 cm). The Horace W. Goldsmith Foundation Fund, through Joyce and Robert Menschel, 2010 (2010.35)

As can be seen in the colorized print of an artillery drummer shown here, the side drum is worn on a sling to the player's side. The drum has two heads, with cords (called snares) stretched across the bottom head that rattle or buzz when the batter, or top, head is struck. Side drums were never completely standardized in size, material, or decoration but generally became smaller over time, as can be seen in three important examples in the Museum's collection. The very large drum with a brass shell was made for the army of Augustus II, "the Strong," elector of Saxony and king of Poland (center). It measures nearly two feet in both height and diameter. A beautifully painted American drum by Henry Prentiss bears the Latin motto *Monstrat Viam* (The Star Points the Way), associating the drum with the First Corps of Cadets of Boston (far right). The example at near right dates to the American Civil War. Its eagle design was commonly seen on drums used by the Union army.

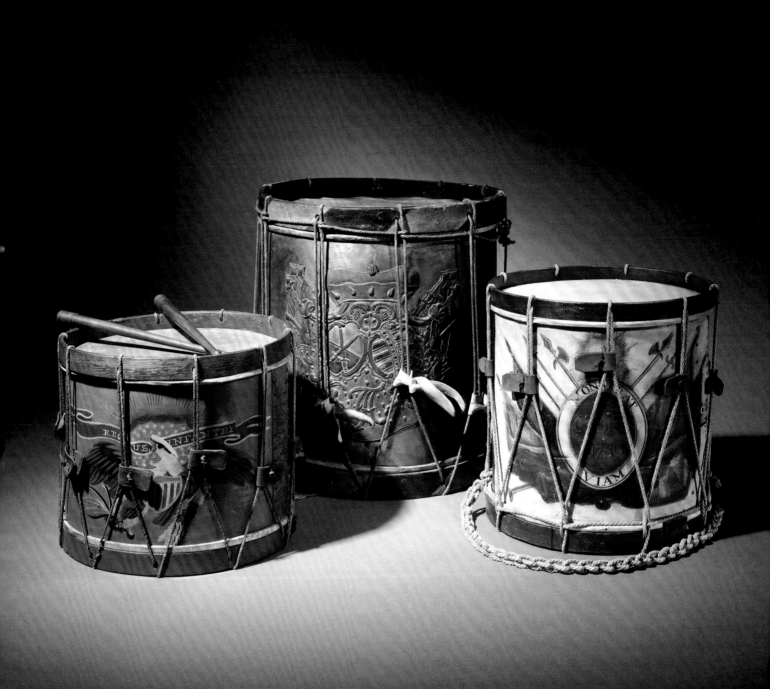

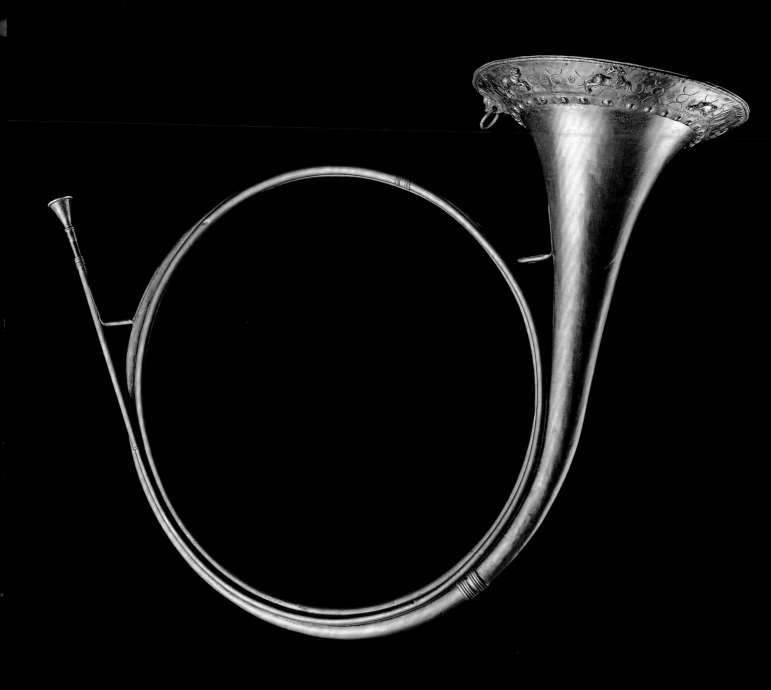

Jagdhorn (Hunting Horn)

Jacob Schmidt (1642–1720)
Germany, Nuremberg, ca. 1710–20
Brass, W. (across coils) 16 ⅛ in. (41 cm)
Gift of William H. Riggs, 1913 (14.25.1623)

During a hunt, when participants were often spread out beyond the range of the voice, horns such as this one provided clear communication. They were used to play a series of distinctive calls that kept hunters apprised of events as they unfolded in the field. Mounting an elaborate hunt, including finely crafted horns and servants trained in the art of playing them, was an expression of wealth and power. The horn became an emblem of status in European courts, and the hunt, complete with horn players, was a popular subject of objets d'art produced for aristocratic patrons, such as the Meissen hunting goblet shown at right.

Jacob Schmidt was a well-known producer of brass instruments in Nuremberg, a city noted for its trumpet-making guilds during the seventeenth and early eighteenth centuries. Schmidt produced trumpets, trombones, and horns, which are closely allied in design, materials, and production techniques.

The brass garland that protects and decorates this jagdhorn's bell bears Schmidt's name and is adorned with repoussé scallop shells, stamped ornamental motifs, cast figures of game animals, and a lion's head with a hoop suspended from its jaws, which enabled the instrument to be carried on a leather strap. All those features indicate that this horn was designed to be used in the hunt or in the *Jagdcorps* (hunting troupe), an outdoor ensemble of horns, oboes, and bassoons that provided entertainment before and after the hunt. Such groups paved the way for hunting instruments later to join the orchestra.

Horns such as this could play complex melodies and were used in early operas to evoke the hunt and the noble attributes associated with it. Over the course of the eighteenth century the horn developed into an important orchestral and solo instrument, but allusions to its hunting ancestry can be heard in much of its music.

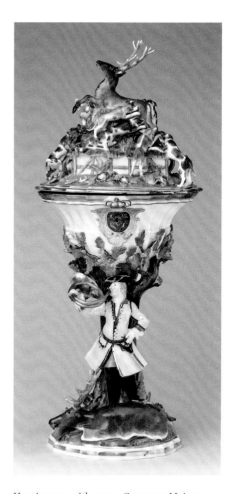

Hunting cup with cover. Germany, Meissen, ca. 1741. Hard-paste porcelain, 14 ¾ x 5 ¾ x 6 in. (37.3 x 14.6 x 15.2 cm). The Lesley and Emma Sheafer Collection, Bequest of Emma A. Sheafer, 1973 (1974.356.337a, b)

Piano

Bartolomeo Cristofori (1655–1731)
Italy, Florence, 1720
Painted wood case with cypress veneer inside,
spruce soundboard, and boxwood keys, L. of case
90 in. (228.6 cm)
The Crosby Brown Collection of Musical
Instruments, 1889 (89.4.1219)

This humble-looking instrument is the earliest extant piano. It was made in the workshop of Bartolomeo Cristofori, who is credited with developing the first successful hammer-action keyboard instrument. Working in the 1690s, when the violin and opera were creating an expectation for more spontaneous and natural nuances and dynamics, Cristofori was inspired to create a stringed keyboard instrument that would marry the expressiveness of the clavichord with the louder volume of the harpsichord. Others before him had experimented with creating such instruments, but Cristofori's design was the first to catch on. It featured a hammer mechanism to strike the strings instead of the harpsichord's jacks, which pluck them; it also used an escapement mechanism that separated the hammer from the key that propels it. Those innovations accomplished two important things. First, the propelled hammer could drop back quickly rather than stay in contact with the string (which would dampen its vibration), even if a key remained depressed, allowing the player to repeat notes rapidly and to modulate volume simply by changing the force of the finger stroke. Second, the hammer made the instrument's overall volume much louder than the clavichord's and thus more suitable for use in ensembles.

Cristofori did not consider his invention a new instrument, referring to it as a *gravicembalo col piano y forte* (harpsichord with soft and loud). He achieved a successful version in about 1700, but this instrument of 1720 is the earliest of the three surviving pianos he made. Cristofori's piano remained in limited use until the third quarter of the eighteenth century, when makers in Germany and Austria modified the mechanism, making the piano louder, faster, and more sensitive to the player's touch (see page 108).

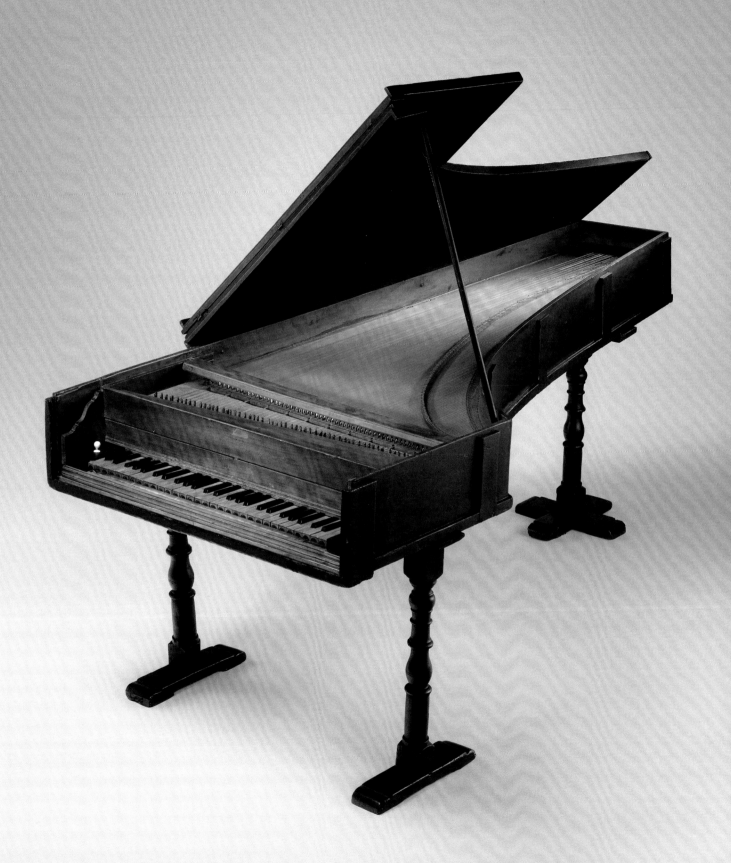

Archlute

David Tecchler (1666–1748)
Rome, ca. 1725
Spruce top, ebony bowl with ivory spacers,
tortoiseshell veneer on fingerboard and neck,
ivory binding, mother-of-pearl inlay, and gut
strings, L. 70 ¾ in. (179.7 cm)
Purchase, Clara Mertens Bequest, in memory
of André Mertens, 1988 (1988.87)

Archlutes, chitarrones, and theorbos all extend the range and musical function of the lute by adding a separate set of long, low-pitched strings to its fretted strings. These bass strings are played open, not stopped by the fingers, which creates a particularly resonant low register. The long neck that carries these strings gives the archlute its striking and characteristic appearance. The instrument achieved its greatest popularity during the seventeenth and early eighteenth centuries in Rome, where it was especially used within the church to accompany voices, as a solo instrument, and in ensembles. As a continuo instrument, it was an important member of the early orchestra. Lutes of all sizes were popular subjects in still life and portraiture; their curved bowls allowed artists to demonstrate their mastery of perspective. In his *Allegory of Music* (shown below), Laurent de La Hyre depicts an archlute being tuned—a popular allegory for the creation of order and harmony.

This instrument is one of a handful of Roman archlutes to survive. It is the only known example by David Tecchler, the city's most celebrated luthier of the day, who was particularly noted for his cellos. Its construction and decoration are elegantly simple, with an intricately carved sound hole and luxurious materials, such as tortoiseshell. Its vaulted back is made up of fourteen staves of ebony, a precious and rare material before it became widely obtainable through increased trade and travel.

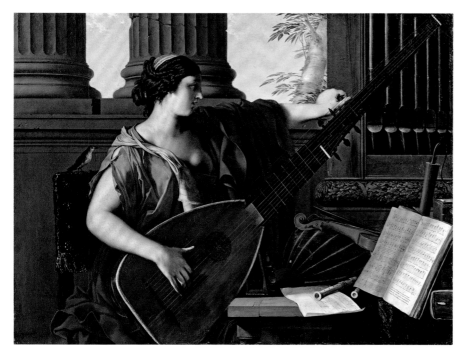

Laurent de La Hyre (French, 1606–1656). *Allegory of Music*, 1649. Oil on canvas, 41 ⅝ x 56 ¾ in. (105.7 x 144.1 cm). Charles B. Curtis Fund, 1950 (50.189)

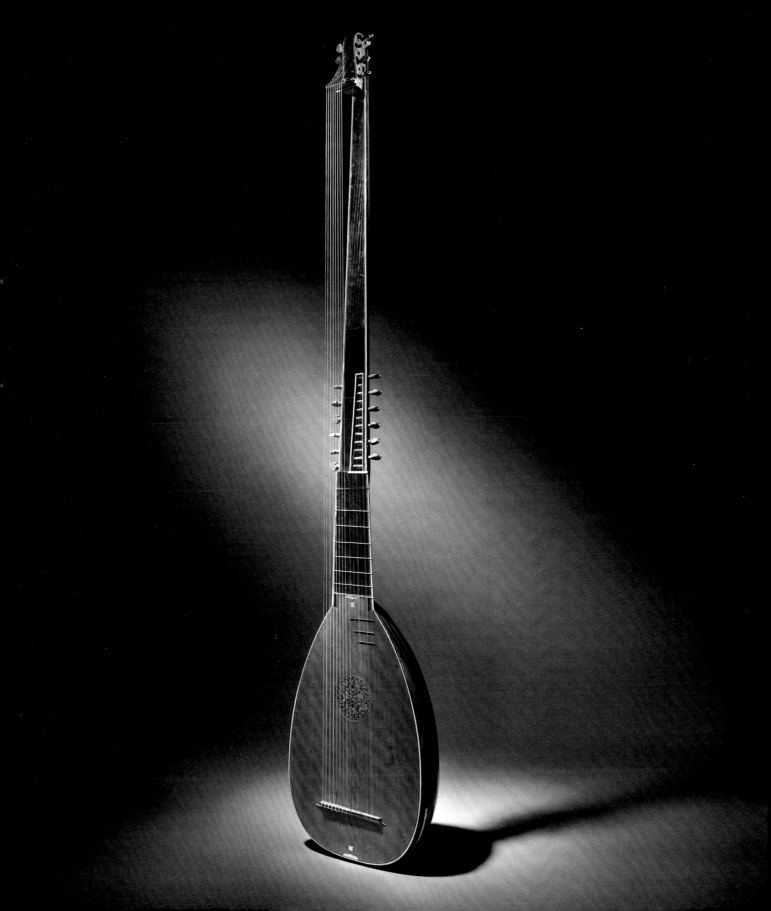

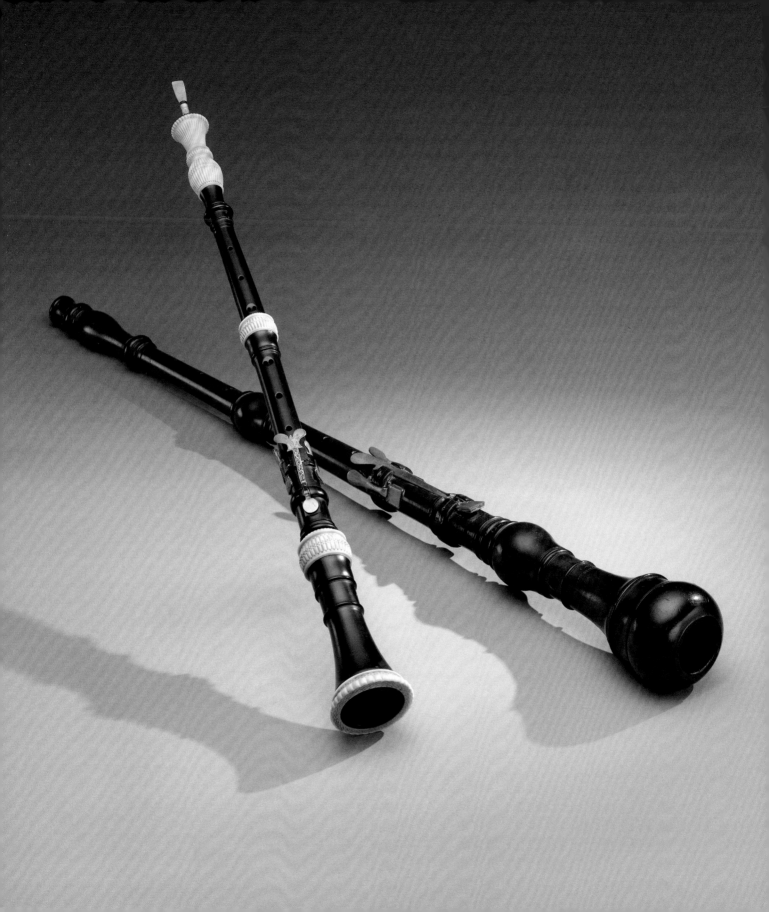

Oboe

Hendrik Richters (1683–1727)
Amsterdam, first quarter of the 18th century
Ebony with ivory ferrules and silver keys,
L. 22 ½ in. (57.2 cm)
Gift of The University Museum, University
of Pennsylvania, 1953 (53.56.11)

Taille de Hautbois
(Tenor Oboe)

Johann Wolfgang Köningsperger (active 1725–52)
Germany, Bavaria, Oberpfalz, Roding, ca. 1730
Stained pearwood body and brass keys,
L. 32 ¼ in. (81.8 cm)
Purchase, Amati Gifts, 2011 (2011.416)

The primary use of the oboe in the early eighteenth century was not in the orchestra but in military bands. It was also used to provide popular music for weddings, funerals, and other social occasions, especially outdoor events. The oboe family consisted of instruments of various sizes and pitches that could be played together with bassoons, forming bands composed entirely of double-reed instruments.

One of the most elaborately decorated treble oboes is the ebony example by Hendrik Richters, among the finest oboe makers of his time. The silver keys are engraved with floral designs and figures dancing and playing instruments. The ivory—used for the bell rim, ferrules, and the finial—was painstakingly carved with a rose-engine lathe, a piece of equipment so expensive that it would have been used by only the wealthiest of craftsmen for important clients. This oboe may have been made as a decorative piece for an affluent patron and rarely played.

By contrast, the simple but graceful oboe by Johann Köningsperger was likely built for a player to use in the typical double-reed bands of the era. It is made of pearwood with brass keys and is pitched a fifth below the treble oboe, occupying the tenor range between the oboe and the bassoon.

Both oboes are of a typical eighteenth-century design, with six finger holes and three keys. Each instrument has a swallow-tailed key in the middle and redundant smaller offset keys that allowed a player to place either hand uppermost in performance, as technique had not yet been standardized.

Harpsichord

Louis Bellot (flourished 1717–59)
Paris, 1742
Painted poplar case, ebony naturals and bone-covered accidentals, and spruce soundboard,
L. of case 94 in. (238.7 cm)
The Crosby Brown Collection of Musical
Instruments, 1889 (89.4.1218)

The keyboard soundscape of the seventeenth and eighteenth centuries was dominated by the bright, plucked-string tone quality of the harpsichord. It was a leading solo instrument in the home (as illustrated in the elegant portrait shown at right) and at court, where harpsichord playing was a skill expected of aristocrats. The instrument also flourished in ensemble settings, where it was clearly audible even in large groups of mixed instruments and voices, making it ideal for the improvised figured bass, or continuo accompaniment, that underpinned the musical structure of Baroque repertoire.

Although it is not capable of touch-sensitive dynamics like the piano, the harpsichord can produce dynamic and tonal contrasts through the use of multiple sets of strings and various mechanical stops. This instrument is configured with three sets of strings that can be played together or separately, and a buff, or harp, stop with leather pads that can be activated to mute one set of strings, producing a muffled sound with a gentler attack. Its two keyboards can be played together or in rapid succession, allowing for sudden contrasts and effects such as echoes. Such methods of expression were exploited by Jean-Philippe Rameau, one of the instrument's most celebrated composers. He wrote his last book of harpsichord music in 1741, one year before this instrument was built.

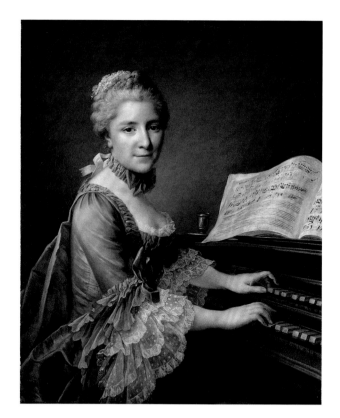

François Hubert Drouais (French, 1727–1775). *Portrait of a Woman, Said to Be Madame Charles Simon Favart (Marie Justine Benoîte Duronceray, 1727–1772)*, 1757. Oil on canvas, 31½ x 25½ in. (80 x 64.8 cm). Mr. and Mrs. Isaac D. Fletcher Collection, Bequest of Isaac D. Fletcher, 1917 (17.120.210)

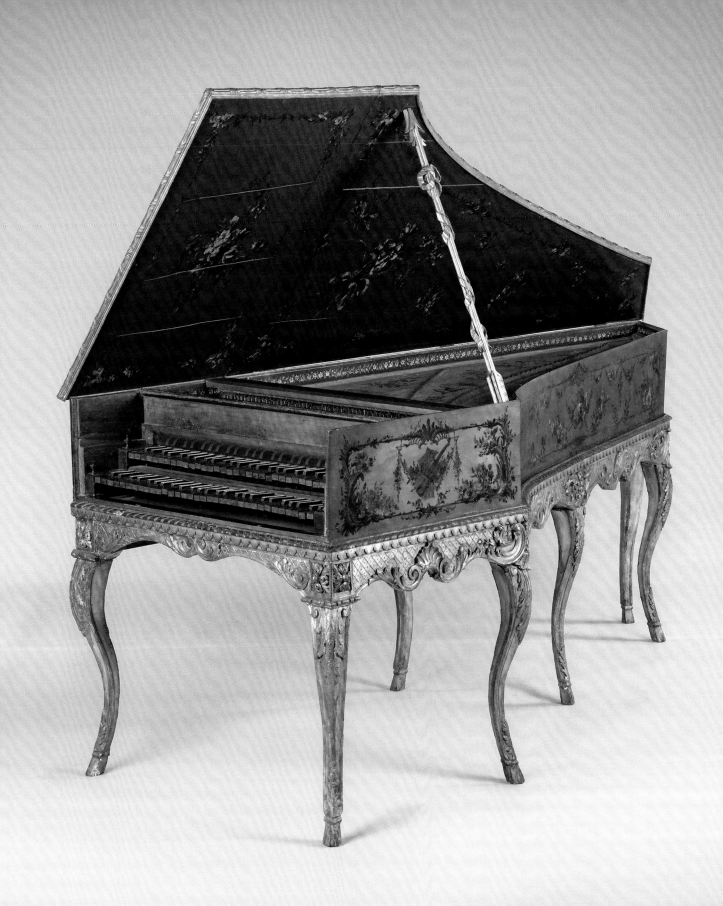

Hardanger Fiddle

Isak Nielsen (Skaar) Botnen (1669–1759) and
Trond Isaksen Flatebø (1713–1772)
Norway, Hardanger region, 1756
Pine body, bone and mother-of-pearl inlay, and
gut strings, L. 22 ¼ in. (56.4 cm)
Gift of Miss Alice Getty, 1946 (46.34.7a)

Hardanger Fiddle

Norway, 1786
Pine body, bone fingerboard, mother-of-pearl
inlay, and gut strings, L. 24 ½ in. (62 cm)
Purchase, Frederick M. Lehman Bequest, 2008
(2008.268)

The Hardanger fiddle, the folk violin of Norway, is deeply embedded in that country's musical identity. Traditionally used to play songs, dances, and wedding music, it has been embraced by nationalistic composers such as Edvard Grieg, who incorporated folk tunes played on the hardingfele into his works.

Hardanger fiddles generally have four bowed strings and an additional four sympathetic strings beneath the bridge; the latter are not played directly but are excited into vibration by the bowed strings above, adding a subtle richness to the sound. These often ornately inlaid instruments first appeared in the 1650s, and their short, straight necks and fingerboards recall those of the violin during the Baroque period. The prolific fiddle makers Isak Nielsen (Skaar) Botnen and his son, Trond Isaksen Flatebø, who made the example at near right, popularized the instrument and are responsible for the tradition that continues today. The fiddle at far right has a scroll in the form of a lion, a national symbol also found on the Norwegian coat of arms and the flag used until 1821. The lion became a typical decorative motif for the Hardanger fiddle, underscoring the instrument's cultural importance.

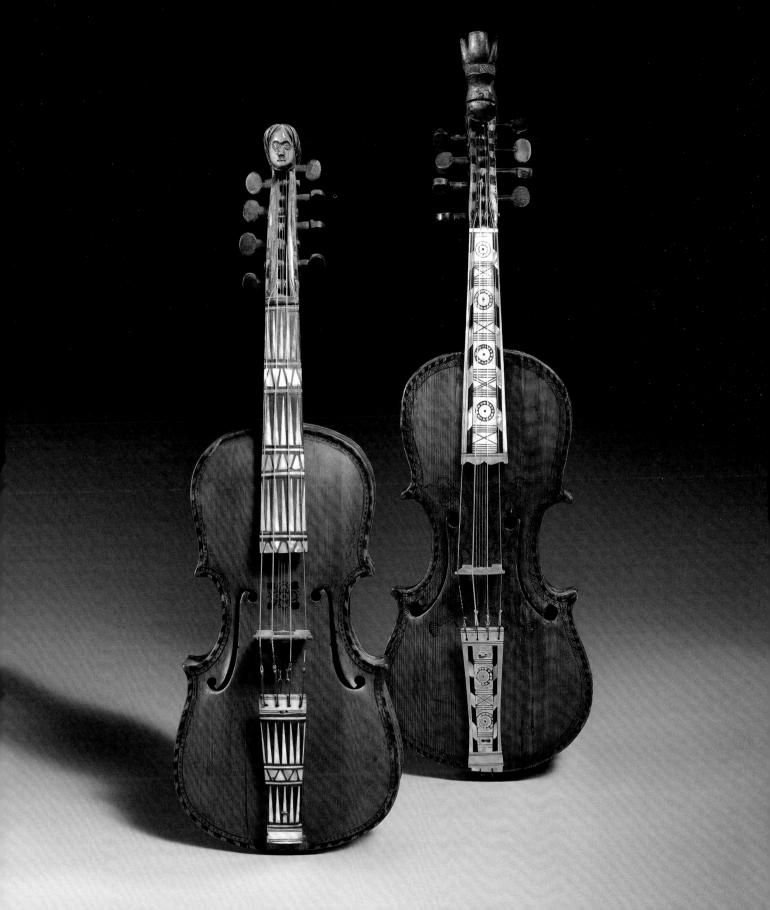

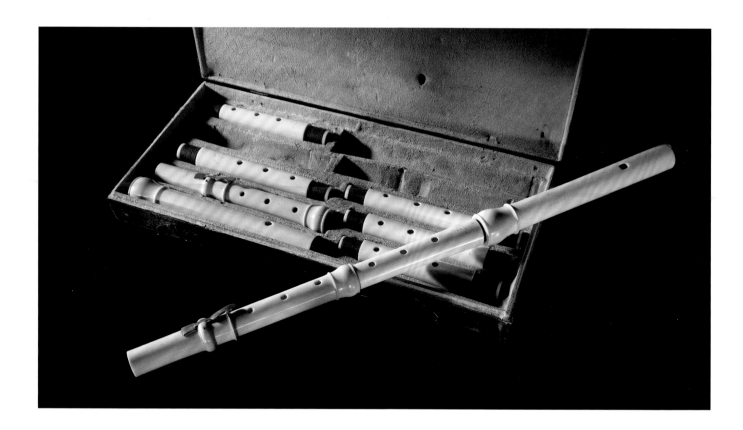

Pair of Transverse Flutes

Johann Wilhelm Oberlender the Elder (1681–1763)
Germany, Nuremberg, mid-18th century
Ivory with silver keys, L. 24½ in. (62.2 cm)
Purchase, Clara Mertens Bequest, in memory of
André Mertens, and The Vincent Astor Foundation
Gift, 1996 (1996.13.1–.3)

Singing and the playing of stringed and keyboard instruments dominated domestic music making during the eighteenth and nineteenth centuries. Wind instruments were generally considered less desirable to cultivate, perhaps because blowing into an instrument and using one's mouth to play was perceived as unseemly, particularly for women. The flute was an exception. Favored by gentlemen amateurs and aristocrats, flutes were often exquisitely decorated and made from valuable or unusual materials. Flutes paired well with the voice and harp, other popular instruments of the music room or salon. The flute's louder volume and ability to produce more dramatic dynamic contrasts led to its dominance over the recorder in both private and public music making in the early eighteenth century.

Professional musicians generally used flutes made from wood. The use of ivory for this pair of flutes and the ornate leather-covered case, which ostentatiously displays the instruments side by side instead of efficiently storing them in stacking trays, as is typical, suggest an aristocratic owner. Pairs of high-quality flutes such as these were sometimes produced for use by a gentleman and his music master.

When they were made, pitch had not been standardized. Each flute in this pair was supplied with three alternate middle joints, enabling it to play in tune at a range of pitch levels.

Walking-Stick Flute/ Oboe

Georg Henrich Scherer (1703–1778)
Germany, Butzbach, ca. 1750–57
Narwhal tusk body, ivory end cap, and gilded
brass mount, L. 42 ⅜ in. (107.5 cm)
Purchase, Amati Gifts, 2006 (2006.86)

This extraordinary instrument combines a flute and an oboe in the form of a walking stick, evidence of the Baroque fascination with multifunctional objects. The flute's embouchure hole, which the player blows across, is the first hole below the handle. For use as an oboe, the instrument would be inverted, a double reed inserted into the end of the cane, and the key repositioned. The body of the instrument is made of narwhal tusk, once valued more highly than gold because it was believed to be the horn of the mythical unicorn.

The instrument's maker, Georg Henrich Scherer, was the last and most important member of a well-known family of German woodwind makers. Among his clients was the king of Prussia, Frederick the Great, who collected flutes and was an accomplished player of the instrument. The king pursued a scientific interest in testing the acoustical attributes of different materials, which may account in part for the use of narwhal tusk. This instrument is said to have been a gift from Frederick to his finance minister.

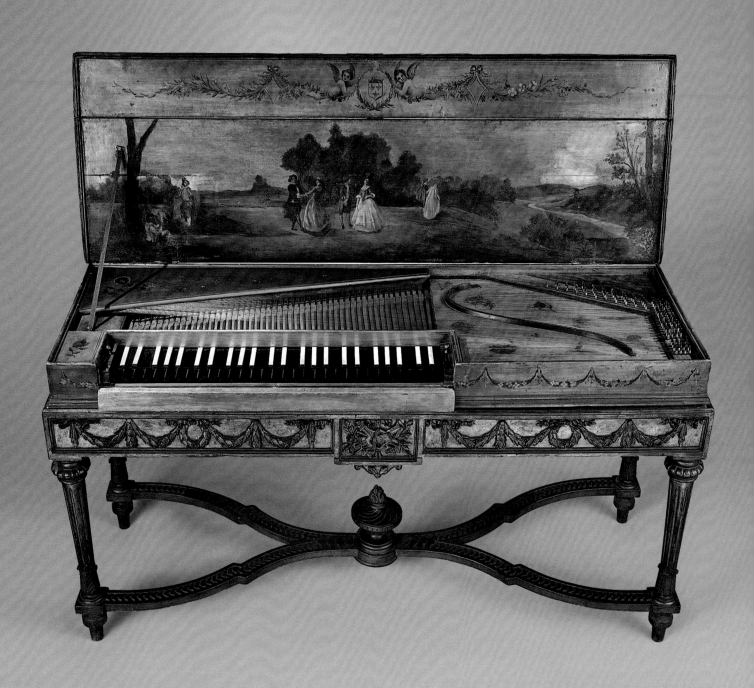

Clavichord

Signed Christian Kintzing (1707–1804)
Germany, Neuwied, 1763
Painted wood case, spruce soundboard, ebony
naturals, and ivory-covered accidentals,
W. 54 ½ in. (138.2 cm)
Purchase, The Crosby Brown Collection of Musical
Instruments, by exchange; Rogers Fund; The
Barrington Foundation Inc. Gift; Gifts of Risa and
David Bernstein, Carroll C., Beverly, and Garry S.
Bratman, Miss Alice Getty, and Erica D. White,
by exchange; and funds from various donors, by
exchange, 1986 (1986.239)

Throughout its history the clavichord has been associated with music making in the home. Its touch sensitive action, where the strings are struck by metal tangents, allowed for great expressiveness in playing, albeit within a proscribed dynamic range, well before the invention of the piano. Because the tangent never flies free, always remaining in contact with the string, clavichords produce less volume than harpsichords or pianos.

Its diminutive size and sound made the clavichord an ideal home practice instrument for organists and a fine tool for composers. It was a favorite instrument in late eighteenth-century Germany, where its capacity for subtle, spontaneous, and highly personal expression aligned perfectly with the aesthetics of the *empfindsamer Stil* (sensitive style), a precursor to the Romantic movement. The music of C. P. E. Bach, the style's main exponent, influenced the work of Mozart, Haydn, and Beethoven.

This clavichord's tonal variety is particularly rich because the instrument is equipped with a pantalon stop. When activated, the stop keeps the strings from being muted after playing, allowing the different notes to blend into each other. This resonant effect imitates the sound of the pantalon, a large dulcimer invented by Pantaleon Hebenstreit in the early eighteenth century. The name of Christian Kintzing, who was famed for his musical clocks and their masterful cabinetry, appears on this clavichord; he likely built the case but not the instrument itself.

Kettle Drums

Franz Peter Bunsen (ca. 1725–1795)
Germany, Hanover, 1780
Silver kettles, iron rims, and calfskin heads,
Diam. of largest drum 20 ⅞ in. (53 cm)
Purchase, Robert Alonzo Lehman Bequest,
Acquisitions Fund, and Frederick M. Lehman
Bequest, 2010 (2010.138.1–.4)

Kettle drums, paired with trumpets, have long been used in European courts to signify the importance of the ruling monarch. The use of the instruments was strictly regulated for processional and ceremonial purposes, and the performers guarded their secrets through a formal guild structure. Kettle drums were only occasionally made of silver for the wealthiest and most powerful members of royalty.

This pair of kettle drums was commissioned by George III (1738–1820), king of Great Britain and Ireland and elector of Hanover, for his Royal Life Guards of the Hanoverian court. An invasion by Napoleon in 1803 caused the drums and much of the silver from the Hanoverian court to be sent to London, where they were exhibited at Windsor Castle. Soon after, the London court had made its own set of silver drums. That set remains in the possession of the British Household Cavalry, while this magnificent pair of drums was returned to Hanover after 1815.

The drums bear the royal coat of arms of George III, which is executed in repoussé (where the decorative reliefs are pushed outward from the reverse side), with the detailing chased into the surface. When not in use, the drums rest on integral tripod stands designed to resemble acanthus leaves. The drums, draped with crimson velvet banners, would have been used mostly on horseback; the drummer, seated behind the instruments, would guide the horse with foot reins as he played.

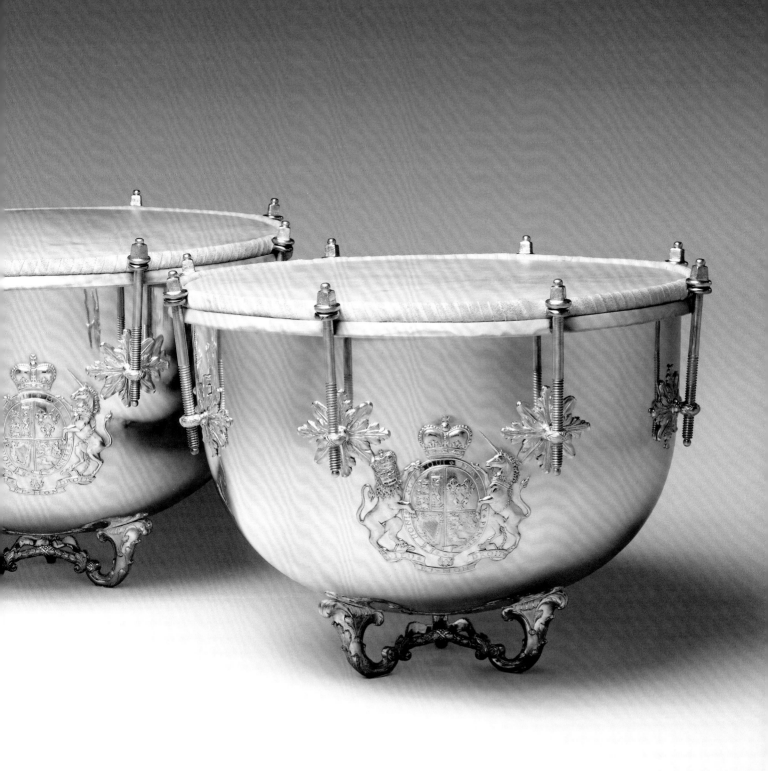

Flute

Southern Germany or Saxony, ca. 1760–90
Hard-paste porcelain and gold-plated brass,
L. 24 ⅜ in. (61.7 cm)
Gift of R. Thornton Wilson, in memory of Florence
Ellsworth Wilson, 1943 (43.34a–g)

This instrument unites two aristocratic pastimes of eighteenth-century Europe: amateur music making and collecting precious and fashionable objets d'art. This example is a tour de force of hard-paste porcelain, which, like narwhal tusk, was a highly prized luxury material shrouded in mystery. The development of the process for manufacturing porcelain in Europe is attributed to the alchemist Johann Friedrich Böttger, who carefully guarded the secrets of its production. Few flutes were made from porcelain because of the challenges working with it presented, including shrinkage during firing and the difficulties of fine-tuning and adjusting the finished piece. While the maker of a wood or ivory flute could play the finished instrument and continue to make small adjustments to the tone holes by carving away material, all aspects of a porcelain flute had to be finalized before the piece was fired. Although this flute's maker deftly overcame many of those obstacles to produce a playable instrument, it was conceived equally as a collector's item—and fittingly, it once was part of the extensive art collection of William Randolph Hearst. This flute was meticulously finished by a metalsmith, who crafted the ferrules, key, and end cap.

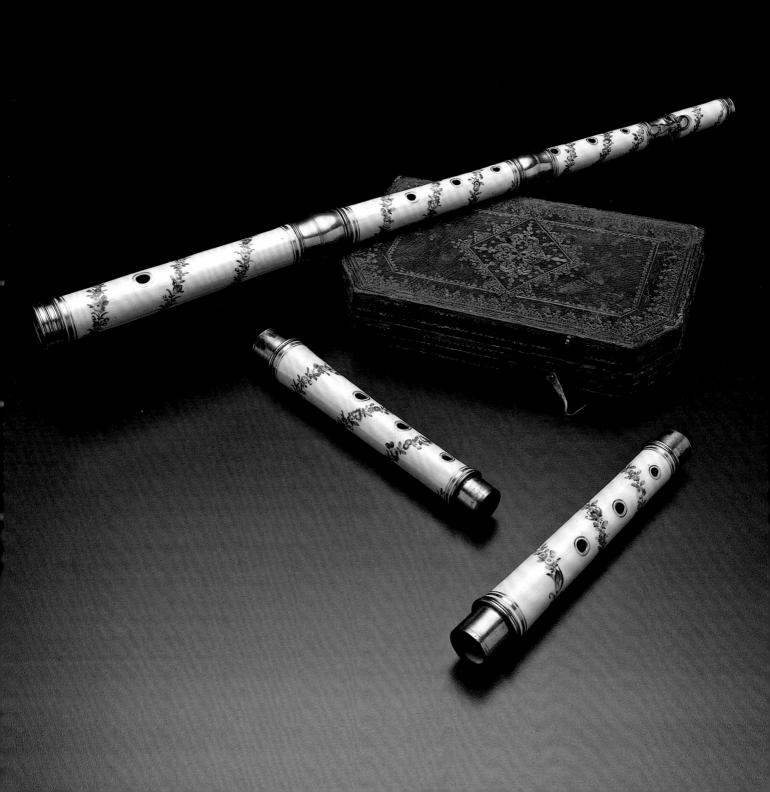

Dizi (Transverse Flute)

China, Qing dynasty, 18th–19th century
Jade, L. 21½ in. (54.5 cm)
Gift of Rolf Jacoby, 1965 (65.149a, b)

Xiao (Vertical Notched Flute)

China, Qing dynasty, 18th–19th century
Jade, L. 20½ in. (52.1 cm)
Rogers Fund, 1987 (1987.109)

Jade has been valued since ancient times in China, where it is believed to embody beauty, nobility, perfection, constancy, power, and immortality. Many objects have been fashioned from it, from containers and jewelry to chimes and flutes. Chinese tradition classified instruments by eight materials with extramusical associations; jade is stone and connected to the earth.

The jade flute provided a potent image that appeared in Chinese literature as early as the Han dynasty (206 B.C.–A.D. 220). However, flutes were not actually made of jade until the eighteenth century, when the supply of the precious stone became plentiful. Though they were designed primarily as decorative items for wealthy amateur players, the jade instruments were functional. Two types of flutes crafted in jade are shown here: the dizi, played horizontally (pictured at near right), and the xiao, an end-blown notched flute. The dizi has, in addition to the blowhole and finger holes, a hole that is covered by a membrane or tissue-thin piece of bamboo, producing a poignant buzzing tone. Vent holes at the end of the instruments provide a convenient place to attach decorative cords (missing from this dizi), tassels, and ornamental knots. Bamboo versions of both flutes are used by professional musicians, as shown in the marble carving here, in solo or *kunqu* opera performances.

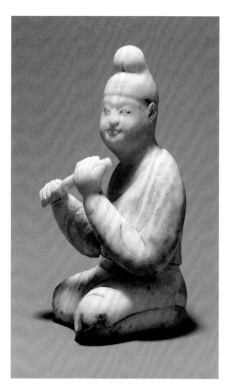

Seated musician. China, Tang dynasty (618–907). White marble, 5½ x 3⅛ x 2¾ in. (14 x 7.9 x 7 cm). Purchase, Friends of Asian Art Gifts, 2006 (2006.156)

Viola d'Amore

Johannes Florenus Guidantus (1687–1760)
Italy, Bologna, 18th century
Spruce top, maple sides and back, and ebony
fingerboard, L. 30 in. (76 cm)
Purchase, Amati Gifts, 2009 (2009.41)

The "viola of love," the direct translation of the Italian *viola d'amore*, is a bowed stringed instrument that flourished from the late seventeenth through the eighteenth century. It is typically similar in size to more common violas but has a flat back, like the viol family of instruments (see page 72). With six or seven strings, it allows for a number of tuning variations. Most viole d'amore also have a set of sympathetic strings that ring "in sympathy" with the vibration of the main bowed strings, producing a silvery tone. Leopold Mozart, Wolfgang's father, described the instrument as a "distinctive kind of violin that sounds lovely in the stillness of the night." Other instruments with sympathetic strings include the Hardanger fiddle (see page 94), the sāraṅgī (see page 158), and the sitar (see page 178).

This eighteenth-century example by Johannes Guidantus has an unusual, festooned body outline and beautifully cut sound holes echoing the shape. A sound-hole rose can be seen under the fingerboard. The top of the pegbox terminates with the carved head of a beautiful young woman. Instrument makers frequently incorporated such images, with eyes closed or even blindfolded, as personifications of the axiom "love is blind."

Piano

Attributed to Johann Schmidt (active late
18th century)
Austria, Salzburg, ca. 1785
Cherry wood veneer case, black-stained wood
naturals, and bone-covered accidentals,
L. 83 ½ in. (212 cm)
The Crosby Brown Collection of Musical
Instruments, 1889 (89.4.3182)

Pedal pianos, with pedal boards like those on organs, are extraordinarily rare. This example has eighteen leather-covered pedals, which are operated by a player's feet. The lowest five pedals extend the piano's range by five bass notes; the other thirteen pedals duplicate the lowest notes on the keyboard, striking the exact same strings with a different set of hammers.

The piano also has knee levers that control the dampers (when pressed, the dampers are lifted and the notes are sustained) and a moderator stop, which softens the volume by moving pieces of felt between the hammers and strings. A hand-operated stop to the left of the keyboard operates a bassoon sound effect, causing a piece of parchment paper to rest on the lowest strings and create a buzzing sound when those notes are played.

Pedal pianos may have been intended as practice instruments for organists. Johann Sebastian Bach is known to have owned a pedal harpsichord, and Wolfgang Amadeus Mozart's piano by Anton Walter is believed to have originally had a pedal mechanism. Mozart's Piano Concerto in D Minor, K. 466, requires the use of pedals for lower notes that were not available on the keyboard of the time. The piano shown here is attributed to Johann Schmidt, a friend of the Mozart family; Leopold Mozart helped him secure the job of court organ maker in Salzburg.

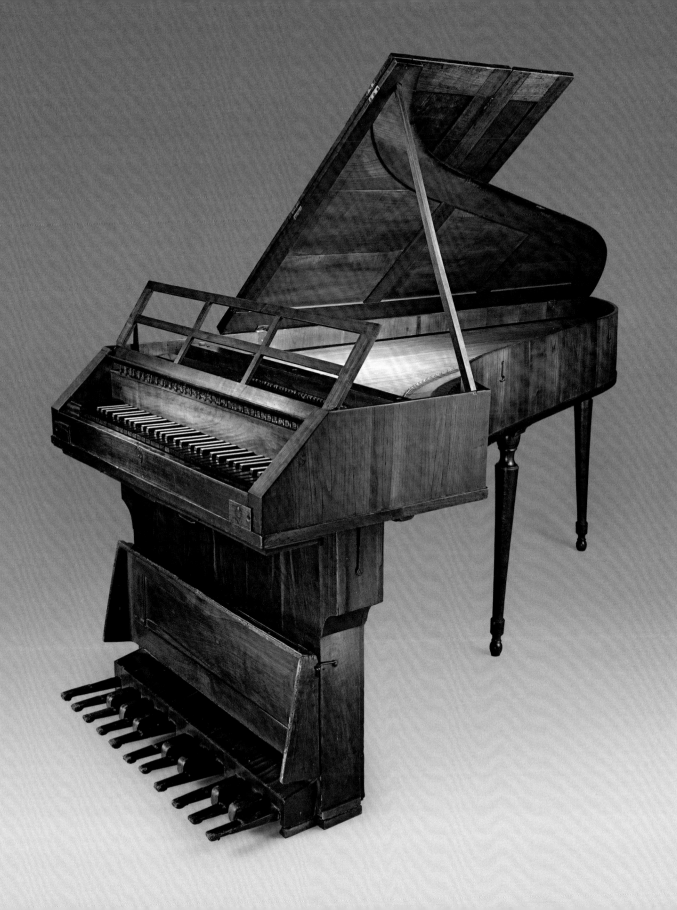

Oni Bearing a Dora (Gong)

Japan, probably Kyoto, early 19th century
Painted and lacquered wood figures with bronze gong, H. 64 ⅜ in. (163.5 cm)
The Crosby Brown Collection of Musical Instruments, 1889 (89.4.2016)

This is one of two Japanese instruments in the Museum's collection that were made solely as artworks, not to be played; the other is the ō-daiko (see page 141). Horned *oni* (demons) standing more than five feet tall carry a large dora (knobbed gong) suspended from a processional pole. Gongs like this one are used in theater, tea ceremonies, and Buddhist ritual. One demon, wearing an embroidered kilt, prepares to strike the gong; the other is dressed in tiger-skin pants.

Oni are popular characters in Japanese art, literature, and theater. Traditionally cast as agents of evil and destruction, in modern times they are seen as benevolent—even capable of warding off evil. These ominous-looking *oni* may be carrying a gong associated with Buddhism in repentance or devotion, or they may be trying to deceive us into thinking that they have turned from their evil ways.

Sọ Sām Sāi (Spiked Fiddle)

Thailand, 19th century
Coconut-shell body, calfskin belly, ivory spike
and pegs, and mother-of-pearl decoration,
L. 46 ⅛ in. (117 cm)
The Crosby Brown Collection of Musical
Instruments, 1889 (89.4.300)

The sọ sām sāi is a spiked fiddle, played with an S-shaped bow and held in a vertical position with its spike on the ground. It accompanies the voice, performs as a solo instrument, and is added to the Thai *mahori* classical ensemble when singers are used. While similar to other Southeast Asian fiddles, it has features that make it distinctly Thai. Its triangular body is formed from half of a type of coconut that has three bulges; calfskin forms the belly. King Rama II (1767–1824) was a skilled player of the instrument and encouraged the propagation of the special coconut used to make it by offering the growers tax exemptions. This example has a neck, spike, and pegs of turned ivory. The neck and spike are partly hollowed, allowing the strings to be inserted into the peg block at the top and through the spike at the lower end. The neck is embellished with mother-of-pearl inlay. The rich materials signal a courtly origin.

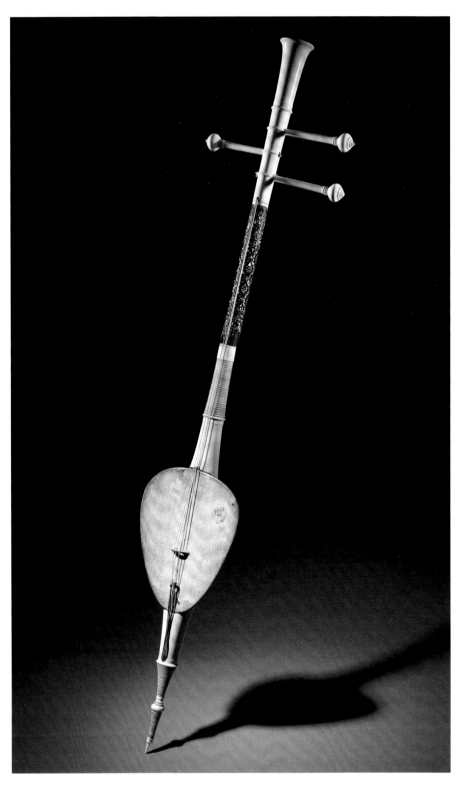

Putorino (Flute)

Maori people
New Zealand, Bay of Plenty region, ca. 1800–1820
Wood and fiber, L. 17⅛ in. (43.5 cm)
The Michael C. Rockefeller Memorial Collection,
Bequest of Nelson A. Rockefeller, 1979
(1979.206.1599)

Putorino (Flute)

Maori people
New Zealand, late 19th century
Wood and fiber, L. 22 in. (55.9 cm)
The Crosby Brown Collection of Musical
Instruments, 1889 (89.4.1754)

The putorino is a flutelike instrument once made by the Maori of New Zealand. It was fashioned from a piece of matai wood (*Podocarpus spicata*, a black pine) that has been split, hollowed out, and bound back together to form the body of the instrument, with a single hole at the top and a figure-eight-shaped hole at the center. The ends and middle are usually carved as masks with abalone eyes; the defiant faces represent Tiki, the first man in Maori mythology. The out-thrust tongue is a typical gesture of the haka, a posturing dance performed to prepare for war or to entertain guests.

Some scholars speculate that putorino were used as megaphones; played as flutes (held transversely and played by blowing across the hole at the center or across the open end); or played as trumpets (held outward from the body and played with the lips vibrating). Their sound was said to represent Hineraukatauri, the goddess of music. Use of the putorino gradually died out after the mid-1800s, but contemporary Maori musicians have begun to re-create the instrument, sometimes playing it like a Western flute.

Bassoon

Jean-Jacques Baumann (1772–1845)
Paris, ca. 1813–25
Maple and brass, L. 50 ⅜ in. (127.9 cm)
The Crosby Brown Collection of Musical
Instruments, 1889 (89.4.885)

In addition to being the lowest
woodwind voice in the orchestra,
the bassoon was a versatile solo and
chamber music instrument during
the Classical and early Romantic
periods. Mozart, Weber, Haydn, and
Hummel all produced important
works for bassoon and orchestra.

This exceptional bassoon fea-
tures finely crafted and decorative
metal ferrules and key work, sug-
gesting that it was made for a notable
owner—perhaps a prominent soloist.
Underscoring the importance of
the instrument's visual aesthetic is
the fact that the maker of the metal
parts inscribed them: C. H. Felix,
Paris 1813. Demonstrating that func-
tion was as vital as appearance, the
instrument is equipped with two
interchangeable wing joints of dif-
fering lengths, enabling it to play at
different pitch standards.

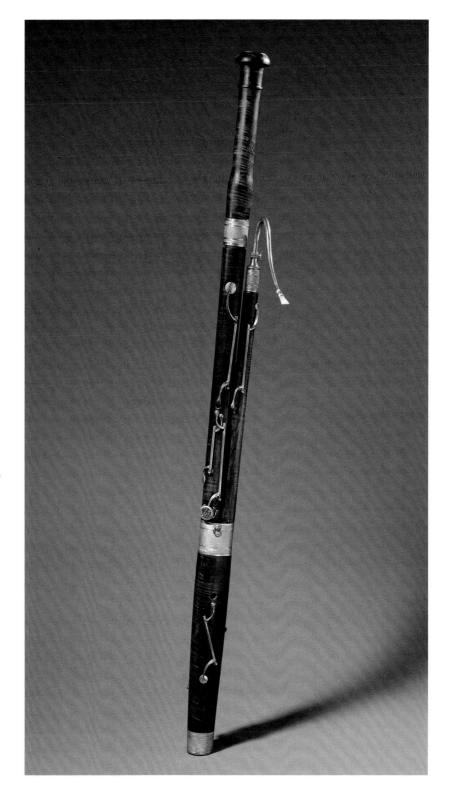

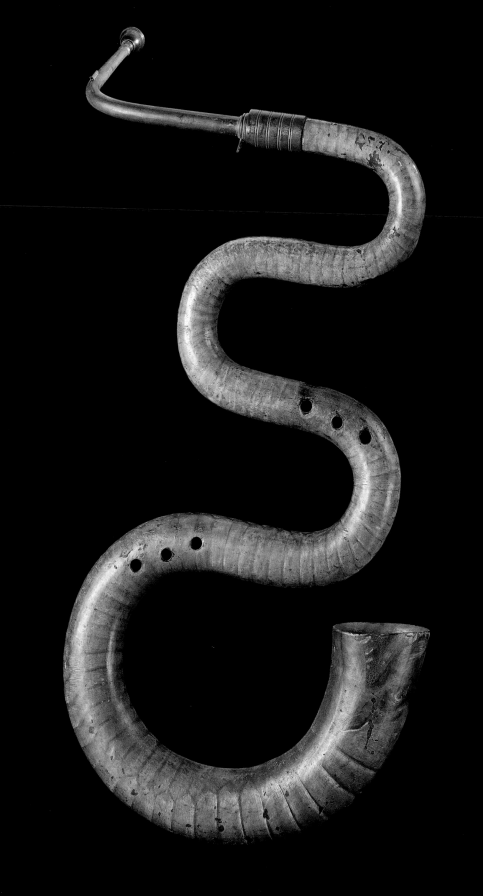

Serpent

C. Baudouin (flourished ca. 1812–36)
Paris, ca. 1820
Wood body covered in leather with brass bocal
and keys, H. 33½ in. (85 cm)
Purchase, Robert Alonzo Lehman Bequest, 2012
(2012.568)

The serpent, a bass brass instrument, has a long association with church music. In France it was used to bolster and accompany plainsong from the late sixteenth century on. Its warm, resonant sound complemented male voices, and it found favor in English church bands during the eighteenth and nineteenth centuries. Played alongside the cello and the bassoon, it provided vital accompaniment in churches that could not afford organs. The serpent became a popular military band instrument in England and Germany in the mid-eighteenth century. It sometimes was used as a low bass voice in the orchestra, notably by Handel, Haydn, Berlioz, and Mendelssohn.

The serpentine qualities of this example, created by one of the most celebrated makers, are heightened by its zoomorphic paint scheme, a rare decorative embellishment for an instrument that was generally finished in black. Its visual appeal was clearly matched by its strong musical properties; the wear marks and discoloration around its finger holes are evidence of extensive use. They also show how this serpent was held, with the left hand in an overgrip on the top set of holes and the right in an overgrip on the lower ones. Although the instrument's sinuous, snakelike form helps position the finger holes within the player's grasp, hand reach nonetheless requires the holes to be drilled more closely together than optimal for playing in tune. Consequently, the serpent was supplanted by the ophicleide (a deep-toned keyed brass instrument) and the newly developed tuba in the mid-nineteenth century.

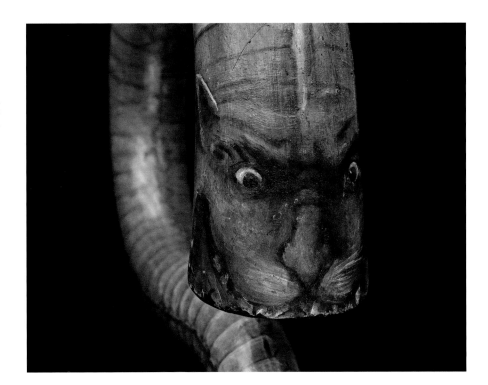

Pipe Organ

Thomas Appleton (1785–1872)
Boston, 1830
Mahogany case with metal and wood pipes,
brass reeds, and gilded facade pipes,
H. 16 ft. 1 in. (490.2 cm)
Purchase, Margaret M. Hess Gift, in memory of
her father, John D. McCarty, 1982 (1982.59)

Nineteenth-century organ builders in New England typically followed an English style of organ building geared toward music that accompanied choral singing rather than solo organ literature. This example by the renowned Boston craftsman Thomas Appleton has a conservative tonal design, reminiscent of late eighteenth-century British instruments with fewer reed stops and mixtures (stops that sound multiple pipes per note) than were found on continental European organs. The limited range of notes available on its pedal board would not have sufficed for the intricate footwork called for by much of the late eighteenth- and early nineteenth-century solo literature but would have been perfect for leading hymns and accompanying choral singing. The organ has 836 pipes and 2 keyboards, each with 58 notes. The 27-note pedal board was added in 1883, replacing a smaller original.

Standing more than sixteen feet tall in a skillfully carved and joined mahogany Greek Revival case, this organ retains a hand-pumped bellows that supplies the instrument with air during performances. It was probably made for and installed in the South Church of Hartford, Connecticut, before being moved to the Sacred Heart Church in Plains, Pennsylvania, in 1883. It was discovered there, unused, in 1980 and subsequently came to The Metropolitan Museum of Art.

Clarinet

Charles-Joseph Sax (1791–1865)
Brussels, 1830
Ivory and gold-plated brass, L. 26 ¾ in. (68 cm)
Funds from various donors, 1953 (53.223)

Clarinets were typically made from boxwood during the first half of the nineteenth century. Precious ivory was generally reserved for special commissions and showpieces such as this masterwork of wind instrument making by Charles-Joseph Sax. The cups of the gold-plated keys are decorated with finely cast lions' heads. This instrument is equally sophisticated technically. Its key system is based on the revolutionary clarinet model that the distinguished virtuoso and inventor Iwan Müller presented in Paris in 1812. Typical clarinets of the period had five or six keys, and players needed as many as six clarinets to play in all keys. Müller's system made a full range possible on a single instrument with thirteen keys.

This clarinet's other innovative features include the rollers on its long key levers, which enable the player's little finger to glide between the two keys. Sax emphasized the roller keys' significance by elaborately engraving them with leaves.

The bell section of this clarinet is proudly inscribed "Factueur d'instrument[s] de Musique de la Cour" (Manufacturer of Musical Instruments to the Court), the title bestowed upon Sax in 1816 by William I. The coat of arms of the Kingdom of the Netherlands (which then included Belgium) is depicted above the inscription.

Sax's fine work as a maker of wind instruments undoubtedly inspired the career of his son Adolphe, who invented the saxophone. Adolphe was also an accomplished clarinetist, illustrating the dual roles played by some of the nineteenth century's leading wind instrument makers.

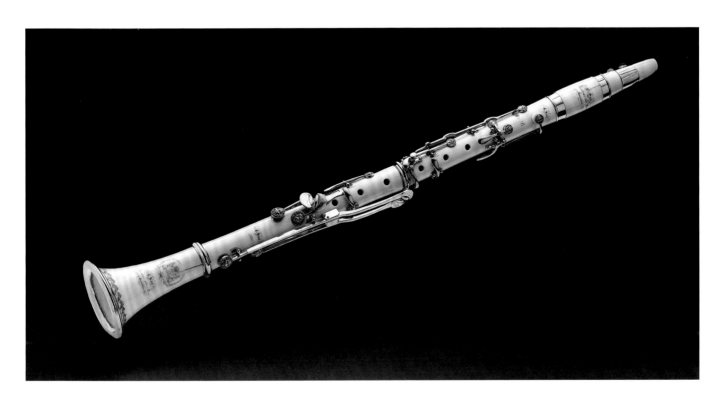

Cor d'Orchestre (Orchestral Horn)

Pierre Piatet (ca. 1797–ca.1868)
France, Lyons, 1845–50
Brass and paint, H. 21¾ in. (55 cm)
Purchase, The Howard Bayne Fund Gift, 1977
(1977.315a–n)

Cor Omnitonique (Omnitonic Horn)

Charles-Joseph Sax (1791–1865)
Brussels, 1833
Brass, H. 21¾ in. (55 cm)
The Crosby Brown Collection of Musical
Instruments, 1889 (89.4.2418)

The orchestral horn of the Classical and early Romantic periods was a natural brass instrument (that is, one without valves). Like the bugle, the two horns depicted here have no devices for playing chromatically and sound only the limited sequence of notes of the harmonic series. Horn players altered the pitch of the notes to produce a complete chromatic scale by placing their hand in the bell of the horn and closing it off to varying degrees, enabling them to play the complicated melodies found in works such as Mozart's horn concertos and Brahms's symphonies. When players needed to pitch the horn in a new key, they used interchangeable crooks (segments of tubing) to change the instrument's sounding length. The ten crooks supplied with the cor d'orchestre (shown in its case) would have been typical; they are needed to play the standard orchestral repertoire, necessitating a large, cumbersome case for storage and transport.

The cor omnitonique (bottom) was a natural horn designed to dispense with the loose crooks; it was among Charles-Joseph Sax's efforts to create single instruments capable of playing in many keys, as did his innovative thirteen-key clarinet (see previous page). In this example of a type patented in 1824, tubing for the individual crooks has been built into its body. The player selected the desired length of tubing by adjusting the plunger mechanism that extends from the instrument. While it eliminated loose crooks and was visually intriguing, the omnitonic horn was heavy and unwieldy in comparison to the elegant design of the natural horn and achieved no lasting popularity. It is notable that both instruments shown here were made after the advent of valves for brass instruments in 1814. The subtle tonal difference between the open and covered notes of the natural horn remained a prized characteristic of horn sound throughout much of the nineteenth century, and players were slow to adopt valves.

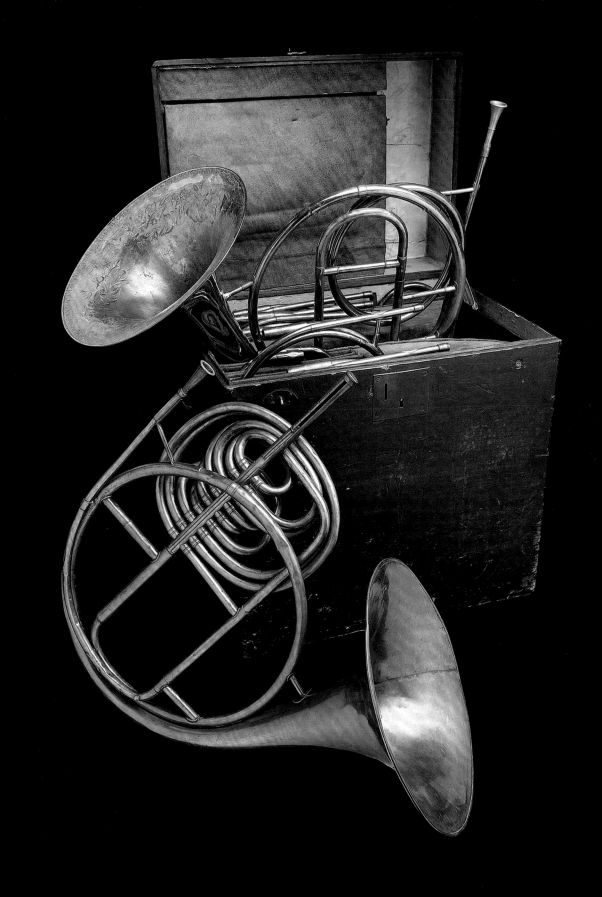

Shō (Mouth Organ)

Japan, early Tokugawa period, 19th century
Lacquered wood, bamboo pipes, and brass reeds,
L. 19 in. (48.3 cm)
The Crosby Brown Collection of Musical
Instruments, 1889 (89.4.2957)

Free reed instruments such as this
shō and its Chinese forebear, the
sheng, have been known in East and
Southeast Asia since antiquity. They
produce sound when air is passed
through a slot, causing the small
reed that is fixed within to vibrate.
The appearance of a sheng in Paris
at the end of the eighteenth century
inspired the development of free
reed instruments in Western Europe,
including the harmonica, accordion,
and symphonium (see next page).

Each of the fifteen sound-
ing pipes of this shō has a metal
reed mounted in its base, which is
concealed from view by the instru-
ment's decoratively lacquered wind
chamber, from which projects the
mouthpiece. Two dummy pipes that
produce no sound give the instru-
ment a graceful symmetry. The
arrangement of pipes symbolizes the
folded wings of the mythical phoenix,
whose cry the shō's sound is said
to represent. The shō's sustained
chords are a distinctive and immedi-
ately recognizable feature of gagaku,
the ancient court music of Japan.

The elegantly depicted insects
that decorate the wind chamber of
this shō may have been inspired by
the work of the celebrated artist
Kitagawa Utamaro, whose illustrated
books of insects were extremely
popular and influential in the late
eighteenth and early nineteenth
centuries.

Kitagawa Utamaro (Japanese, 1753?–1806).
Page from the *Picture Book of Crawling
Creatures* (*Ehon mushi erami*), Edo period,
1788. Ink and color on paper, 10 ½ x 7 ¼ in.
(26.7 x 18.4 cm). Rogers Fund, 1918 (JP1046)

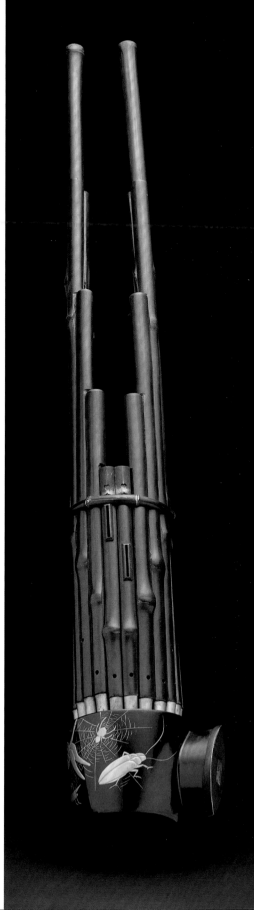

Symphonium

Charles Wheatstone (1802–1875)
London, ca. 1835
Nickel-silver case, mother-of-pearl, ivory buttons,
and brass and gold reeds, H. 2 ¾ in. (7 cm)
The Crosby Brown Collection of Musical
Instruments, 1889 (89.4.2085)

The symphonium, a pocket-size mouth organ, is one of the instruments inspired by Asian free reed instruments such as the sheng and shō (see previous page). Their method of sound production captured the imagination of the English inventor, physicist, and telegraph pioneer Charles Wheatstone, who maintained in his laboratory a small collection of musical instruments that included examples of Asian mouth organs. His 1829 patent for the symphonium attributes them as forerunners and includes an illustration of a sheng.

The symphonium is played by blowing into its mouth hole, which here is edged with mother-of-pearl. (The instrument is pictured with its sliding cover open to reveal its reeds but would have been played with the cover closed.) The buttons, which direct air into the desired reed chambers, are reminiscent of those on Wheatstone's early telegraph transmitters. For this example, made some years after his first symphonium, Wheatstone expanded the number of buttons to twenty-four; they are arranged in four columns on either side of the instrument, enabling the player to produce a two-octave chromatic scale. The symphonium was soon superseded by the more versatile, bellows-blown concertina, Wheatstone's most famous musical invention.

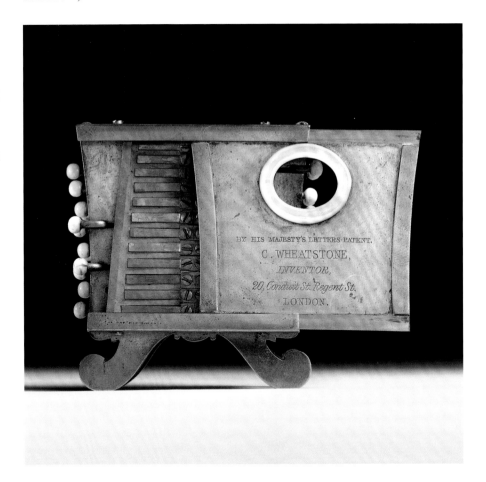

Saùng-Gauk (Harp)

Myanmar (Burma), mid-19th century
Gold-painted wood body, gold-lacquered
deerskin belly, glass decoration, and silk strings,
H. 35⅜ in. (89.7 cm)
The Crosby Brown Collection of Musical
Instruments, 1889 (89.4.1465a, b)

The saùng-gauk was depicted in Burmese art as early as the mid-seventh century and was probably introduced from southeast India and Sri Lanka in about A.D. 600. This type of arched harp is closely associated with Buddhist and animistic beliefs, and its makers traditionally practice rituals during the course of its manufacture. Its richly decorated surfaces and the materials used are steeped in symbolism. For example, the upturned finial atop the elegant incurving neck represents a leaf of the Bodhi tree under which the Buddha achieved enlightenment; the neck is from the root of a tree that grows in sacred hills thought to be inhabited by nats (spirits); and the four sound holes punctured in the gold-lacquered deerskin belly provide openings for the nats said to dwell in the instrument. The piercing of the sound holes, sometimes scheduled upon an astrologer's advice, recalls a Burmese retelling of the Buddha's previous life as a courtly harpist: during a contest, he played so divinely that four tiny nat daughters broke through the skin, forming the sound holes. The sides of the body feature scenes from the Burmese version of the *Rāmāyana*, an ancient Indian epic. Traditionally thirteen twisted silk strings attach to a string holder that runs the length of the instrument but surfaces above the skin belly in the middle of the harp. The strings, of varying diameters (thicker for longer, lower notes), are tuned by red cords, each twisted three times around the neck. The tassels at the ends of the cords represent flowers.

The Museum's harp is uniquely decorated with gold lacquer and paint—a departure from the red-and-black scheme found on most others—raised scrollwork and foliate designs, and red, green, and white mirrored glass. The instrument typically accompanies song or participates in chamber music and rests in a decorative stand when not in use.

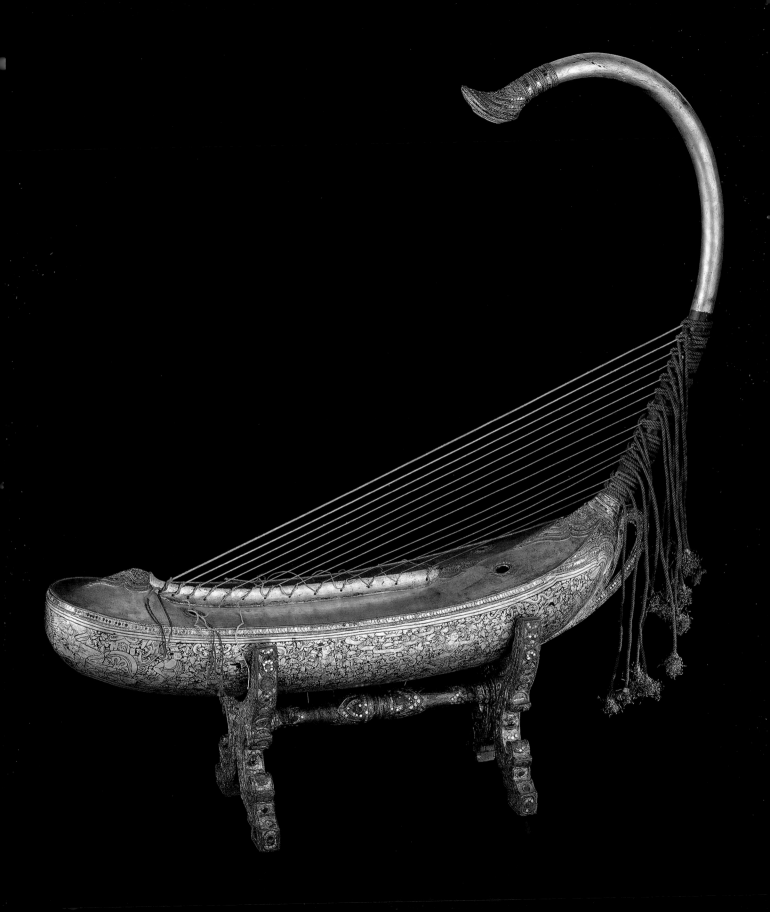

Piano

Érard et Cie
London, ca. 1840
Oak case with satinwood veneer, inlays of
stained and natural wood, ivory, and mother-of-
pearl, and gilded wood decorations; ivory naturals
and ebony accidentals, L. 97¼ in. (247 cm)
Gift of Mrs. Henry McSweeney, 1959 (59.76)

Even when silent, this piano speaks volumes about the elevated status of its original owner, Sir Thomas Foley, fourth baron of Kidderminster, England. Its case, made in the Louis XV style and lavishly decorated in marquetry by George H. Blake, is a commanding display of wealth and fashion. The Foley coat of arms and monogram, both surmounted by a baron's coronet, appear amid intricate depictions of classical gods and musical motifs. According to surviving family records, the sculpted faces of the Greek gods that adorn the piano's stand are those of the Foley family; Sir Thomas was depicted as Dionysus.

The instrument is as sophisticated as its extraordinary case and features the most advanced technology of its day, including the Érard double-escapement action, which Sébastien Érard invented in 1821. The mechanism allows for the quick repetition of a note without fully releasing the key, a vital innovation for playing the demanding virtuoso repertoire of the Romantic period and a technical development that remains at the heart of the modern piano action.

Among instruments, the piano is a prominent and perennial emblem of status. Its presence in the home signifies the owner's cultural, social, and financial achievements. Pianistic prowess was considered essential for women hoping to marry well in the nineteenth century, and the instrument was seen as a vehicle of social betterment. Even in the digital age, the ability to own and house a piano—and perhaps even to play it—continues to convey cachet.

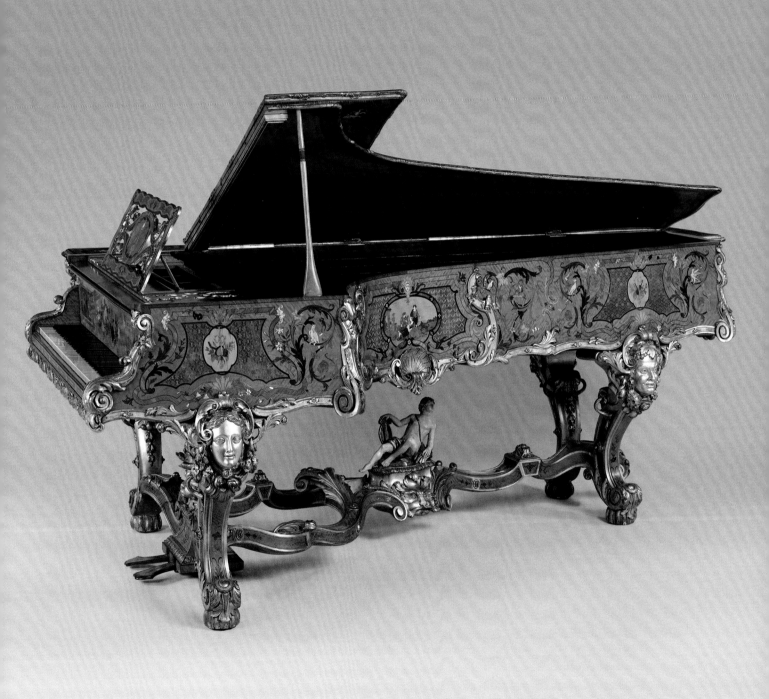

Rattle

Haida or Tsimshian
Canada, British Columbia, ca. 1880
Painted wood and string, L. 11½ in. (29.2 cm)
The Crosby Brown Collection of Musical
Instruments, 1889 (89.4.1963)

Bird Rattle

Haida
Canada, British Columbia, ca. 1840
Wood with ivory decoration, L. 8¾ in. (22.1 cm)
The Michael C. Rockefeller Memorial Collection,
Bequest of Nelson A. Rockefeller, 1979
(1979.206.444)

Raven Rattle

Tsimshian
Canada, British Columbia, Skidegate, 19th century
Painted cedarwood, L. 12¼ in. (31 cm)
The Crosby Brown Collection of Musical
Instruments, 1889 (89.4.611)

Among the Haida and other First Nations peoples of North America's northwest coast, finely sculpted wood rattles—specifically ones featuring the raven and the oyster-catcher—were long used for celebration, to placate malevolent forces, and to heal. The rattle with the colorful raven (bottom)—who, according to myth, positioned the sun and created the universe—symbolizes transmission of power from the raven to humankind. On its back a figure receives medicinal powers from a kingfisher, the raven's messenger. The bird rattle (at far right) depicts a long-beaked oystercatcher in an uncharacteristic position. With the bird's neck extended (as on the raven rattle), such rattles were sometimes used by shamans in an ecstatic ritual that nullified serious illnesses caused by witchcraft. The spherical rattle (at near right), which depicts a hook-nosed mask (perhaps a bird figure) on one side and a human face on the other, was probably used in dance.

These three rattles differ in their decoration, ranging from low relief to fully sculpted forms, and from traces of pigment to full polychrome, but are similar in construction. Two pieces are carved to form the front and back, leaving ample room within for a chamber that accommodates small stones or seeds. Wooden pins and vegetal or hide lacing secure the halves. Raven rattles may be adorned with feathers, fur, and beads, particularly along the seam of the two halves and at the handle base.

Only the initiated fully comprehend the objects' specific symbols and powers, but the raven rattle was considered so powerful that it was played upside down, in the belief that if it were played upright it would come to life and fly away. Such rattles are no longer used for healing but are kept by clan leaders as symbols of power and may appear at ceremonies such as potlatches.

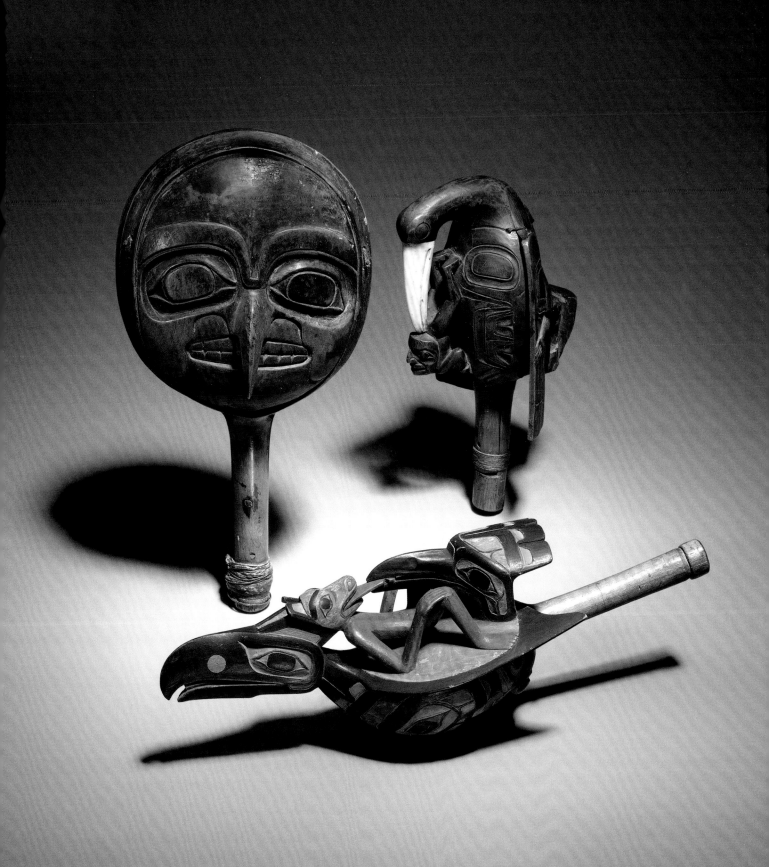

Banjo

William Esperance Boucher Jr. (1822–1899)
Baltimore, Maryland, ca. 1845
Hardwood body, calfskin belly, iron brackets and
rim, and gut strings, L. 34 ½ in. (87.6 cm)
Gift of Peter Szego, 2013 (2013.639)

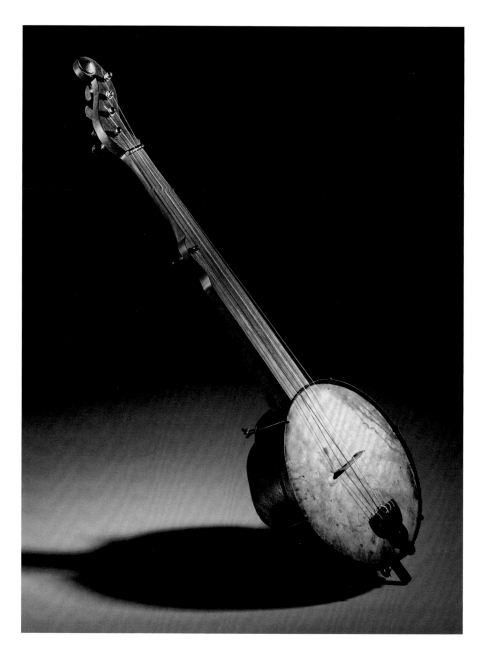

This antebellum banjo was made by
William Esperance Boucher Jr., one
of the earliest and most important
makers of the instrument. Born in
Germany, Boucher immigrated to
Baltimore, where he sold all man-
ner of musical items and was known
as both a drum maker and the first
specialized maker of the banjo.
Boucher helped to standardize its
features and is credited as the first to
use metal rods that allow the player
to adjust the tension on the skin, a
feature he may have borrowed from
his drum designs. This example
features Boucher's metal tension-rod
system and a clever scalloped wood
rim, which recesses the metal pieces
so they will not snag the player's
clothes. The wood rim and neck
are painted to look like rosewood.
Boucher used a distinctively shaped
headstock, which is reminiscent of
the profile view of a violin scroll.

The banjo developed in the
Caribbean and North America from
West African stringed instruments.
In the United States it initially
was associated with the music of
enslaved Africans on plantations and
then gained widespread popularity in
the middle decades of the nineteenth
century, in large part because it was
appropriated and used in the new
genre of minstrel music.

Kamānche (Fiddle)

Iran (Persia) or Caucasus region, ca. 1869
Wood body with ivory and mother-of-pearl inlay,
skin head, and gut strings, L. 36½ in. (92.7 cm)
The Crosby Brown Collection of Musical
Instruments, 1889 (89.4.325)

Kamānche (Fiddle)

Iran (Persia), Tehran, ca. 1880
Wood body with metal, bone, and stained
wood inlay, skin belly, and gut strings,
L. 40½ in. (102.8 cm)
Purchase, Mr. and Mrs. Thatcher M. Brown III
Gift, 1998 (1998.72)

The kamānche is the earliest documented bowed instrument, first described in the tenth century. It is frequently depicted in Persian miniatures being played by heavenly and earthly creatures. From Persia, bowed instruments diffused to Byzantium, Central Asia, and the East, then to Europe.

Held upright on its spike, the kamānche is bowed with the right hand in a palm-up position, a hand-grip used when bowed instruments were introduced to Europe and still used around the world for playing spiked fiddles. Kamānches are often elegantly inlaid or painted and, in special instances, such as the example on the right, decorated with minute pieces of wood, bone, and brass in a marquetry technique called *khatam-kari* (see page 138).

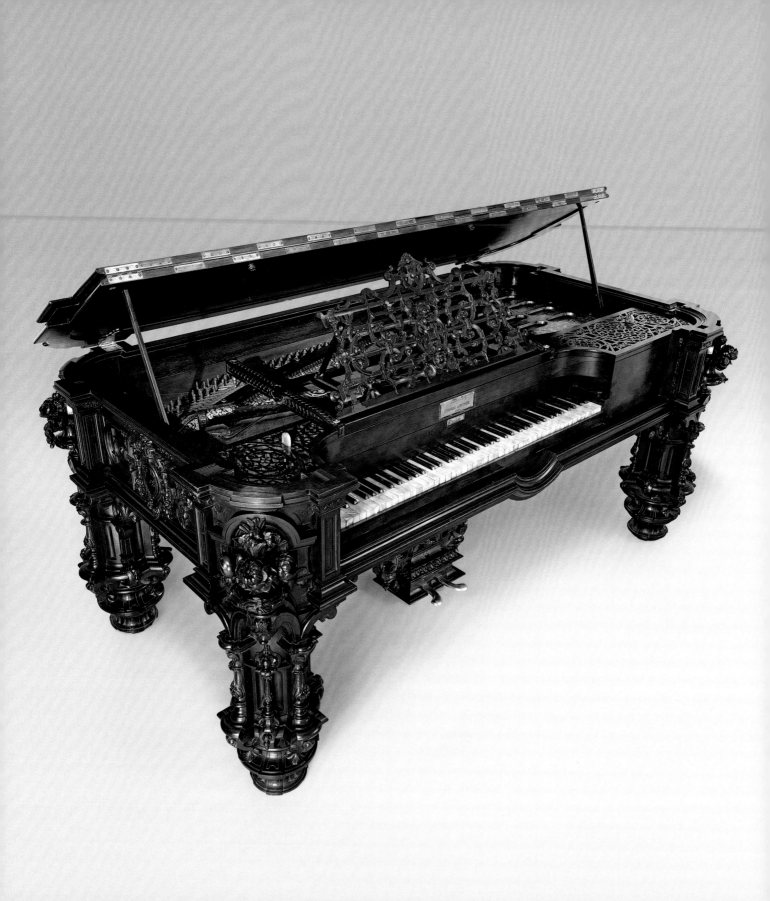

Square Piano

Nunns & Clark
New York, 1853
Rosewood case, partial iron frame, mother-of-pearl-covered naturals, and abalone- and tortoiseshell-covered accidentals, W. 87⅞ in. (223.3 cm)
Gift of George Lowther, 1906 (06.1312)

An ornate showpiece, this square piano probably represented the piano makers Robert Nunns and John Clark at the New York Crystal Palace exhibition of 1853. Nunns and Clark were English immigrants who began building pianos in New York in 1833. This example is massive, about the size of a billiard table, with a case of rosewood and lavishly carved elephantine legs. Its partial iron frame helped to strengthen its structure against the extreme temperature and humidity changes of the Mid-Atlantic states. Slips of mother-of-pearl, tortoiseshell, and abalone embellish the seven-octave keyboard.

Square pianos, which are actually rectangular in shape, were originally designed as small instruments for use in the home; they were introduced by Johannes Zumpe in London in 1767. In the nineteenth century the piano occupied a cherished role at the center of entertainment in middle- and upper-class homes across Europe and North America, as can be seen in Renoir's painting of two girls at an upright piano, shown below. The instrument was used for amateurs to learn the literature of the great composer-pianists, for chamber music, for lighter music such as the songs of Stephen Foster, and for leading the family in hymn singing. The square piano became a ubiquitous symbol of domestic life, and millions of instruments were made by large manufacturing firms in Europe and the United States. It gradually fell from fashion and by the end of the nineteenth century was supplanted by the upright piano.

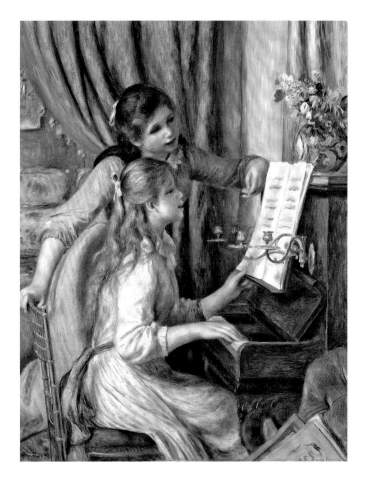

Auguste Renoir (French, 1841–1919). *Two Young Girls at the Piano*, 1892. Oil on canvas, 44 x 34 in. (111.8 x 86.4 cm). Robert Lehman Collection, 1975 (1975.1.201)

Keyed Bugle

Elbridge G. Wright (1811–1871)
Boston, 1854
Silver, L. 13⅛ in. (33.4 cm)
Purchase, Robert Alonzo Lehman Bequest, 2004
(2004.269a–e)

Elbridge Wright, one of the great American wind instrument makers of the nineteenth century, was known for his beautiful presentation instruments, such as this elegantly engraved keyed bugle made for the bandmaster Daniel H. Chandler of Portland, Maine. When Chandler received this instrument, his band was one of the most celebrated civilian ensembles on the East Coast. The group was later mustered to serve in the Union army during the Civil War.

The keyed bugle, which traces its origins to the traditional military bugle, was a popular band instrument. Regardless of what materials are used to make them, bugles are classified as brass instruments because they are played by buzzing the lips into a cup-shaped mouthpiece. The instrument's body amplifies the sound-producing vibrations and determines their pitch. By changing the tension of their lips and thus the speed of the vibrations, players can produce a limited range of notes, the harmonic series. To play all the notes of the scale, the player must change the length of the instrument's tubing, which can be accomplished with crooks, valves, and keys.

Bugles had none of those features until the early nineteenth century, when George Astor and John Köhler of London added keys to a bugle. Depressing the twelve keys opens and closes holes in the tubing, effectively changing the bugle's sounding length. The masterful silhouette of noted bandleader Frank Johnson and his wife (shown below) shows the keyed bugle in use, even accurately depicting the open-standing key on the instrument's bell.

Keyed bugles were used into the third quarter of the nineteenth century, despite the advent in 1814 of valved brass instruments, which produce a louder, more homogenous sound. While the keyed bugle was prized for its warm sound and subtle tonal inflections, the more technically agile cornet eventually became the undisputed leader of the band.

Auguste Edouart (French, 1789–1861). *Frank Johnson, Leader of the Brass Band of the 128th Regiment in Saratoga, with His Wife, Helen* (detail), 1842–44. Cut paper silhouettes mounted on board, overall 11¼ x 9¼ in. (28.6 x 23.5 cm). Gift of Philip S. P. and Elisabeth W. Fell, 1976 (1976.652.3–.4)

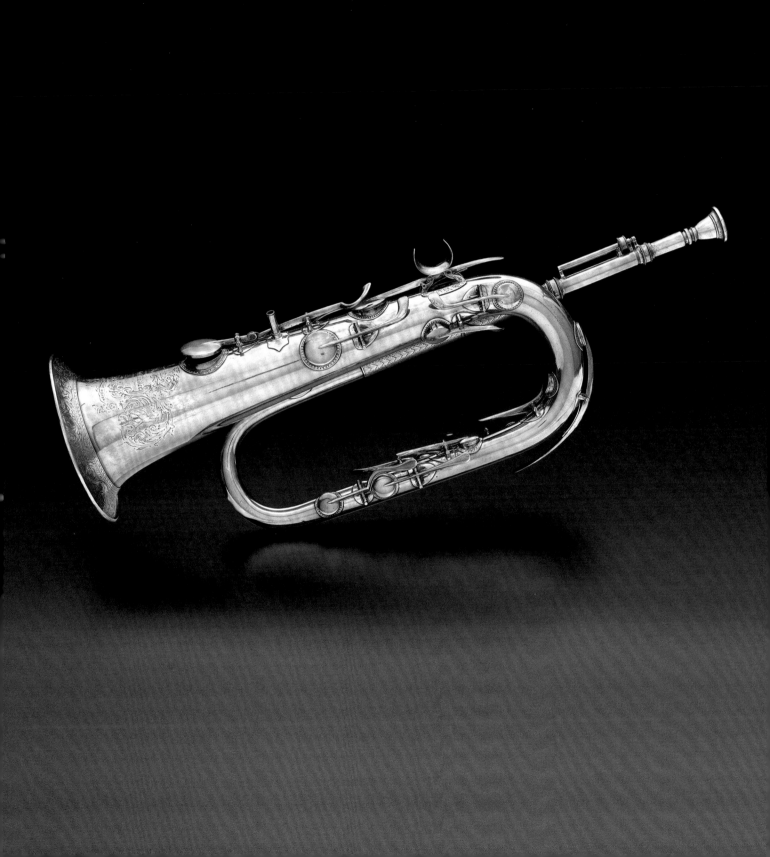

Bondjo (Side-Blown Trumpet)

Ekonda people
Democratic Republic of the Congo, 1915
Ivory and painted wood, L. 55 in. (139.5 cm)
Purchase, Rogers Fund, Roger L. Stevens Family
Fund Gift, Gifts of Herbert J. Harris, and Brian and
Ann Marie Todes, by exchange, Kay T. Krechmer
Bequest, in memory of her husband, Harold H.
Krechmer, and funds from various donors, 1992
(1992.326)

Side-Blown Trumpet

Mangbetu people
Democratic Republic of the Congo, 19th century
Ivory, L. 50 in. (127 cm)
Purchase, Bequest of Olive Huber, by exchange,
and Brian and Ann Marie Todes Gift, 1999
(1999.74)

Animal horn or tusk trumpets with mouthpieces drilled into the side are found throughout Africa; a sculpture from the Edo people of Nigeria (shown below) depicts how the side-blown trumpet was played. Ivory trumpets often symbolize kingly power, and those associated with royal ensembles are decorated with skins, wooden extensions, and beautiful carving.

Horn player. Nigeria, Court of Benin, Edo people, 1550–1680. Brass, 24 ⅞ x 11 ⅝ x 6 ¾ in. (63 x 29.4 x 17.2 cm). The Michael C. Rockefeller Memorial Collection, Gift of Nelson A. Rockefeller, 1972 (1978.412.310)

These examples from the Democratic Republic of the Congo show two different types of side-blown trumpets. The one from the Mangbetu people (bottom) is entirely of ivory, and skilled carvers decorated it in deep relief with an integral, projecting mouthpiece. Elegant trumpets like this are used in pairs or in larger ensembles to accompany dances or signal the king's entrance and departure.

The larger trumpet from the Ekonda people was originally intended to be used in battle; today it is used at occasions such as weddings, hunting or planting ceremonies, or the investiture of a *nkumu* (leader). A wood extension to the ivory horn is painted with black-and-white stripes and checks; its flanged shape, characteristic of early twentieth-century royal motifs, is similar to that of the headpieces worn by Ekonda leaders. The decorative motif also appears on drums and stamping sticks, a type of percussion instrument.

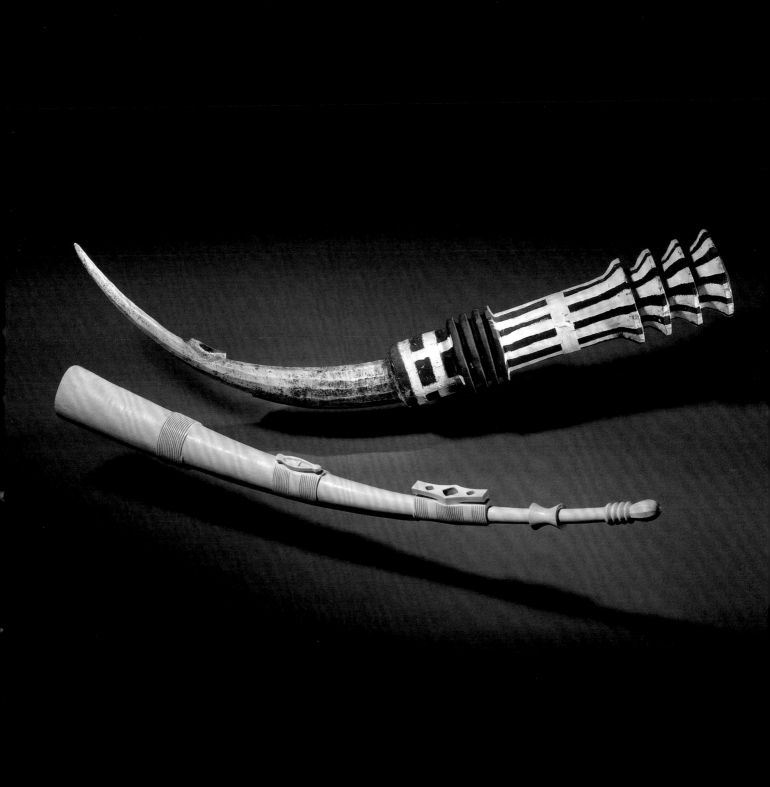

Drum

Akan Ashanti people
Ghana, early 20th century
Painted wood body with skin head,
H. 20 ⅛ in. (53 cm)
Gift of Raymond E. Britt Sr., 1977 (1977.454.17)

Ngoma (Drum)

Vili or Yombe people
Democratic Republic of the Congo, Loango region,
19th century
Painted wood body with skin head,
H. 30 ¾ in. (78 cm)
The Crosby Brown Collection of Musical
Instruments, 1889 (89.4.1743)

Caryatid drums—drums supported by carved figures—are common among several sub-Saharan African peoples. The Congolese Vili, who live along the coast, and their inland neighbors the Yombe link their sculpted drums with certain *nkisi* (spirit) rituals and with ancestors who speak via the drum.

Both drums pictured here underscore the importance of parenting. In the Vili/Yombe example (at right), a man sits on a leopard, symbol of courage and fierceness. He and the child seated on his lap each place a hand on a small drum, suggesting paternal protection and guidance. In the Ghanaian example (at left), Akan

Ashanti carvers supported the drum on the shoulders of nurturing mother figures: one nurses a child and the other is writing in a book. The mother and child theme, frequently depicted in Ashanti sculpture, here combines with an emphasis on writing, serving as a reminder of the importance of family and history.

Dombak (Goblet Drum)

Iran (Persia), late 19th century
Wood with bone, brass, and stained wood inlay
and skin head, H. 22 ¼ in. (56.5 cm)
The Crosby Brown Collection of Musical
Instruments, 1889 (89.4.1310)

Tār (Lute)

Iran (Persia), late 19th century
Wood with bone and stained wood inlay, skin
belly, and metal strings, L. 32 ¾ in. (83.2 cm)
The Crosby Brown Collection of Musical
Instruments, 1889 (89.4.1679)

The intricate Persian marquetry known as *khatam* is produced by an elaborate micromosaic inlay technique, which involves assembling thin lengths of wood, bone, ivory, and metals into glued rods that, in cross section, form geometric shapes. The ends of these sticks are thinly sliced and glued to the surface of the object. *Khatam*, usually reserved for boxes, tables, desks, and frames, is sometimes seen on musical instruments. During the Safavid period (1501–1722) marquetry production was centered in southern Iran, especially Isfahan, Shiraz, and Kerman, and *khatam-kari* (the art of making *khatam*) was taught at court alongside music and painting. The art form declined in the eighteenth and nineteenth centuries but was revived during the reign of Reza Shah Pahlavi (1925–41).

Khatam incorporating hexagonal stars, lozenges, inscriptions, and borders reminiscent of Islamic wall and vase designs encrusts this drum and lute, a rare set of nineteenth-century instruments. The dombak (goblet drum), the principal percussion for Persian music, has a central band with large six-pointed stars

and miniature stars filling the spaces between the larger ones. Among the inscriptions on the borders of the goblet is one that translates as, "When it sounds, it makes everyone in the world happy." Stars are also inlaid on the Museum's tār, a plucked lute found in Iran and the Caucasus and played in solo performance. This six-string Persian-style example has a mulberry wood body shaped like a figure eight. The strings are plucked with a brass plectrum coated with wax. The instrument usually has twenty-five movable gut frets, which are missing from this tār.

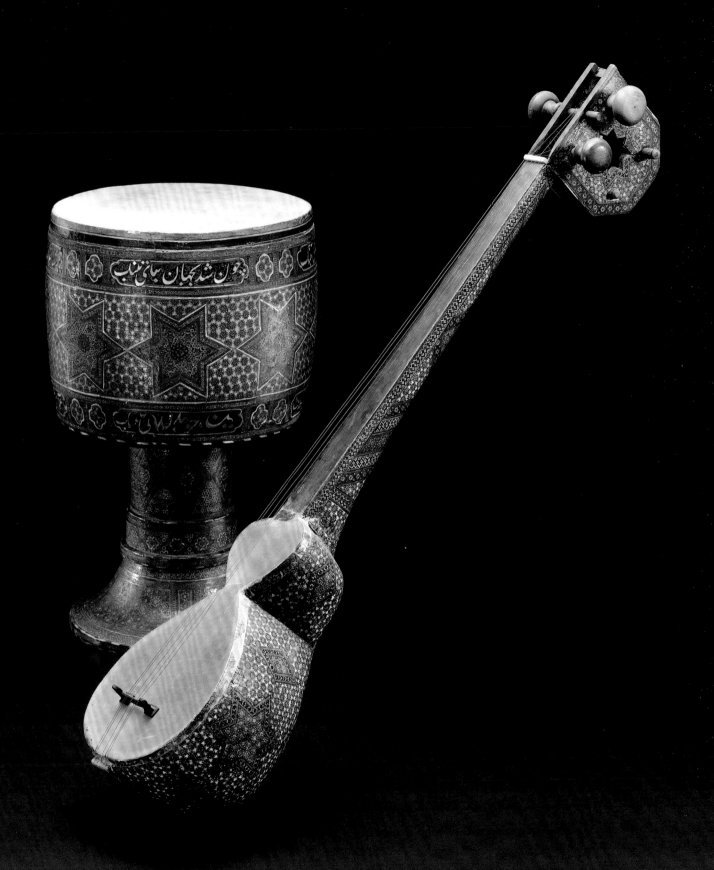

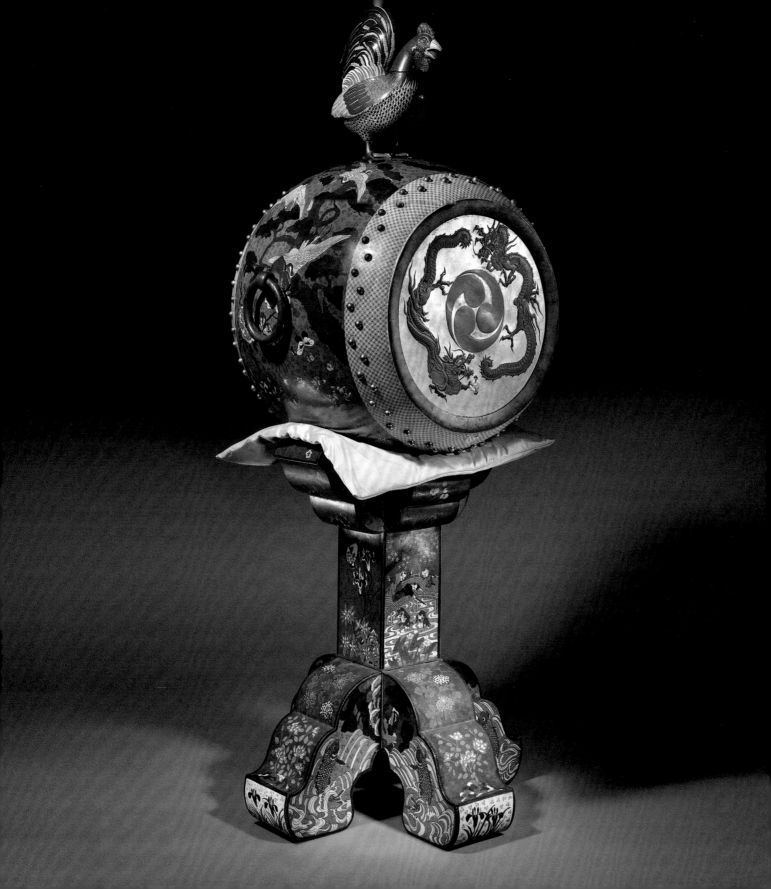

Ō-Daiko (Barrel Drum)

Attributed to Kodenji Hayashi (1832–after 1911)
Japan, Aichi Prefecture, Nagoya, Meiji period,
ca. 1873
Wood drum, metal stand and decorative rooster,
cloisonné, silk pillow, and skin heads,
H. 62 ¼ in. (158 cm)
The Crosby Brown Collection of Musical
Instruments, 1889 (89.4.1236)

An ō-daiko is a barrel drum played in temples, theater orchestras, and at festivals, but this one was never meant to be played. Unusually ornate, with a cloisonné stand and body, it was ordered by the Japanese government for display at the 1873 Vienna International Exposition, the first world's fair in which Japan participated formally as a nation.

The drum's cowhide skins served as a canvas for playful lacquerwork dragons chasing each other around the cosmic *mitsu-tomoe* symbol. Pine trees and cranes, symbols of long life, abound on both the drum and its stand, but the object in its entirety is a symbol of peace, signified by the colorful rooster atop the drum. The imagery references an ancient story of a drum that was positioned at a village gate to sound an alarm during an attack. The drum was never struck and, as the years passed, gradually became home to hens and roosters—and thus an emblem of contentment and peace, similarly depicted in the painting shown at right.

Shibata Zeshin (Japanese, 1807–1891). *Cock on Drum*, Edo period, 1882. Lacquer on silver paper, 4 ¾ x 3 ½ in. (12.1 x 8.9 cm). The Howard Mansfield Collection, Purchase, Rogers Fund, 1936 (36.100.113)

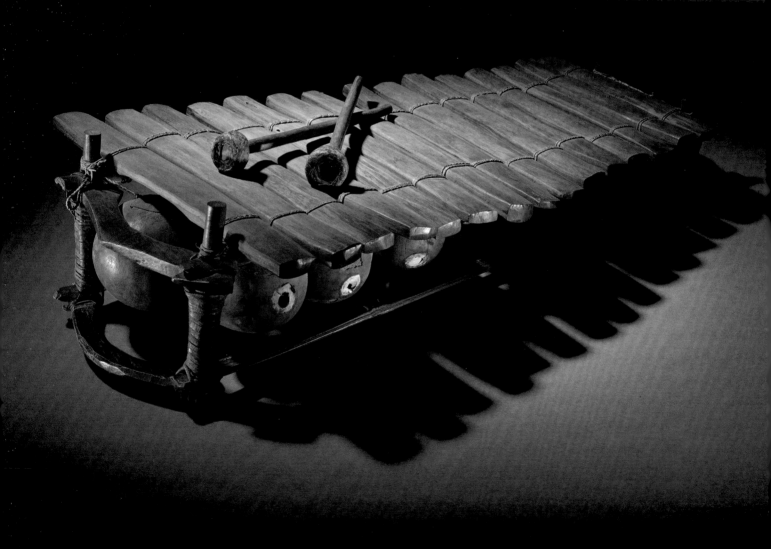

Bala (Xylophone)

Mandinka people
West Africa, 19th century
Wood, gourd, and membrane, L. 34 ⅛ in. (86.5 cm)
The Crosby Brown Collection of Musical
Instruments, 1889 (89.4.492)

This bala, or xylophone, has fifteen bars with gourd resonators. Versions of the instrument, like the tall bala depicted in the Dogon sculpture shown below, are popular throughout Africa, with different tuning systems and performance contexts. Among the Mandingo people (including the Mandinka), professional musicians called *jalis* use rubber-tipped mallets to play the bala, usually as a solo instrument accompanying the recitation of heroic deeds, historic events, religious proselytizing, and social messages, as well as praise songs. Under each tuned bar is a gourd resonator with a side hole covered by a membrane that modifies the sound. On older instruments like this one, the modifier is a membrane from a spider's-egg case, which produces the secondary buzzing sound that is a hallmark of African sonic aesthetics. Today's makers use cigarette paper or other durable, readily available materials to achieve the effect. The xylophone, like many African instruments—the banjo, rattles, and drums—made its way to the Americas. It both became the national instrument of Guatemala and was adapted into classical Western music.

Pair of balafon players. Mali, Dogon people, 18th–early 19th century. Wood and metal, 15 ½ x 5 ¾ x 6 ½ in. (39.3 x 14.6 x 16.5 cm). The Michael C. Rockefeller Memorial Collection, Bequest of Nelson A. Rockefeller, 1979 (1979.206.131)

Nyonganyonga
(Lamellaphone)

Barwe people
Mozambique, Zambesi Province, ca. 1900
Wood, shell, metal, and beads, L. 9¼ in. (23.4 cm)
The Crosby Brown Collection of Musical
Instruments, 1889 (09.163.6)

The nyonganyonga is a lamellaphone, an instrument consisting of thin metal or split cane tongues (lamellae) mounted on a resonating board or box. Depressing the free ends of the tongues with the thumbs produces a gentle ringing sound, sometimes augmented by jingling objects attached to the board. The instrument may be amplified by holding it in or over a hollow gourd, as illustrated by the Museum's Chokwe sculpture, shown here. Tuning is accomplished by sliding the tongues in or out to change their vibrating length and thus the pitch. Various types of lamellaphones (generally known by two regional terms: mbira and sanza) are found across sub-Saharan Africa and were brought to Latin America by enslaved Africans. Depending upon the context and regional tradition, lamellaphones may be used to accompany narratives or children's songs, or to summon spirits and induce trance and spirit possession, bridging this world with that of watchful ancestors.

This nyonganyonga with thirty-one keys came from Mozambique and is believed to have been made by the Barwe people, members of the Shona community. The Shona use instruments like this in ensembles that accompany song and dance in a *bira*, an all-night ritual in which families consult with ancestral spirits. The music helps induce the trance of a medium, who advises the family on health and domestic problems.

Seated chief playing a chisanzi (lamellaphone). Angola, Chokwe people, before 1869. Uapaca wood, cloth, fiber, and beads, 16 ¾ x 4 ¾ x 5 ¼ in. (42.5 x 12.1 x 13.3 cm). Rogers Fund, 1988 (1988.157)

Pahu (Drum)

Austral Islanders
French Polynesia, early 19th century
Wood, sharkskin head, and fiber, H. 51⅜ in.
(130.5 cm)
The Michael C. Rockefeller Memorial Collection,
Gift of Nelson A. Rockefeller, 1969 (1978.412.720)

Cylindrical hardwood drums with
openwork bases and sharkskin heads
laced and kept taut with long lengths
of cord are typical of Polynesia.
The drum's lower section is usu-
ally carved in a curvilinear pattern,
ranging from a simple wavelike
design in small Hawaiian versions
to the complex and elaborate embel-
lishment seen in this spectacular
example from the Austral Islands.
Stylized female figures dance around
the base, perhaps reflecting the
drum's role in ritual. In pre-Christian
Hawaii such drums were used on sol-
emn occasions and in sacred temple
dances, which men performed with
prescribed movements to please
Lono, deity of peace and agriculture,
and Ku, god of war.

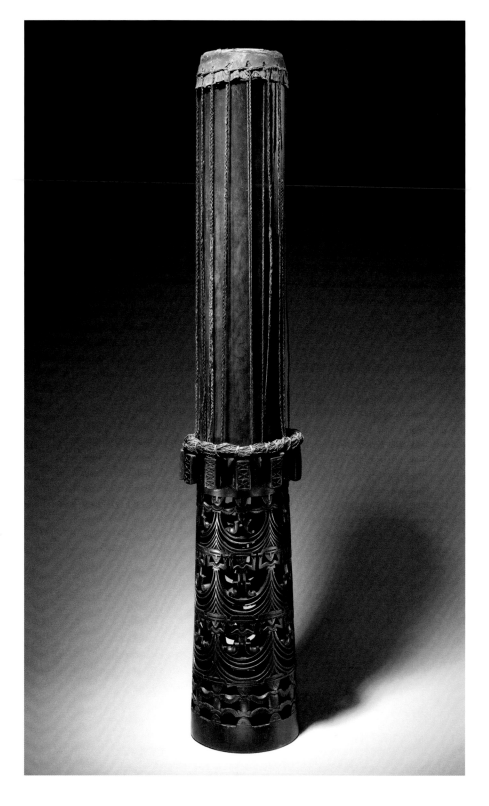

Dadabuan (Goblet Drum)

Philippines, Mindanao, 19th century
Palm wood body with mother-of-pearl inlay and
skin head, H. 32 ⅜ in. (82.2 cm)
Rogers Fund, 1982 (1982.32)

This large goblet-shaped drum from the southern Philippine islands reveals Islamic influences that date to the thirteenth century, when Arabs initiated trade with nearby Malaysia and Indonesia, demonstrating how one culture adapts another's musical and ornamental ideas. Its name derives from the Arabic word for a goblet drum, and its shape and mother-of-pearl geometric inlaid designs—similar to those of the Persian dombak (see page 138)—clearly derive from the Muslim world. Indigenous decorative elements include the carvings of flowing leaf patterns and stylized S-shaped serpents, and the darkening of the palm wood with oil and soot. The drum is played with two rattan sticks, usually from a standing position, to accompany other instruments. It is the sole non-gong instrument in the traditional Philippine kulintang ensemble, which otherwise consists of metal gong kettles.

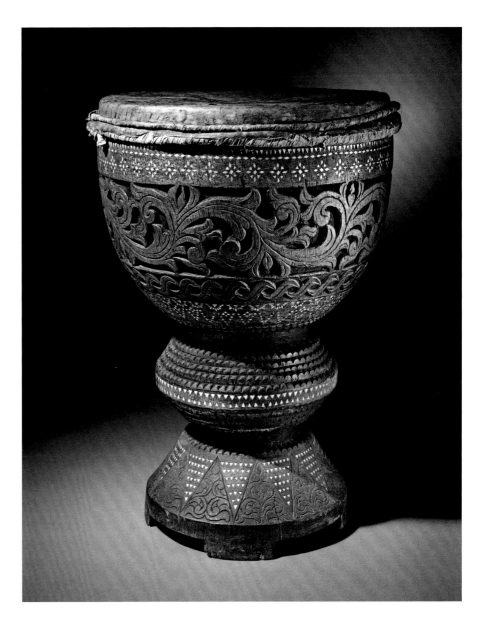

Drum

Kuba (Shoowa) people
Democratic Republic of the Congo, Sankuru River
region, 19th–20th century
Wood, skin head, and braided fiber,
H. 34 ½ in. (87.5 cm)
Purchase, Robert Alonzo Lehman Bequest, 2013
(2013.623)

Elaborate drums like this, which came to be known as "kings' drums," are symbols of kingship that provided Kuba royalty with a lucrative trade item after their discovery by European dealers at the beginning of the twentieth century. The drums typically had richly carved cylindrical bodies supported by outward-curving legs and a central pillar mounted on a base. They were decorated with geometric motifs—interlocking patterns similar to those seen on Kuba textiles—and often featured a handle in the form of a head atop a downward-pointing hand. The drumhead is attached to a hide collar secured to the drum with wooden pegs, a system typical among the Kuba people. The kings' drums seem to have developed from plainer types that also use the collar system and feature the head-and-hand motif. In Kuba lore, the hand—once used as proof of having killed the enemy—is the warrior's emblem.

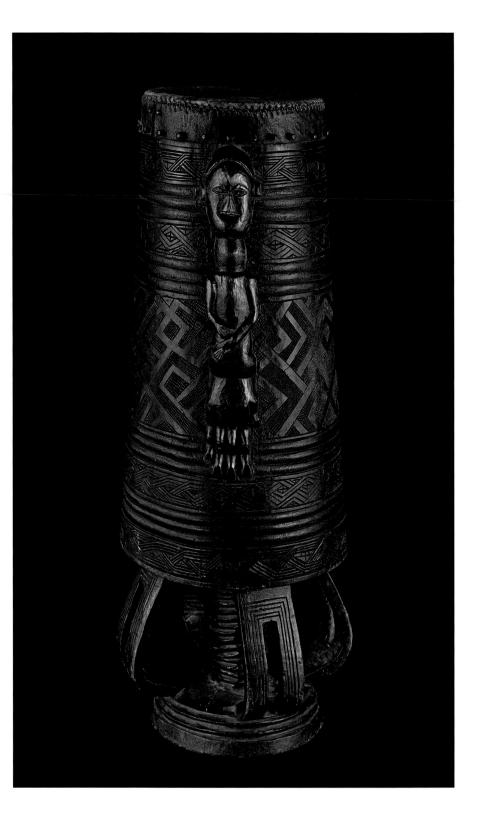

Sesando (Zither)

Indonesia, Nusa Tenggara, Timor, late 19th century
Bamboo, wood, palm, and metal wire,
H. 22⅛ in. (56 cm)
The Crosby Brown Collection of Musical
Instruments, 1889 (89.4.1489)

Musical instruments were often crafted from materials that were readily at hand and thus reflected their makers' environment. The sesando, a plucked tubular zither, is popular in the provinces of Nusa Tenggara. Like much of Indonesia, these islands are forested with lontar palms (*Borassus flabellifer*). Historically this tree played a central role in everyday life owing to its abundance and versatility. The nectar of the flowers can be distilled into alcohol or converted to sugar. Housing, hats, and containers are fashioned from its timber and fan-shaped fronds. Woven palm fronds also form the distinctive resonator of the sesando. Its fragile appearance belies the strength of its construction, which is similar to that of lontar baskets used to harvest nectar from the trees; this example has survived for well over a century. Bamboo, also locally abundant and durable, is used for the tubular body of the sesando.

The musician uses the right hand to pluck the bass strings and the left hand to play the treble. The pitch of the wire strings is adjusted with a complex series of movable bridges and tuning pegs. Occasionally played as a solo instrument, this zither is primarily used to accompany songs, which are often philosophical, portraying fate as inescapable and life as sometimes disappointing and ultimately fleeting. Used at weddings and funerals, the sesando is believed to possess supernatural powers. In an enlarged and amplified form, it has entered the world of Indonesian pop music.

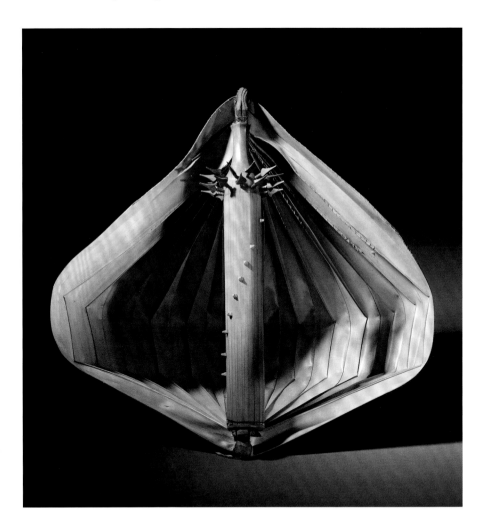

Tsii'edo'a'tl (Bowed Zither)

Apache
Arizona, 19th century
Agave stalk with paint, wood, and horsehair, L. 17½ in. (44.5 cm)
The Crosby Brown Collection of Musical Instruments, 1889 (89.4.2631a, b)

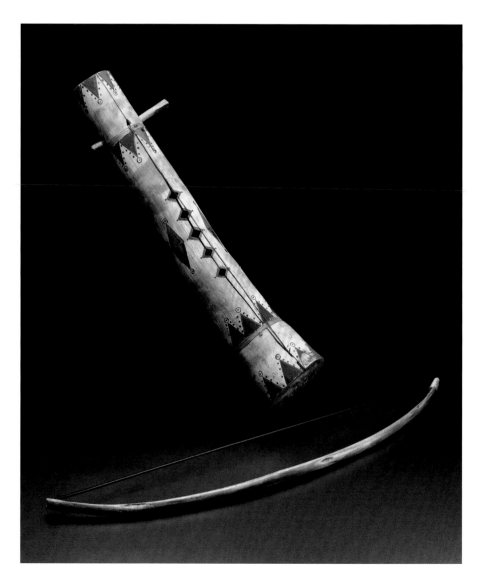

Tsii'edo'a'tl, the Apache name for this one- or two-string bowed zither, means "wood that sings." Held against the chest or stomach and bowed like European fiddles, it is played by the White Mountain and particularly the San Carlos Apache of Arizona for personal enjoyment, for healing, or for entertaining at gatherings with songs and dances. Geronimo, the famous nineteenth-century Apache leader, made tsii'edo'a'tls and was an accomplished player.

The tsii'edo'a'tl is the only Native American bowed instrument; whether it is indigenous, as Apache sources claim, or of European derivation remains unclear. It does seem distinctively Native American, unlike violin-shaped instruments found in Mexico, which have obvious European roots. A dried and hollowed agave stalk forms the tubular body, to which one or two horsehair or wire strings are internally attached. Some of the painted designs are difficult to decipher, as they have personal significance to the maker; others are traditional patterns and symbols, such as the circle (sun or moon), the sawtooth (mountains), crescents (wind spirits), and colors that may symbolize the four directions. Diamond-shaped, triangular, or round sound holes are often placed prominently. When the string is sounded with an arched horsehair bow, its melodic tone is sweet and delicate.

Lunet (Friction Drum)

Papua New Guinea, New Ireland, late 19th–early
20th century
Wood with shell decoration, W. 22⅛ in. (56 cm)
The Michael C. Rockefeller Memorial Collection,
Bequest of Nelson A. Rockefeller, 1979
(1979.206.1477)

The lunet, an instrument unique to northern New Ireland, a large island in Papua New Guinea, is used during elaborate, days-long *malagan* ceremonies honoring the dead. The player rubs his moistened palm across the drum's three graduated wedges, or tongues, producing a three-toned call that evokes the spirit world and suggests the cry of the lunet, the bird for which the instrument was named. The bird is also referenced in the simple carvings that form the drum's wedges, which are accented by almond-shaped eyes inset with opercula, the calcified "doors" that cover the openings of snail shells. The instrument, played only by men, was unseen during the ceremony, sometimes concealed in a tree, further evoking the namesake bird.

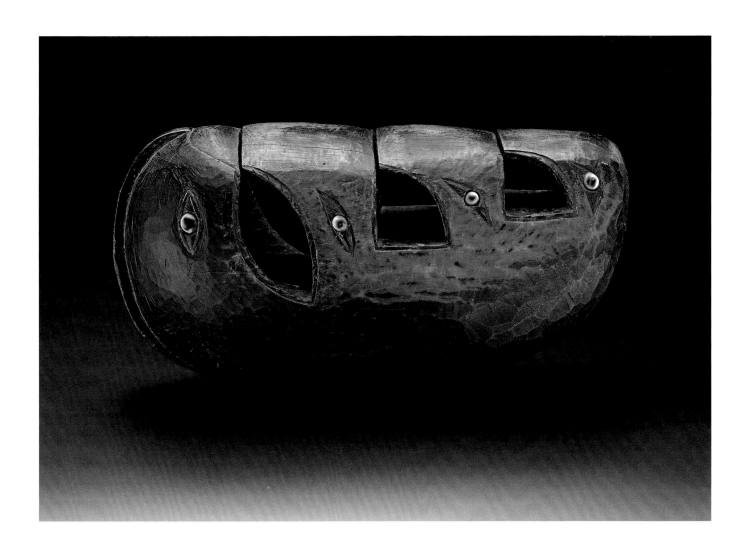

Lawle (Bell Mallet)

Baulé people
Ivory Coast, 19th–20th century
Wood and cotton, L. 9 ⅞ in. (25.1 cm)
Purchase, Pace Editions Inc., Fred and Rita
Richman, and Mr. and Mrs. Milton F. Rosenthal
Gifts, 1977 (1977.335)

Lawle (Bell Mallet)

Baulé people
Ivory Coast, 19th–20th century
Wood and cotton, L. 11 in. (27.9 cm)
Purchase, Joan Taub Ades Gift, 2010 (2010.349)

Lawle (Bell Mallet)

Baulé people
Ivory Coast, 19th–20th century
Wood and cotton, L. 10 ⅜ in. (26.4 cm)
Gift of Drs. Herbert F. and Teruko S. Neuwalder,
1993 (1993.383.1)

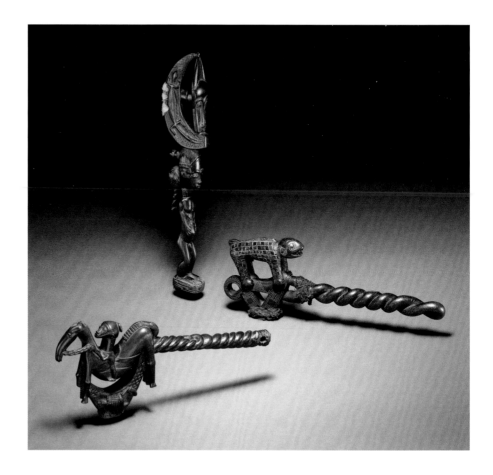

Handheld P-shaped wood beaters like these, known as lawre waka or lawle, are used in the Ivory Coast by Baulé diviners (*komien*) to strike a flat, flanged iron bell whose steady beat helps to induce and maintain a trance state. The bell's beating may last for hours; it may be resumed after it is silenced if the trance begins to wane. The entranced diviner speaks with the voices of nature spirits to prescribe cures.

These mallets are typically carved so that the handles represent a coil and the striking surface forms a crescent shape. Baulé carvers decorate the space within the crescent to transform a musical accessory into a work of art. These three examples reveal the carvers' ingenious creativity in individualizing the beaters. The first (left) depicts a swaybacked horse and rider and, in relief, a lizard and a snake biting a crocodile. The second (center) has an elegantly sculpted female figure with an elaborate coiffure, and within the padded crescent-shaped striking portion is a masklike steer head. The third (right) represents a leopard.

Mí-Gyaùng (Crocodile Zither)

Myanmar (Burma), late 19th century
Wood with gold leaf, L. 54 in. (137.2 cm)
The Crosby Brown Collection of Musical
Instruments, 1889 (89.4.1473)

The mí-gyaùng is mentioned in the earliest known document to reference music in Myanmar. This ninth century record states that a group of Burmese dancers and musicians with chamber instruments was sent to the Tang dynasty court in China to perform for the emperor. Among the instruments were the saùng-gauk (see page 122), the khene (mouth organ), and the aptly named mí-gyaùng ("crocodile zither" in Burmese).

The mí-gyaùng and particularly the saùng-gauk are still played in chamber music. Similar box zithers exist from Thailand to Indonesia. Although they do not have the zoomorphic form of the mí-gyaùng, their names—the Thai čhakhē (alligator) and Cambodian krapeu (alligator or crocodile)—retain a reptilian reference.

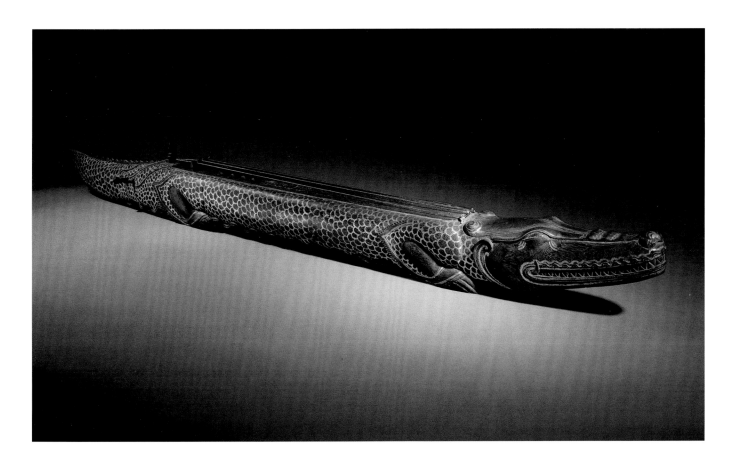

Baton

Köhler & Son
London, 1881
Ivory, gold, and ruby, L. 21¾ (55.1 cm)
Gift of Gene Young and Linda Surridge, 2006
(2006.577.4a–c)

Baton

Tiffany & Company
New York, early 20th century
Ebony and silver, L. 20⅛ in. (50.9 cm)
Gift of Gene Young and Linda Surridge, 2006
(2006.577.3a, b)

Baton

Germany, Breslau, 1855
Silver and ebony, L. 18⅝ in. (47.1 cm)
Gift of Gene Young and Linda Surridge, 2006
(2006.577.2)

Until the beginning of the nineteenth century orchestras were generally led by either the principal violinist or the keyboard player, much as chamber music ensembles are. The first conductors often used rolled-up sheets of music or spontaneously pressed violin bows into service; today they favor small, utilitarian batons, like the one in the drawing shown below. Although batons are instruments that produce no sound, the conductors who wield them exercise authority over the orchestra and are often accorded great prestige, as evidenced by the three presentation batons shown here. They were conceived as commemorative gifts and function primarily as status objects and badges of office, much like the ceremonial staffs and maces they resemble in both their form and their use of exotic and expensive materials.

The snake-entwined ivory baton is inscribed: "Presented by the Management, Members of the Gaiety Company and a Few Friends to William Meyer Lutz, as a mark of friendship, esteem, and appreciation. Gaiety Theatre. November 5th 1881." Lutz, a composer and conductor of light music, was resident musical director at the Gaiety, in London, where he conducted *Thespis*, the first Gilbert and Sullivan comic opera, in 1871.

The elegant ebony baton mounted with silver was presented by Bessie McCoy, a Ziegfield Follies performer, vaudeville veteran, and composer, to the Broadway musical director DeWitt Coolman. The third baton, bearing a gilded orb surmounted by a silver lyre, was a token of thanks given to Gottlieb Siegert, who reinvigorated choral music in Breslau, Germany, by founding a *Singverein* (choral society).

William Gropper (American, 1897–1977). *The Conductor*, ca. 1920. Ink and graphite on paper, 11 x 8½ in. (27.9 x 21.6 cm). Bequest of Scofield Thayer, 1982 (1984.433.178)

Sārindā (Fiddle)

India, Bengal, late 19th century
Teak body, ivory and bone inlay, skin belly, and gut
and steel strings, L. 27 ⅞ in. (70.8 cm)
Gift of Miss Alice Getty, 1946 (46.34.42a, b)

Indian music requires a flexible melody to accommodate the structure and ornaments of ragas (melodic modes), and stringed instruments are well suited to the task. Bowed stringed instruments like this example are distributed only from eastern Iran to northern India, where it is called a sārindā. Carved from a globular piece of wood, the front is characterized by two openings connected by a deep waist. The lower opening is covered with animal skin and supports the instrument's bridge, which guides four bowed strings and eighteen sympathetic strings to pegs within the neck and in the pegbox. Uniquely for a stringed instrument, the sārindā's rounded back projects the sound toward the uncovered upper section.

The sārindā was initially a folk instrument used by street musicians, but Allauddin Khan, a renowned Bengali court musician, composer, and teacher credited with reshaping Indian classical music in the late nineteenth century, incorporated it into his orchestra. The rich decoration around the front openings and fingerboard reflects the sārindā's elevation from its humble roots to a courtly setting, where it interpreted a classical repertoire.

Lira (Short-Necked Fiddle)

Attributed to Küçük İzmitli (Greek, active late 19th century)
Greece, ca. 1890
Wood, mother-of-pearl, tortoiseshell, and gut strings, L. 15 ⅞ in. (40.3 cm)
Purchase, Robert Alonzo Lehman Bequest, 2003 (2003.378)

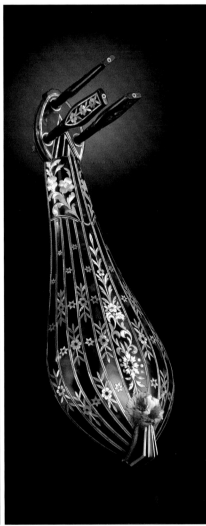

The term "lira" or "lyra" is applied to many different instruments across the globe, from a Ukrainian hurdy-gurdy to a Bhutanese flute. In Greece, where this instrument is from, it refers to two distinct short-necked fiddles: the rectangular Pontic lyra (also known as a kementze), which was introduced by Turkish refugees in the early 1900s, and the pear-shaped version seen here, which is found mainly on the Greek islands and in Thrace and Macedonia. It varies in size depending on the maker's preference and region. From the back the lira resembles a rabbit, its pegs the ears and the pompom at the base its tail.

Rarely is a lira so elaborately decorated as this one, with its lavish use of tortoiseshell and mother-of-pearl. The stunning workmanship and the similarity to attributed liras in an instrument museum in Athens strongly suggest that it is the work of a late nineteenth-century maker known only as Küçük İzmitli (Little Izmitli), who was famous in Greece. The lira is shown without its original arched bow, which would have had small bells attached to it to enliven the dance tunes played by male musicians.

Sāraṅgī (Fiddle)

India, ca. 1865
Toona wood body with ivory inlay, gut and steel
strings, and skin belly, L. 29 ½ in. (74.7 cm)
Gift of Mrs. Harold H. Krechmer, in memory of her
husband, Harold H. Krechmer, 1982 (1982.143.2)

A full and rich sound that approximates the melodic flexibility of the human voice makes the sāraṅgī the most important bowed instrument of classical Hindustani music of northern India and Pakistan. Four gut melody strings cross over the bridge and attach to pegs in the pegbox; the metal sympathetic strings beneath them pass through the bridge and run either to the side or through the diagonally placed holes on the neck to attach to side pegs. The number of sympathetic strings varies from instrument to instrument; in modern usage the classic sāraṅgī has thirty to forty. To produce melody and virtuosic embellishment, the player bows the four melody strings with the right hand, changing the pitch by pushing those strings to the side with the fingernails of the left hand, avoiding the sympathetic strings below, a technique that makes the sāraṅgī a particularly difficult instrument to master.

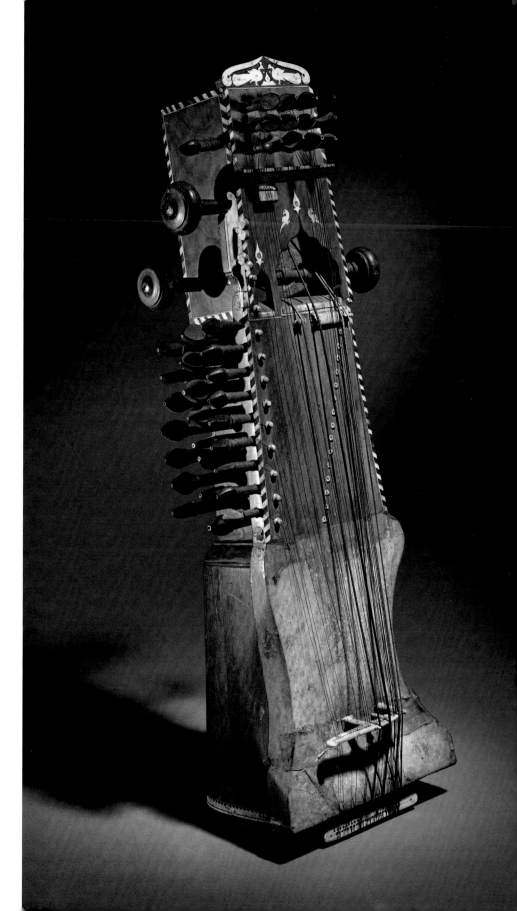

Śankh (Shell Trumpet)

India, Kerala State, 19th century
Shell (*Turbinella pyrum*), brass, and wax,
L. 16 ¾ in. (42.5 cm)
Purchase, The Barrington Foundation Inc. Gift,
1986 (1986.12)

Conch shell trumpets have been used throughout the world to send messages, signal military commands, and draw the attention of gods and spirits, which is how this example was used in India.

The mouthpiece at the smaller end suggests a lotus; brass work on the conical midsection features rows of alternating nagas (serpent divinities) and pear-shaped yonis, representing male and female energy respectively, on either side of a central register with wreath-bearing *kirti-mukhas* (faces of glory). Emerging from the tip is the head of a makara (a water monster) spewing a vegetal or watery form from its mouth and trunk; a *yali* (elephant-lion monster) strides across its head.

The conch shell is considered an attribute of the Hindu god Vishnu, Lord of the Waters, but the three figures on the upper edge associate this instrument with Shiva and forces of renewal: a conjoined yoni-lingam (representing the deity and male-female energy); Ganesh, the elephant-headed son of Shiva; and Nandi, a white bull who serves as Shiva's vehicle. The instrument, sounded to attract Shiva's attention, perhaps to aid fertility, rests on a tripod representing a *mukhalingam* (face lingam), with hooved feet and a tail engraved with a face.

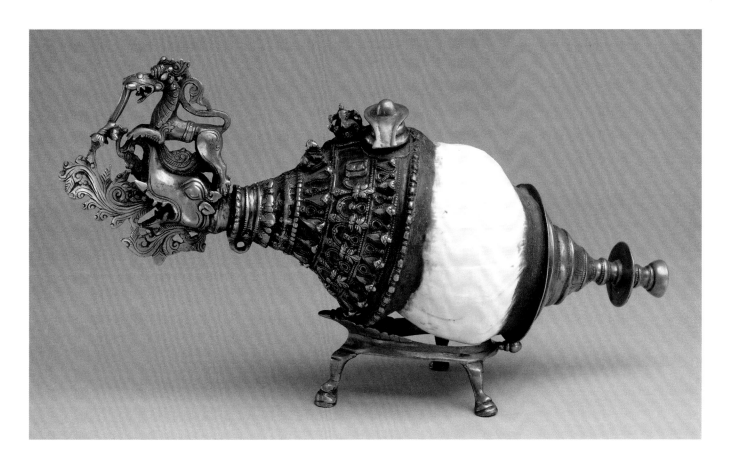

Mandolin

Angelo Mannello (1858–1922)
New York, ca. 1900
Spruce top, maple back, tortoiseshell, ivory,
mother-of-pearl, nickel silver, gold-plated brass,
and metal strings, L. 24⅝ in. (62.5 cm)
Gift of the family of Angelo Mannello, 1972
(1972.111.2a, b)

Mandolin

Angelo Mannello (1858–1922)
New York, ca. 1900
Spruce top, tortoiseshell veneer, ivory and mother-
of-pearl inlay, nickel silver, silver, and metal
strings, L. 24⅝ in. (62.4 cm)
Gift of the family of Angelo Mannello, 1972
(1972.111.1a–c)

The bowlback mandolin, developed in Naples in the late eighteenth century, became a symbol of that city and a familiar instrument used in both popular and classical music. Its distinctive shape made it a favorite of artists, including Pablo Picasso, who often depicted it in Cubist still lifes, such as the image at right.

In the 1880s a craze for the Neapolitan bowlback mandolin swept the United States. With four double courses of strings that are tuned like a violin's and frets like those on a guitar's fingerboard, the instrument was relatively easy for amateur musicians with some training to pick up. Playing in orchestras of mandolins of different sizes was a social activity.

New York City was home to a large number of immigrant mandolin makers whose workshops supplied instruments across the country. One of the most important makers was Angelo Mannello, originally from the town of Morcone, northeast of Naples; he set up a workshop in New York soon after arriving from Italy in 1885. He is best known for his richly decorated mandolins, which were exhibited at events such as Chicago's 1893 World's Columbian Exposition and the Saint Louis World's Fair in 1904. The two extraordinary examples shown here are his most highly decorated masterpieces. The more ornate of the two has a bowl completely covered with ivory and tortoiseshell inlay, the highlight of which is a female nude suspended in vines that creep up the back.

At the height of his manufacturing, Mannello employed seventy-five people at his factory in the Bronx and provided thousands of instruments to distributors, such as C. Bruno & Son, who often sold the instruments under their own names. The 1895 Bruno catalogue lists twenty-seven models of bowlback mandolins, probably supplied by Mannello, ranging in price from $7 to $150. None of them, though, was as exquisitely decorated as these examples.

Pablo Picasso (Spanish, 1881–1973). *Mandolin, Fruit Bowl, and Plaster Arm*, 1925. Oil on canvas, 38½ x 51½ in. (97.8 x 130.8 cm). Bequest of Florene M. Schoenborn, 1995 (1996.403.2)

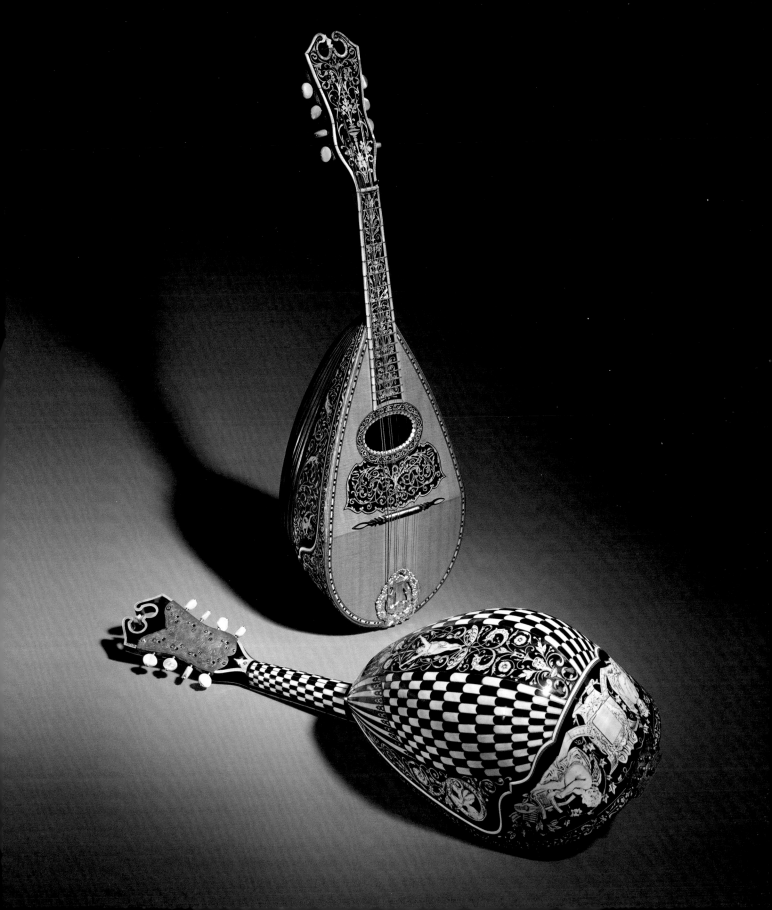

Sanxian (Fretless Lute)

China, ca. 1900
Rosewood, ivory, mother-of-pearl inlay,
snakeskin belly and back, and gut strings,
L. 32⅜ in. (82.2 cm)
Gift of Estate of Mrs. Alexander Glass, 1944
(44.51.1)

The sanxian is a long-necked three-stringed plucked lute with a resonant snakeskin-covered body and a sound-modifying metal rattle inside. Popular in China, it accompanies narrative song and traditional opera and serves as a support instrument in both secular ensembles and Buddhist ritual. It appeared during the Yuan dynasty (1279–1368) and probably derives from similar Central Asian lutes. By the fifteenth century it had disseminated to the Ryukyu Islands, where it was known as the jamisen, then to the Japanese port of Sakai, where it became the shamisen.

The sanxian varies in size from region to region; this small one is typical of the southern type that emerged during the Southern Song dynasty (1127–1279). Its rosewood neck and body are decorated with floral mother-of-pearl designs. A carved bat (a symbol of good luck) perches atop the finial's carved, inlaid ovoid plaque; another bat secures the strings at the base; and a capotasto, a device for changing the pitch of the strings, here carved in the form of a rose, rides the neck.

Pedal Harp

Lyon & Healy
Chicago, 1929
Spruce soundboard, gilded wood, and iron,
H. 74 ¼ In. (188.5 cm)
Bequest of Mildred Dilling Parker, 1982 (1983.346)

Often billed as the "First Lady of the Harp," Mildred Dilling was one of the greatest classical harpists of the twentieth century. She was famous for her NBC Radio program of harp music that was broadcast Sunday nights preceding performances by the New York Philharmonic. Dilling regularly appeared on celebrity radio programs, including some with Bing Crosby; toured extensively; and became Harpo Marx's teacher. She performed for five American presidents, beginning with Warren G. Harding.

Dilling owned this beautiful harp, which was built in 1929 by Lyon & Healy as a top-of-the-line instrument in the Art Nouveau style. Carved floral designs decorate the column, which is designed to look as if it grows out of the pedestal; hand-painted flowers cover the soundboard; and four colors of gold leaf and shadings embellish the instrument. The harp's original owner was Evangeline Booth, the fourth (and first female) general of the Salvation Army, from whom Dilling purchased it directly. Dilling had a large collection of harps, numbering more than sixty-five at her death. She used this one in her home, as it was too fine to risk transporting to performances, and appeared with it in some advertisements.

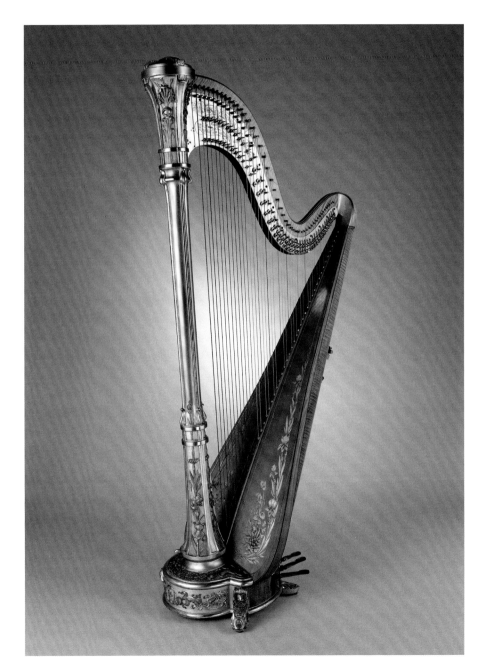

Kerar (Lyre)

Ethiopia or Sudan, early to mid-20th century
Wood, beads, shells, fiber, metal, and skin belly,
H. 33½ in. (85.1 cm)
Purchase, Amati Gifts, 2008 (2008.54)

The lyre is an ancient instrument, its shape readily familiar from numerous depictions on Greek vases, like the one pictured here. The instrument spread from Mesopotamia throughout the Middle East and parts of East Africa, where we find the kerar. Its strings fan out from a ring string holder, following the configuration of the bead-covered arms. The dense beadwork, cowry shells, small bells, and pouches that adorn this example are typical decorations for this instrument in Ethiopia, Sudan, and across the Persian Gulf. In Ethiopia the kerar is played by an *azmari*, a traditional singer who entertains at weddings, birthdays, and other family parties as well as at popular drinking establishments, extemporizing love songs and historical epics, much like a bard or griot.

Lyres appear in diverse forms, which give clues to their origin. Some, like this example, have V-shaped arms and strings, while others have vertical arms with parallel stings. Ancient Roman examples often had a boxlike string holder and pegs attaching strings to the supporting yoke above. Lyre players in most cultures and periods used a plectrum to pluck the strings and used the left hand to dampen the strings from the instrument's back.

Attributed to the Berlin Painter. Terracotta amphora, Greek, Attic, Late Archaic period, ca. 490 B.C. Terracotta, H. 16⅜ in. (41.5 cm). Fletcher Fund, 1956 (56.171.38)

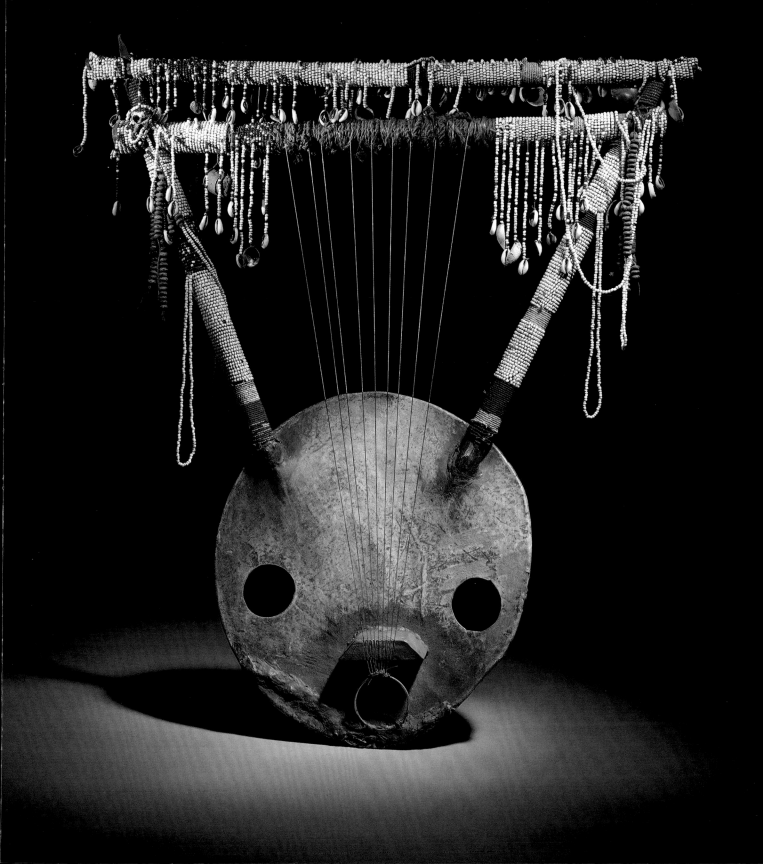

Pair of Clarinets in B-flat and A

William S. Haynes Company
Boston, 1930
Silver, L. 25 in. (63.5 cm)
Purchase, Robert Alonzo Lehman Bequest,
2012 (2012.571.1, .2)

Unlike most members of the orchestra, clarinet players usually have a pair of instruments at hand to tackle the concert repertoire. That is because the clarinet's complicated key system is easiest to operate when the key in which the instrument is built is the same as or close to the key of the music being played. The B-flat clarinet is better suited to music in flat keys, while music in sharp keys lies best under the hands on the A clarinet. Over the course of a typical concert, clarinetists must quickly switch back and forth between instruments—which can be a problem for tuning, because the clarinet's pitch does not stabilize until the instrument has been warmed up by playing.

The William S. Haynes Company addressed that challenge with its innovative and proprietary thermoclarinets, produced from 1926 to 1942, of which this pair is an example. Like the flutes for which Haynes is famed, they are made of fine silver. Their double-wall construction features a set of vents that enabled the player to exhale warm air into the cavity between the inner and outer walls, quickly and silently bringing the instrument to a uniform temperature along its whole length.

Despite its inspired design and high-quality workmanship, the thermoclarinet failed to achieve lasting favor among conservative orchestral musicians and few were produced. Players may have been deterred by the metal body, unfairly associating it with poorly made metal band instruments. The double-wall metal construction also makes these clarinets heavier to hold than typical examples. The preferred material for professional-level clarinets remains tropical hardwoods, but their dwindling supplies may reignite the search for new materials and innovative design ideas for the clarinet.

Euphonium

C. G. Conn Ltd.
Elkhart, Indiana, 1936
Silver and gold-washed silver, H. 31½ in. (80 cm)
Purchase, Werner Kramarsky Gift, 1989 (1989.322)

During the heyday of concert bands in America, in the late nineteenth and early twentieth centuries, ensembles fiercely competed for audiences and strove to outshine their rivals. The double-bell euphonium, which offered both sonic and visual novelty, first appeared in Patrick Gilmore's acclaimed band in 1888 and shortly thereafter was adopted by John Philip Sousa's band. Other bands across the United States soon followed suit.

The instrument's fifth valve enables the performer to alternate between the large bell, with a typically mellow euphonium sound, and the small bell, which produces a brighter sound akin to that of a baritone horn or valve trombone. The player can switch between the two bells instantaneously, creating echo and call-and-response effects. This design was popular with soloists, but most players employed only the large bell, so that the small bell merely added excess weight. Production of the instrument tapered off in the 1960s.

C. G. Conn was noted for its lavishly engraved brass instruments during the late nineteenth and early twentieth centuries, and Julius Stenberg was the company's most celebrated engraver. This double-bell euphonium, among the most intricate examples of his work, was a gift for his son. The decoration includes patriotic motifs, portraits of famous composers, depictions of women, and whimsical references to local places and traditions in Elkhart, Indiana, where the company was based. Stenberg is estimated to have taken more than two hundred hours to engrave this instrument.

Guitar

Hermann Hauser (1882–1952)
Germany, Munich, 1937
Spruce top, rosewood back and sides, and nylon strings, L. 38½ in. (97.7 cm)
Gift of Emilita Segovia, Marquessa of Salobreña, 1986 (1986.353.1)

In 1924 the German luthier Hermann Hauser met the famed classical guitarist Andrés Segovia and asked if he could examine his guitar from the workshop of José Ramírez. Hauser was interested in studying Spanish guitars and building instruments on the same model. According to oral history passed down by Segovia, Hauser then built a series of guitars that he shared with Segovia for advice. In 1937 he gave this instrument to Segovia and changed music history. The maestro immediately fell in love with the guitar's tone and would later write that it was the "greatest guitar of our epoch."

From 1937 until 1962, when it was damaged in an accident in a recording studio, this was Segovia's main guitar. Featured in nearly all of his performances and recordings, it came to define the sound of the classical guitar. Segovia worked tirelessly to establish the guitar as an instrument of classical music and built a repertoire that included nineteenth-century guitar literature, transcriptions of lute music, and new commissions from living composers.

Kora (Harp)

Mamadou Kouyaté (died 1991)
Senegal, mid-20th century
Gourd, goatskin, antelope hide, metal,
upholstery tacks, wood, and nylon strings,
L. 45 ⅝ in. (115.8 cm)
Rogers Fund, 1975 (1975.59)

Since its invention, probably in sixteenth-century Senegal, the kora has been used by professional bards called *jalis*, or griots. The plucked instrument's harplike sound accompanies the *jali*'s song—praise for patrons, histories and genealogies, satire, political commentary, and poetic recitation. The kora eventually spread to Guinea, Guinea-Bissau, Mali, the Gambia, and Burkina Faso, each of which fashioned its own myths about the instrument's origin, usually involving the theft of the kora or the help of jinns. Made from a large skin-covered calabash and pierced with a rosewood neck, its nylon (formerly antelope hide) strings rise vertically from its belly by means of a special bridge that has notches on each side, creating two columns of strings, with ten of varied thicknesses on the right and eleven on the left. Each attaches to an antelope-hide tuning ring on the neck. Today the hide tuning rings may be replaced by pegs or machine heads (geared tuning pegs) like those found on guitars.

Holding the kora upright, the player grasps the short handles on either side of the neck and plucks the strings with the thumb and forefingers, alternating sides to produce a scale. Modern adaptations and amplification have transformed the kora's traditional role, and today it is also used in pop recordings.

This kora, with its signature spiral handles and decorative patterns of upholstery tacking on the body, was made by Mamadou Kouyaté, the chief musician under Senegal's president Léopold Sédar Senghor (ruled 1960–80). The bridge was made by his nephew, Djimo Kouyaté.

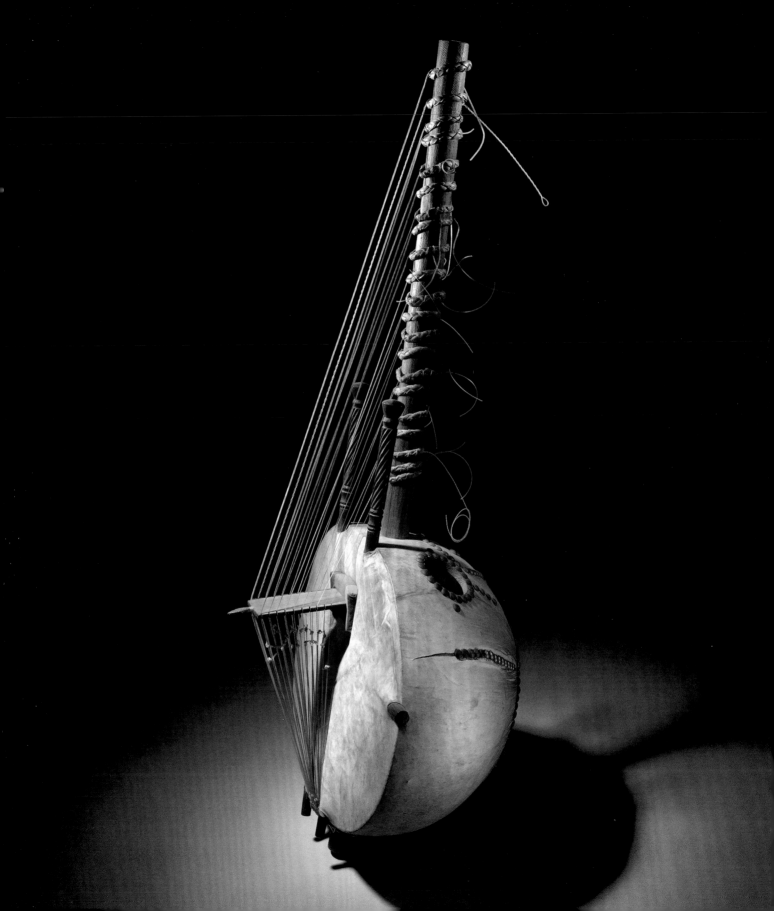

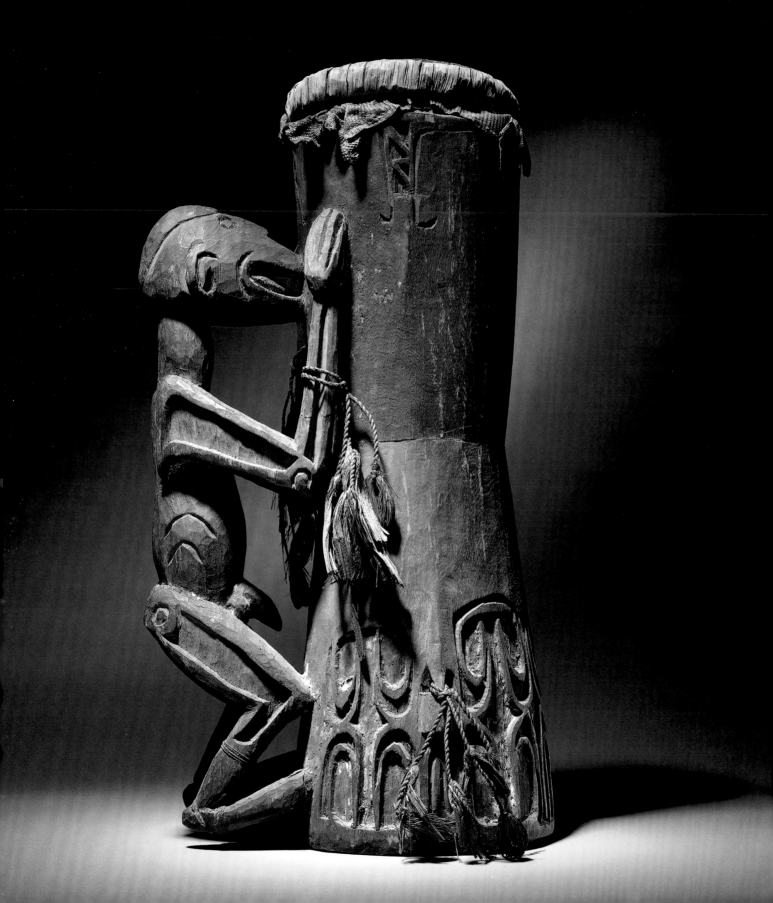

Drum

Omas (active mid-20th century)
New Guinea, Papua Province, Pomatsj River
region, Sauwa Village, mid-20th century
Wood, lizard-skin head, beeswax, sago palm
leaves, fiber, and paint, H. 22¾ in. (57.8 cm)
The Michael C. Rockefeller Memorial Collection,
Gift of Nelson A. Rockefeller and Mrs. Mary C.
Rockefeller, 1965 (1978.412.962)

Hourglass-shaped drums identify specific groups of indigenous peoples in New Guinea, including the Asmat. Asmat drums have distinctively carved handles, customary positioning and contouring of the waist, and a traditional method of attaching the lizard-skin head (with an adhesive mixture of lime juice and human blood). These portable instruments appear in lengthy performances at ceremonies, men's gatherings, or feasts (as shown in the photo of a different New Guinean group, below). Women occasionally play them, but they accompany singing and dancing that are done chiefly by men.

Drums play a significant part in the Asmat creation myth, which tells that a primordial being named Fumeripits carved human figures of wood to assuage his loneliness. He then made a drum, and his playing animated the figures, who became the first Asmat people. The Asmat consider Fumeripits the first wood-carver and, prizing the craft, honor their ancestors with elaborate and stylized depictions in wood.

This drum, made by the Asmat master carver Omas, depicts a man named Pam, possibly the father of the person who commissioned it. The figure has the beak of a black king cockatoo, which was metaphorically associated with the Asmat's headhunting practices, discontinued in the mid-twentieth century.

Male Dancers with Drums (detail). Papua New Guinea, probably northeastern Papua, before 1955. Gelatin silver print, overall approximately 3 x 5 in. (7.6 x 12.7 cm). Funds from various donors, 1992 (1992.417.1088)

Atingting Kon (Slit Drum)

Tin Mweleun (active 1960s)
Vanuatu, Ambrym Island, mid- to late 1960s
Wood and paint, H. 14 ft. 7¼ in. (445.1 cm)
Rogers Fund, 1975 (1975.93)

In Ambrym and Malakula, islands in the South Pacific archipelago of Vanuatu, veritable groves of monumental slit drums, carved from the trunks of breadfruit trees, stand along the edges of the village dance grounds. Each is decorated with an ancestral head featuring enormous, peering eyes. These impressive instruments are played in ensembles, providing complex and varied rhythms for initiations, dances, funerals, and other secular and ritual events, including the *ha huqe*, a ceremony celebrating a man's rising social status. The honoree typically commissions the drums to acknowledge his accumulation of wealth, which is measured in pigs.

Acoustically, the drums are bells that generate sound by vibrating at their edges—in this case, the slits. The player stands before the instrument, coaxing out its voice by striking near the slit with a cylindrical wood beater. Large and small slit drums are found in Asia, Africa, Oceania, and the Americas. Large ones like this towering example can be heard for miles. (The drum's monumental scale can be gauged by the photo of it within the Museum's galleries, below.) In Oceania vertical or upright drums may be associated with patrilineal kinship systems, while horizontal ones that lie on the ground may be associated with the matrilineal.

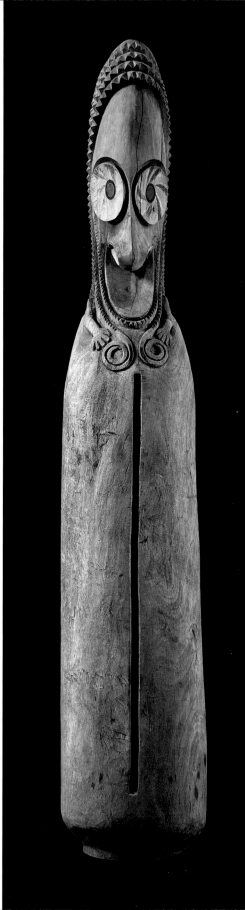

Archtop Guitar

James D'Aquisto (1935–1995)
Greenport, New York, 1993
Spruce top, maple back and sides, macassar
ebony, and steel strings, W. 17 in. (43.2 cm)
Gift of Steve Miller, 2012 (2012.246)

The archtop guitar has a carved convex top and back, a bridge that is held in place by the pressure of the strings, and a tailpiece, features that are taken from the violin. The construction gives the instrument a powerful tone, with a particular percussive punch that gained favor with guitarists playing rhythmic accompaniment in big-band orchestras of the 1930s. In the 1950s and 1960s guitarists used the archtop guitar—with an electrical pickup—as a lead instrument in small ensembles and explored its tonal capabilities across many styles, including bebop and cool jazz.

One of the most famous of all archtop guitar makers was the Brooklyn-born James D'Aquisto. As a teenager he began working as an assistant in luthier John D'Angelico's workshop in Little Italy, on the Lower East Side of Manhattan. He gradually learned every detail of guitar building from the master craftsman and, after D'Angelico died in 1964, began building his own instruments. D'Aquisto built this magnificent guitar during the final period of his life, when he created a remarkable series of guitars that represented a radical departure from traditional acoustic guitar design. He favored natural materials rather than metal or plastic and used macassar ebony for the tailpiece, bridge, and pick guard of this guitar. Instead of the usual Art Deco motifs, he drew upon modern design for his sound hole and headstock and used an expanded palette of finish colors. His only decorative elements are the asymmetrical inlaid lines of lighter-colored wood in the tailpiece, headstock, and pick guard. This guitar was purchased by D'Aquisto's friend the rock-and-roll musician Steve Miller.

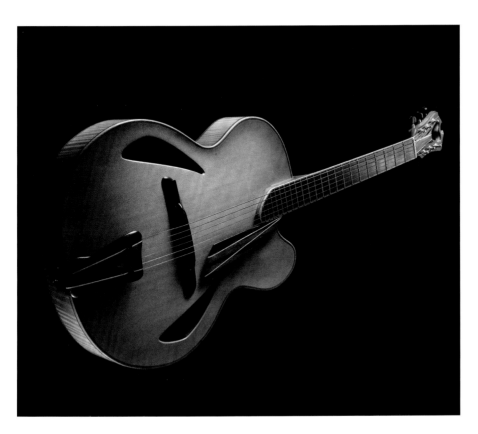

Sitar

Murari Adhikari (1934–2006)
India, Kolkata (Calcutta), 1997
Teak with ebony and bone inlay, metal frets, and
metal strings, L. 49 in. (124.5 cm)
Gift of Steven Landsberg, 1999 (1999.399)

Family dynasties of musical instrument makers, which pass techniques, tools, and secrets from one generation to the next, are still found throughout the world, although they are less common today. The maker of this 1997 sitar, Murari Adhikari, comes from such a tradition. In 1882 Murari's grandfather established Damodar and Sons in Kolkata's Barabazar neighborhood, home to other musical instrument makers and shopkeepers; poets like Rabindranath Tagore; and musicians like Maharaja Sourindro Mohun Tagore, a musicologist who donated instruments to many museums, including The Metropolitan Museum of Art. In 1910 Damodar passed the workshop to his son Kanailal, who renamed it Kanailal and Brother. Kanailal's brother, Nityananda, set standards for the modern sitar. He added elaborate engraving and carving, rounded frets, and a concave neck; changed the bridge design; and made other adjustments that produced an even tone from high to low. Such changes gave musicians more flexibility in playing and enabled them to be more expressive. Nityananda's son, Murari, the last member of the dynasty, followed his father into business, continuing the sitar-making tradition and contributing significant changes to the design of another plucked stringed instrument, the rudra veena (tube zither).

Despite Murari's success and distinguished clientele, including great Indian musicians such as Ravi Shankar, his instruments were superseded by others that were adapted for amplification and microphones used in the recording industry. The shop closed in 1995, but he continued to make instruments like this one, for the musician Steven Landsberg, on demand.

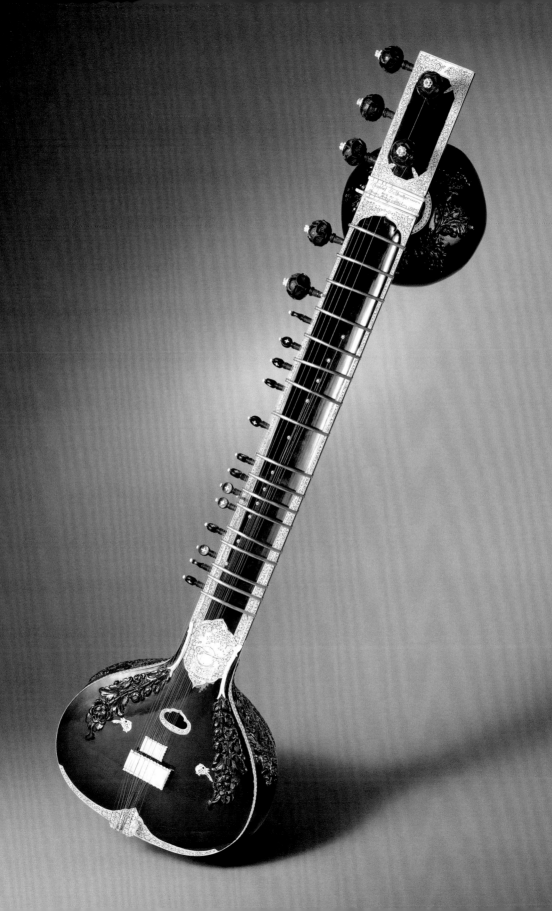

About the Musical Instruments Collection

The oldest comprehensive assemblage of instruments in the United States, The Metropolitan Museum of Art's collection has for more than 125 years set international standards for quality, diversity, and interpretive innovation. Its instruments were selected for tonal and visual beauty, for technical and social importance, and as expressions of the musical and aesthetic tastes of diverse peoples from around the globe. Although there are museums dedicated to musical instruments and collections of instruments in art museums, natural history museums, and universities throughout the world, many have a limited purview; they may specialize in specific periods, instrument types, and regions or be working collections that are lent out to students and other players. The Met's strength lies in its encyclopedic approach. Its collection includes more than five thousand musical instruments, dating from about 2300 B.C. to the present and ranging from ancient Anatolian cymbals, Egyptian harps, and Chinese lutes to rare violins, modern guitars, and the earliest existing piano. The breadth and depth of its collection, augmented by the Museum's rich and extensive musical iconography, make it unrivaled.

The Museum's leaders and donors welcomed instruments to the collection as early as 1878, just eight years after the Museum's founding. While the Museum's focus was the visual arts, the early interest in instruments is not surprising, as several of the founders were associated with the New York Philharmonic Society, including Allen T. Dodworth and Joseph W. Drexel, an instrument collector. Others who were closely involved with the Museum also promoted and appreciated music, including patrons like John Pierpont Morgan, a founding subscriber of the Metropolitan Opera, and Waldo Seldon Pratt, assistant to the Museum's president and a contributor to and editor of the *Grove Dictionary of Music and Musicians*. A musical collection reflected a belief in the correlations among the arts and a recognition of instruments not only as educational and historically significant objects but as works of art in their own right.

Between 1889 and 1911 the Museum accessioned nearly four thousand instruments from around the world, with gifts from Drexel but primarily from Mary Elizabeth Adams Brown, the wife of a merchant banker. Long before widespread awareness and appreciation of art outside the Western canon, she sought to preserve fading and now rare non-Western traditions; at that time, only a few European institutions collected as broadly and systematically. Brown concentrated on building the collection one geographical location at a time and did so by corresponding with missionaries, American consulates, explorers, anthropologists, musicologists, shipping agents, and dealers in art and ethnography. Most of her acquisitions were contemporary. To this day the largest groupings are from the nineteenth century, mirroring the collecting history, although the collection also includes instruments that were found at archaeological sites. And while the collection represents some of the most important achievements in Western traditional and art music—particular strengths include European and American keyboards and wind instruments from the late seventeenth through the nineteenth century—two-thirds of it is from other cultures, the result of Brown's comprehensive collecting priorities.

Glossary

This brief list of terms elucidates some specialized vocabulary as used in this book. For more comprehensive consideration of terminology relating to instruments and music, consult the *Grove Dictionary of Musical Instruments* and other sources listed in Suggested Readings.

Words appearing in *italic* type are defined elsewhere in the glossary.

ACCIDENTALS: on a musical keyboard, the smaller, shorter *keys* that are raised and recessed from the *naturals*. Corresponding to the black keys on a modern keyboard, they are typically a half step above or below the associated natural keys. Not to be confused with symbols used in musical notation that indicate raising or lowering a musical *pitch*.

BELLY: a skin or wood covering on the resonating body of some *stringed instruments*. Synonymous with *soundboard* and *top*.

BOCAL: a curved tube that connects a *reed* or mouthpiece to the main body of some *woodwind* instruments.

BRASS or **BRASSWIND:** a category of Western *wind instruments* whose sound is produced by the buzzing of a player's lips against a cupped mouthpiece attached to a tube. (See *lip-vibrated instruments*.) Instruments in the family include trumpets and horns. They are commonly made of brass, but other materials may be used, including wood, ivory, and various metals. For other families of instruments, see *flute, keyboard instrument, percussion, reed,* and *stringed instrument*.

BRIDGE: the support on the body of a *stringed instrument* that guides the strings and transfers their vibrations to the *soundboard*. The *nut* and bridge together define the string's *sounding length*.

CHROMATIC SCALE: a scale that divides an octave into twelve relatively equally spaced *pitches*, exemplified by the twelve notes in an octave on a keyboard.

CONSORT: a Renaissance and Baroque term for an ensemble of musical instruments. A whole consort is made up of instruments from one family, such as recorders or viols. A broken consort consists of instruments from different families.

CONTINUO: an instrument or group of instruments that provides the bass line and harmonic structure played continuously underneath solo lines in Baroque music. Continuo instruments include the harpsichord, lute, and viol.

DOUBLE REED: See *reed*.

FERRULE: a band that reinforces and protects the areas where sections of a *wind instrument* are joined together. Ferrules are sometimes decorated with engraving and stamping and can be made from a variety of materials, including metal, ivory, and horn.

FINGERBOARD: the part on the neck of a *stringed instrument* where the player presses the strings, shortening their length to change the *pitch*.

FLUTE: a type of *wind instrument* in the form of a tube or vessel that is punctured by at least two holes. Flutes do not use *reeds*. To produce sound, the player's breath is directed against an edge: either across the tube's end or a side hole (as for Western orchestral flutes) or through a mouthpiece (as for recorders, whistles, and vessel flutes). This creates sound by splitting the airstream and setting it into vibration. For other families of instruments, see *keyboard instrument*, *lip-vibrated instrument*, *percussion*, *reed*, and *stringed instrument*.

FREE REED: See *reed*.

FRET: a raised element on the *fingerboard* of some *stringed instruments*. Pressing a string against a fret divides the string into fixed segments, establishing the positions for the desired notes. Frets can be movable, made of gut or cord tied around the instrument's neck, or fixed in place, made of metal or other materials.

HARMONIC SERIES: a series of *pitches* comprising the fundamental tone and its acoustically dictated overtones, or secondary higher pitches. Portions of a vibrating entity (such as a string or a column of air) vibrate at different rates, producing overtones that are related to and contribute to the sound of the fundamental tone. The harmonic series features strongly in the playing technique of *lip-vibrated* and *stringed instruments*. Players of lip-vibrated instruments can produce pitches in the harmonic series without *keys* or *valves* by changing the speed at which their lips vibrate.

HEADSTOCK: the part of the guitar or other *stringed instrument* that secures the strings and, in many cases, where tension may be adjusted to tune the strings.

KEY (instrument): the lever pressed down to produce a specific *pitch*. Most common on *wind* and *keyboard instruments*, keys are also found on some *brass* and *percussion* instruments. On wind instruments, keys are used to

open and close *tone holes*, changing the *sounding length*. (Closing holes lengthens the column of air, lowering the pitch.) On keyboard instruments like the piano, depressing a key activates a hammer that strikes a string.

KEY (music): in Western music, the specific *pitch* that a musical piece or section of a piece prioritizes as its tonic, or "home" pitch. Also, the home pitch in which an instrument is built.

KEYBOARD INSTRUMENT: one of the musical instruments played using a keyboard, each of which also can be classified in other families. Keyboard *wind instruments* like the organ and regal produce sound by driving air through pipes. Keyboard *stringed instruments* produce sound either by plucking strings, like the harpsichord, or by striking strings, like the piano and clavichord, which also can be categorized as *percussion* instruments. For other families of instruments, see *flute, lip-vibrated instrument*, and *reed*.

LIP-VIBRATED INSTRUMENT: a *wind instrument* whose sound is produced by the player's lip vibration when blowing into a mouthpiece. The family includes instruments made of animal horn and conch shells, pottery trumpets, and Western *brass* instruments. For other families of instruments, see *flute, keyboard instrument, percussion, reed*, and *stringed instrument*.

NATURAL (instrument): a type of horn, trumpet, or other *lip-vibrated instrument* that does not have any *keys, valves*, slides, or holes that alter the *sounding length* and thus change the *pitch*. The only pitches available to the player are those of the *harmonic series*, which can be played by changing the shape, tension, and vibration of the lips and manipulating the air flow.

NATURALS: on a musical keyboard, the larger, longer *keys* (as opposed to the raised, shorter *accidentals*). They correspond to the white keys on the modern keyboard.

NUT: on a *stringed instrument*, a piece of hard material that supports the strings at the opposite end from the *bridge*. The nut and bridge together delineate each string's *sounding length*.

PEG: the part of a *stringed instrument* around which the string terminates and is wrapped. The peg usually is inserted in a hole in the *headstock* or *pegbox*. The peg may be tightened or loosened to tune the instrument.

PEGBOX: the part on some *stringed instruments* that houses the tuning *pegs*; it often has a carved scroll or figural head.

PERCUSSION: a family of musical instruments that are sounded by being struck, scraped, shaken, or rubbed by hand or by a beater. It includes drums, rattles, cymbals, and tambourines. For other families of instruments, see *flute, keyboard instrument, lip-vibrated instrument, reed*, and *stringed instrument*.

PICK GUARD: a piece of wood, plastic, or other material that rests on the *belly* of some plucked *stringed instruments* to protect them from being scratched while the player strums the strings.

PITCH: a term that refers to the perceived highness or lowness of notes, determined by the frequency of the vibration of the sound waves that produce it. It can also refer to the frequency to which an instrument is tuned.

PLECTRUM: a pick or flat tool held in the hand and used to pluck or strum strings.

REED: a thin strip of cane or metal that vibrates to produce a sound on some *wind instruments*. *Single-reed* instruments (including the clarinet and saxophone) produce sound when air is blown across a single piece of reed cane, which vibrates against a mouthpiece. *Double-reed* instruments (including the oboe, bassoon, shawm, and some bagpipes) produce sound when air vibrates two pieces of reed cane, which vibrate against each other. *Free reed* instruments (including the sheng, shō, harmonica, accordion, and symphonium) produce sound when air is blown through a reed that is affixed to a plate at one end, allowing the other end to vibrate freely within a slot on the plate. For other families of instruments, see *flute, keyboard*

instrument, lip-vibrated instrument, percussion, and *stringed instrument.*

REGISTER: the different ranges of notes produced by an instrument or voice.

RESONATOR: a part of a musical instrument, often the body and the *soundboard,* that amplifies the sound produced by a string, skin, or air column.

RIBS: on violins, viols, and guitars, the strips of wood that constitute the sides.

ROSE: a decoration of wood or parchment in the *sound holes* of some *stringed instruments.*

SINGLE REED: See *reed.*

SOUNDBOARD: on *stringed instruments,* including harps, pianos, and harpsichords, the resonant surface that receives vibrations from the string through the *bridge* and helps amplify the volume of the sound through its own vibrations. See *belly* and *top.*

SOUND HOLE: an opening in the body of a *stringed instrument* that equalizes internal and external air pressure. Sound holes are made in a wide variety of shapes and sizes, which modify the instrument's voice with varying effect.

SOUNDING LENGTH: for *wind instruments,* a measurement of the column of air at the instrument's longest point. For *stringed instruments,* the vibrating length of the string as determined by

the distance between the *nut* and the *bridge.* The longer the column of air or the string, the lower the *pitch.*

STRINGED INSTRUMENT: a musical instrument that produces sound from vibrating strings that may be plucked or bowed. The string family includes lutes, pipas, violins, harps, banjos, and some *keyboard instruments.* For other families of instruments, see *flute, lip-vibrated instrument, percussion,* and *reed.*

SYMPATHETIC STRINGS: strings that typically are not played directly but are excited into vibration by bowed or plucked strings, ringing "in sympathy" with them.

TAILPIECE: the part on many *stringed instruments* that anchors the strings at the bottom of the body.

TONE HOLE: an opening on the body of a *wind instrument* that is covered with a finger or a *key* to produce different notes. Tone holes can be used singly or in combination.

TOP: on many *stringed instruments,* especially violins and guitars, the wooden *soundboard* that receives and amplifies vibrations from the *bridge.* Used interchangeably with *belly* and *soundboard.*

TUNING RINGS: on some *stringed instruments,* rings used instead of *pegs* or tuners to secure the string to the neck. Pushing a ring up or down the neck or rotating it changes the tension

on the string and thus changes the *pitch.*

VALVE: a mechanical device on *brass* instruments that quickly and temporarily opens an airway into sections of auxiliary tubing built into the instrument, changing its *sounding length* and thus its *pitch.*

WAIST (adj. waisted): a narrowing at the center of the body of an instrument, usually a *stringed instrument* or drum.

WIND INSTRUMENT: a musical instrument that produces sound when air is blown into it by a player's lungs or by a bellows. Wind instruments include *flutes, lip-vibrated instruments, reeds,* and some *keyboard instruments.*

WOODWIND: a category of Western *wind instrument* that includes *flutes,* recorders, whistles, and *reeds.* Woodwinds may be made of wood or other materials, including metal, ivory, bone, and ceramic. For other families of instruments, see *keyboard instrument, lip-vibrated instrument, percussion,* and *stringed instrument.*

Suggested Readings

The following titles provide an overview of musical instruments and music making or feature instruments from The Metropolitan Museum of Art's collections. The list, prepared with the general reader in mind, includes only accessible publications and favors works in English; the one foreign-language title, which translates as *Music History in Pictures*, contains primarily illustrations and is the definitive publication of its type. Note that some areas of the subject are better published than others.

For additional information about individual instruments in this book, the reader is encouraged to consult the Museum's online catalogue at www.metmuseum.org and look up an object to find related publications, such as journal articles. For further reading, detailed bibliographies relating to specific instruments can be found at the end of the articles in the *Grove Dictionary of Musical Instruments*.

Ardley, Neil. *Music*. New York: Knopf, 1989.

Ausoni, Alberto. *Music in Art*. Translated by Stephen Sartarelli. Los Angeles: J. Paul Getty Museum, 2009.

Baines, Anthony. *Brass Instruments: Their History and Development*. 1976. Reprint, Mineola, N.Y.: Dover, 2012.

———. *Woodwind Instruments and Their History*, 3rd ed. 1967. Reprint, Mineola, N.Y.: Dover, 2012.

Besseler, Heinrich, and Max Schneider, eds. *Musikgeschichte in Bildern*. 4 vols. 1961. Reprint, Leipzig: Deutscher Verlag für Musik, 1989.

Bhattacharya, Dilip. *Musical Instruments of Tribal India*. New Delhi: Manas, 1999.

Brincard, Marie Thérèse, ed. *Sounding Forms: African Musical Instruments*. New York: American Federation of Arts, 1989.

Burgess, Geoffrey, and Bruce Haynes. *The Oboe*. New Haven: Yale University Press, 2004.

Campbell, Murray, Clive Greated, and Arnold Myers. *Musical Instruments: History, Technology, and Performance of Instruments of Western Music*. Oxford: Oxford University Press, 2004.

Cole, Michael. *The Pianoforte in the Classical Era*. Oxford: Clarendon Press, 1998.

Cook, Nicholas. *Music: A Very Short Introduction*. Oxford: Oxford University Press, 1998.

Dagan, Esther A., ed. *Drums: The Heartbeat of Africa*. Montreal: Galerie Amrad African Art, 1993.

DjeDje, Jacqueline Cogdell, ed. *Turn Up the Volume! A Celebration of African Music*. Los Angeles: UCLA Fowler Museum of Cultural History, 1999.

Dobney, Jayson Kerr. *Guitar Heroes: Legendary Craftsmen from Italy to New York*. New York: The Metropolitan Museum of Art, 2011.

Douglas, Gavin. *Music in Mainland Southeast Asia: Experiencing Music, Expressing Culture*. New York: Oxford University Press, 2010.

Fischer, Hans. *Sound-Producing Instruments in Oceania: Construction and Playing Technique—Distribution and Function*. Edited by Don Niles. Translated by Philip W. Holzknecht. Papua New Guinea: Institute of Papua New Guinea Studies, 1983.

Gill, Dominic, ed. *The Book of the Piano*. Ithaca, N.Y.: Cornell University Press, 1981.

Grunfeld, Frederic V. *The Art and Times of the Guitar: An Illustrated History of Guitars and Guitarists*. New York: Macmillan, 1969.

Heyde, Herbert. "The Brass Instrument Collection of the Metropolitan Museum in New York." *Historic Brass Society Journal* 11 (1999).

Hoeprich, Eric. *The Clarinet*. New Haven: Yale University Press, 2008.

Kopp, James B. *The Bassoon*. New Haven: Yale University Press, 2012.

Lee, Yuan-Yuan, and Sin-Yan Shen. *Chinese Musical Instruments*. Chicago: Chinese Music Society of North America, 1999.

Libin, Laurence. *American Musical Instruments in the Metropolitan Museum of Art*. New York: The Metropolitan Museum of Art, 1985.

———, ed. *The Grove Dictionary of Musical Instruments*, 2nd ed. 5 vols. New York: Oxford University Press, 2014.

———. "Keyboard Instruments." *The Metropolitan Museum of Art Bulletin* 47, no. 1 (Summer 1989).

Malm, William P. *Traditional Japanese Music and Musical Instruments*. Tokyo: Kodansha International, 2000.

Midgley, Ruth, et al., eds. *Musical Instruments of the World: An Illustrated Encyclopedia*. 1976. Reprint, New York: Sterling, 1997.

Miller, Terry E., and Sean Williams, eds. *Southeast Asia*. Vol. 4 of *The Garland Encyclopedia of World Music*. New York: Garland, 1998.

Miner, Allyn. *Sitar and Sarod in the 18th and 19th Centuries*. Delhi: Motilal Banarsidass, 1997.

Montagu, Jeremy. *Musical Instruments of the Bible*. Lanham, Md.: Scarecrow, 2002.

———. *Origins and Development of Musical Instruments*. Lanham, Md.: Scarecrow, 2007.

———. *Timpani and Percussion*. New Haven: Yale University Press, 2002.

Morley-Pegge, Reginald. *The French Horn: Some Notes on the Evolution of the Instrument and Its Technique*. 1960. Reprint, New York: W. W. Norton, 1973.

Olsen, Dale A., and Daniel E. Sheehy, eds. *South America, Mexico, Central America, and the Caribbean*. Vol. 2 of *The Garland Encyclopedia of World Music*. New York: Garland, 1998.

Ord-Hume, Arthur W. J. G. *The Musical Clock: Musical and Automaton Clocks and Watches*. Ashbourne, U.K.: Mayfield Books, 1995.

Peyser, Joan, ed. *The Orchestra: Origins and Transformations*. New York: Scribner, 1986.

Pollens, Stewart. *The Early Pianoforte*. Cambridge: Cambridge University Press, 2009.

Powell, Ardal. *The Flute*. New Haven: Yale University Press, 2002.

Price, Percival. *Bells and Man*. New York: Oxford University Press, 1983.

Qiang, Xi. *Chinese Music and Musical Instruments*. New York: Better Link Press, 2011.

Rice, Timothy. *Ethnomusicology: A Very Short Introduction*, 3rd ed. New York: Oxford University Press, 2014.

Sachs, Curt. *The History of Musical Instruments*. 1940. Reprint, Mineola, N.Y.: Dover, 2006.

Schoenbaum, David. *The Violin: A Social History of the World's Most Versatile Instrument*. New York: W. W. Norton, 2013.

Shephard, Tim, and Anne Leonard, eds. *The Routledge Companion to Music and Visual Culture*. New York: Routledge, 2014.

Stone, Ruth M., ed. *Africa*. Vol. 1 of *The Garland Encyclopedia of World Music*. New York: Garland, 1998.

Wallace, John, and Alexander McGrattan. *The Trumpet*. New Haven: Yale University Press, 2011.

Winternitz, Emanuel. *Musical Instruments and Their Symbolism in Western Art: Studies in Musical Iconology*, 2nd ed. New Haven: Yale University Press, 1979.

Index

Page numbers in italics refer to illustrations.

accessories
 baton (Germany, Breslau), 154–*55*
 baton (London, Kohler & Son), 154–*55*
 baton (New York, Tiffany & Company), 154–*55*
 lawle, bell mallet (Ivory Coast, Baulé people), 152, *152*
Adhikari, Murari, 178
Akan Ashanti people, 137
Amati, Andrea, 53
Apache culture, 150
Appleton, Thomas, 116
arched harp, 24, *24–25*, 122–23
archlute, 88–*89*
archtop guitar, *4–5*, 177, *177*
Asmat people, 175
atingting kon (slit drum), 176, *176*
Austral Islanders, 146
automata, musical clock (Germany, Samuel Bidermann and Veit Langenbucher), 64, *64–65*

bajón (bass dulcian), 55, *55*
bajoncillo (soprano dulcian), 55, *55*
bala (xylophone), *2–3*, *142–43*
balafon players, sculpture of (Mali, Dogon people), *143*
banjo, *21*, 128, *128*
Barwe people, 144
Bassano family, 62
bassoon, 113, *113*
baton, 154–*55*
Baudouin, C., 115
Baulé people, 152
Baumann, Jean-Jacques, 113
bell. *See* **percussion instruments**
Bellot, Louis, 92
Berlin Painter (attr.), terracotta amphora, *164*
Bidermann, Samuel, 64
bo (bell), 27, *27*
bondjo (side-blown trumpet), 134–*35*
Botnen, Isak Nielsen (Skaar), 94
Boucher, William Esperance Jr., 128
bowed instruments. *See* **stringed instruments**

brass instruments. *See* **wind instruments: lip-vibrated**
bugle, keyed, 132–*33*
Bunsen, Franz Peter, 100

C. G. Conn, *168–69*
Calima culture, 36
Chandler, Daniel H., 132
Chiriqui people, 40
chitarrino, *46–47*, 47
cittern, *74–75*, 75
clappers, 26, *26*
clarinet, 117, *117*, 166, *166–67*
Clark, John, 131
clavichord, 98–99
cog rattle, 45, *45*
cor d'orchestre (orchestral horn), 118–*19*
cor omnitonique (omnitonic horn), 118–*19*
cornett, 56–*57*
Cristofori, Bartolomeo, 86

dadabuan (goblet drum), 147, *147*
D'Aquisto, James, 177
Di Giorgio Martini, Francesco, studiolo from the ducal palace, Gubbio, Italy, *56*
Dilling, Mildred, 163
dizi (transverse flute), 104–5; sculpture of seated musician playing (China), *104*
dombak (goblet drum), 138, *138–39*
domu (harp), *24–25*
dora (gong), 110, *110*
dōtaku (bell), 34, *34*
Drouais, François Hubert, *Portrait of a Woman Said to Be Madame Charles Simon Favart*, *92*
drum. *See* **percussion instruments**
drums, photo of male dancers with (Papua, New Guinea), *175*
Ducreux, Rose Adélaïde, *Self-Portrait with a Harp*, *20*
Dughet, Gaspard, 70, 73

Eakins, Thomas, *Cowboy Singing*, *16*
Edouart, Auguste, *Frank Johnson, Leader of the Brass Band of the 128th Regiment*, *132*

Ekonda people, 134
Érard et Cie, 124
euphonium, *168–69*, 169

Flatebø, Trond Isaksen, 94
flute. *See* **wind instruments**

gong, 110, *110*
Gropper, William, *The Conductor*, *154*
Guidantus, Johannes Florenus, 107
guitar, *66–67*, 170, *170–71*, 177, *177*

Haas, Johann Wilhelm (the Elder), 80
Haida culture, 126
Hardanger fiddle, 94, *94–95*
harp, 24, *24–25*, 122–23, 163, *163*, *172–73*
harpsichord, 70–*71*, 73, *73*, 92–93
Hauser, Hermann, 170
Hayashi, Kodenji, 141
Hokusai, Katsushika, *Dressing Room for Musicians at a Theater*, *14*
horn, *84–85*, 118–*19*; image on hunting cup (Germany, Meissen), *85*
horn player, sculpture of (Nigeria, Edo people), *134*

İzmitli, Küçük, 157

jagdhorn (hunting horn), *84–85*

kagura suzu (bells), 78, *78*
kamānche (fiddle), 129, *129*
kerar (lyre), 164–*65*
kettle drum, 100, *100–101*
keyboard instruments
 clavichord (Germany, Christian Kintzing), *98–99*
 defined, 184
 double virginal (Antwerp, Hans Ruckers the Elder), 58, *58–59*
 harpsichord (Italy), 73, *73*
 harpsichord (Paris, Louis Bellot), 92–93
 piano (Austria, attr. Johann Schmidt), 108–9
 piano (Italy, Bartolomeo Cristofori), 86, *86–87*

piano (London, Érard et Cie), 124, *124–25*

piano (United States, New York, Nunns & Clark), *130–31*

pipe organ (United States, Boston, Thomas Appleton), 116, *116*

regal (Germany, attr. George Voll), 54, *54*

spinetta (Italy, Venice), 50, *50–51*

Kintzing, Christian, 99

Kohler & Son, 154

Köningsperger, Johann, 91

kora (harp), *172–73*

koto (long zither), *60–61*

Kouyaté, Mamadou, 172

Kuba (Shoowa) people, 148

La Hyre, Laurent de, *Allegory of Music*, 88

lamellaphone, *144–45*; sculpture of chief playing (Angola, Chokwe people), *144*

Langenbucher, Veit, 64

lawle (bell mallet), 152, *152*

Lewis, Edward, 72

lip-vibrated instruments. *See* **wind instruments**

lira (short-necked fiddle), 157, *157*

Lu, Prince of, 63

lunet (friction drum), 151, *151*

lute, 35, *35*, 44, *44*, *48–49*, *88–89*, *138–39*, 162, *162*

Lyon & Healy, 163

lyre, image on terracotta amphora (Greek, attr. the Berlin Painter), *164*

mahōra thuk (drum), *28–29*

Mandinka people, 143

mandolin, *160–61*

mandora, *46–47*, 47

Mangbetu people, 24, 134

Mannello, Angelo, 160

Maori people, 112

Mayan culture, *36*, 38

Meares, Richard, 72

mi-gyaùng (crocodile zither), 153, *153*

Müller, Iwan, 117

musette de cour (bagpipe), 79, *79*

Mweleun, Tin, 176

Nazca culture, 30

ngoma (drum), *136–37*

Nunns, Robert, 131

nyonganyonga (lamellaphone), *144–45*

ō-daiko (barrel drum), *140–41*, 141

Oberlender, Johann Wilhelm (the Elder), 96

oboe, *90–91*, 91, 97, *97*

oliphant, *42–43*; in detail from a Beatus manuscript (Spain), *42*

Omas, 175

pahu (drum), 146, *146*

Paracas culture, 30

pedal harp, 163, *163*

percussion instruments

bell

atingting kon (Vanuatu, Tin Mweleun), 176, *176*

bo (China), 27, *27*

deer-head bell (Costa Rica, Chiriqui), 40, *40*

dōtaku (Japan), 34, *34*

figural bell (Columbia, Tairona), 40, *40*

kagura suzu (Japan), 78, *78*

spider bell (Panama), 40, *40*

zhong (China), 27, *27*

clappers (Egypt), 26, *26*

cog rattle (poss. France), 45, *45*

defined, 184

drum

dadabuan (Philippines), 147, *147*

dombak (Iran/Persia), 138, *138–39*

drum (Democratic Rep. of the Congo, Kuba), 148, *148*

drum (Ghana, Akan Ashanti), *136–37*

drum (New Guinea, Omas), *174–75*

drum (Peru, Nazca), *30–31*

drums (Peru, Paracas), *30–31*

kettle drums (Germany, Franz Peter Bunsen), 100, *100–101*

ngoma (Democratic Rep. of the Congo, Vili/Yombe), *136–37*

ō-daiko (Japan, attr. Kodenji Hayashi), *140–41*, 141

pahu (French Polynesia, Austral Islanders), 146, *146*

side drum (Germany), *82–83*

side drum (United States, Boston, Henry Prentiss), *82–83*

side drum (United States, Philadelphia, attr. Ernest Vogt), *82–83*

gong, dora (Japan), 110, *110*

lamellaphone, nyonganyonga (Mozambique, Barwe), *144–45*

lunet (Papua New Guinea, New Ireland), 151, *151*

mahōra thuk (Laos or Thailand), *28–29*

rattle

rattle (Canada, British Columbia, Haida and/or Tsimshian), *126–27*

rattle (Hispaniola, Taino), 41, *41*

sistrum (Central Anatolia and Egypt), *22–23*

typanum (Vietnam), 28, *28*

xylophone, bala (West Africa, Mandinka), *142–43*

piano, 86, *86–87*, *108–9*, 124, *124–25*, *130–31*

Piatet, Pierre, 118

Picasso, Pablo, *Mandolin, Fruit Bowl, and Plaster Arm*, 160

pipa, *48–49*; sculpture of female musician playing (China), *49*

pipe organ, 116, *116*

plucked instruments. *See* **stringed instruments**

Prentiss, Henry, 82

putorino (flute), 112, *112*

qin (zither), 63, *63*

rattle, *22–23*, 41, *41*, *126–27*

recorder, tenor, 62, *62*

reed instruments. *See* **wind instruments**

regal, 54, *54*

Renoir, Auguste, *Two Young Girls at the Piano*, 131

Richters, Hendrik, 91

Ruckers, Hans (the Elder), 58

śankh (shell trumpet), 159, *159*

sanxian (fretless lute), 162, *162*

sāraṅgī (fiddle), 158, *158*

sārindā (fiddle), 156, *156*

saùng-gauk (harp), *122–23*

Sax, Charles-Joseph, 117, 118

Scherer, Georg Henrich, 97

Schmidt, Jacob, 85

Schmidt, Johann, 108

Segovia, Andrés, 170

Sellas, Matteo, 66

serpent, *114–15*, 115

sesando (zither), 149, *149*

sgra-snyan (lute), 44, *44*

shō (mouth organ), 120, *120*

side drum, *82–83*

sistrum (rattle), *22–23*; image on relief from chapel of Ramesses I (Egypt), *22*

sitar, *178–79*

sọ sām sāi (spiked fiddle), 111, *111*

spinetta (virginal), 50, *50–51*

Stainer, Jacob, 69

Steen, Jan, *Merry Company on a Terrace*, 19

Stradivari, Antonio, 53, 69, 77

string ensemble of female musicians, image on relief (Egypt), 17

stringed instruments

bowed

bass viol (England, London, Richard Meares, attr. Edward Lewis), 72, *72*

Hardanger fiddle (Norway, Isak Nielsen [Skaar] Botnen and Trond Isaksen Flatebø), 94, *94–95*

kamānche (Iran), 129, *129*

lira (Greece, attr. Küçük İzmitli), 157, *157*

mandora or chitarrino (Italy, poss. Milan), *46–47*, 47

sāraṅgī (India), 158, *158*

sārindā (India), 156, *156*

sọ sām sāi (Thailand), 111, *111*

tsii'edo'a'tl (United States, Arizona, Apache), 150, *150*

viola (Austria, Jacob Stainer), *68–69*, 69

viola d'amore (Italy, Johannes Florenus Guidantus), *106–7*, 107

violin "ex Kurtz" (Italy, Andrea Amati), *52-53*, 53
violin "The Francesca" (Italy, Antonio Stradivari), *76-77*
violin "The Gould" (Italy, Antonio Stradivari), *76-77*
defined, 185
plucked
 arched harp (Egypt), 24, *24-25*
 archlute (Rome, David Tecchler), *88-89*
 archtop guitar (United States, New York, James D'Aquisto), 177, *177*
 banjo (United States, Baltimore, William Esperance Boucher Jr.), 128, *128*
 cittern (Germany, Joachim Tielke), *74-75*, 75
 domu (Democratic Rep. of the Congo, Mangbetu), *24-25*
 guitar (Germany, Hermann Hauser), 170, *170-71*
 guitar (Venice, attr. Matteo Sellas), *66-67*
 kerar (Ethiopia or Sudan), *164-65*
 kora (Senegal, Mamadou Kouyaté), *172-73*
 koto (Japan, workshop of Gotō Yūjō), *60-61*
 lute (Egypt, Coptic), 35, *35*
 mandolin (United States, New York, Angelo Mannello), *160-61*
 mandora or chitarrino (Italy, poss. Milan), *46-47*, 47
 mi-gyaùng (Myanmar), 153, *153*
 pedal harp (United States, Chicago, Lyon & Healy), 163, *163*
 pipa (China), *48-49*
 qin (China, Prince of Lu), 63, *63*
 sanxian (China), 162, *162*
 saùng-gauk (Myanmar), *122-23*
 sesando (Indonesia), 149, *149*
 sgra-snyan (Tibet), 44, *44*
 sitar (India, Murari Adhikari), *178-79*
 tār (Iran, Persia), *138-39*
symphonium (mouth organ), 121, *121*

taille de hautbois (tenor oboe), *90-91*
Taino culture, 41
Tairona people, 40
tār (lute), *138-39*
Tecchler, David, 88
Teijo, Gotō, 61
Teotihuacan culture, 36
tibia, *32-33*; image on sarcophagus (Rome), *33*
Tielke, Joachim, 75
Tiffany & Company, 154
Todini, Michele, 70
Toyohiro, Utagawa, *Woman Putting on Finger Plectrums to Play the Koto*, 61
transverse flute, 96, *96*, 97, *97*, 102, *102-3*, *104-5*
trumpet, *36-37*, 80, *80-81*, *134-35*, 159, *159*
trumpeter, image on ceramic plate (Guatemala or Mexico, Mayan), *36*

tsii'edo'a'tl (bowed zither), 150, *150*
Tsimshian people, 126
typanum (bronze drum), 28, *28*

Utamaro, Kitagawa, *Picture Book of Crawling Creatures*, page from, *120*

Veracruz culture, 38
Vermeer, Johannes, *Woman with a Lute*, *10*
Vili people, 137
viol, bass, 72, *72*
viola, *68-69*, 69
viola d'amore, *106-7*, 107
violin, *52-53*, 53, *76-77*
virginal, 50, *50-51*, 58, *58-59*
Vogt, Ernest, 82
Voll, Georg, 54

Watteau, Antoine, *Mezzetin*, *66*
Wheatstone, Charles, 121
whistle, *38-39*
Willard, Oliver H. (attr.), *Artillery Musician*, *82*
William S. Haynes Company, 166
wind instruments
 defined, 185
 flute
 defined, 183
 dizi (China), *104-5*
 flute, porcelain (Germany or Saxony), 102, *102-3*
 putorino (New Zealand, Maori), 112, *112*
 tenor recorder (Venice or London, Bassano family), 62, *62*
 transverse flute (Germany, Johann Wilhelm Oberlender), 96, *96*
 walking-stick flute/oboe (Germany, Georg Henrich Scherer), 97, *97*
 whistle, bird-headed figure (Mexico, Veracruz), *38-39*
 whistle, double (Mexico, Mayan), *38-39*
 xiao (China), *104-5*
 lip-vibrated
 bondjo (Democratic Rep. of the Congo, Ekonda), *134-35*
 cor d'orchestre (France, Pierre Piatet), *118-19*
 cor omnitonique (Brussels, Charles-Joseph Sax), *118-19*
 cornett (Germany or Italy), *56-57*
 defined, 182 (brass), 184
 euphonium (United States, Indiana, C. G. Conn Ltd.), *168-69*, 169
 jagdhorn (Germany, Jacob Schmidt), *84-85*
 keyed bugle (United States, Boston, Elbridge G. Wright), *132-33*
 oliphant (Italy, Amalfi), *42-43*
 putorino (New Zealand, Maori), 112, *112*
 śankh (India), 159, *159*

serpent (Paris, C. Baudouin), *114-15*, 115
trumpet (Germany, Johann Wilhelm Haas the Elder), 80, *80-81*
trumpet, bone (Columbia, Calima), *36-37*
trumpet, pottery (Mexico, Teotihuacan), *36-37*
trumpet, side-blown (Democratic Rep. of the Congo, Mangbetu), *134-35*
reed, double
 bajón (poss. Spain), 55, *55*
 bajoncillo (Southern Europe), 55, *55*
 bassoon (Paris, Jean-Jacques Baumann), 113, *113*
 defined, 184
 musette de cour (France), 79, *79*
 oboe (Amsterdam, Hendrik Richters), *90-91*, 91
 taille de hautbois (Germany, Bavaria, Johann Wolfgang Köningsperger), *90-91*
 tibia (Syria), *32-33*
 walking-stick flute/oboe (Germany, Georg Henrich Scherer), 97, *97*
reed, free
 defined, 184
 shō (Japan), 120, *120*
 symphonium (London, Charles Wheatstone), 121, *121*
reed, single
 clarinet (Brussels, Charles-Joseph Sax), 117, *117*
 clarinets, pair (United States, Boston, William S. Hayes Co.), 166, *166-67*
 defined, 184
Wright, Elbridge G., 132

xiao (vertical notched flute), *104-5*
xylophone, *142-43*

Yombe people, *136-37*
Yūjō, Gotō, 61

Zeshin, Shibata, *Cock on Drum*, *141*
Zhengming, Wen, joint landscape, *18*
zhong (bell), 27, *27*
Zhou, Shen, joint landscape, *18*

This publication is made possible by the Diane W. and James E. Burke Fund.

Published by The Metropolitan Museum of Art, New York

Mark Polizzotti, Publisher and Editor in Chief
Gwen Roginsky, Associate Publisher and General Manager of Publications
Peter Antony, Chief Production Manager
Michael Sittenfeld, Senior Managing Editor
Robert Weisberg, Senior Project Manager

Edited by Nancy E. Cohen
Designed by Joan Sommers, Glue + Paper Workshop, LLC
Bibliography edited by Leslie Geddes

New photography of musical instruments in the Metropolitan Museum's collection is by Paul H. Lachenauer, The Photograph Studio, The Metropolitan Museum of Art.

Additional photograph credits: page 160: © 2015 Estate of Pablo Picasso/Artist Rights Society (ARS); page 175: © Dadi Wirz and Museum der Kulturen Basel

Typeset in Surveyor Text Light and Milo OT Light
Printed on 150 gsm Perigord
Separations by Professional Graphics, Inc., Rockford, Illinois
Printed and bound by Verona Libri, Verona, Italy

Cover illustrations: front, Laurent de La Hyre. *Allegory of Music* (detail), 1649 (see page 88); back, spinetta (detail). Venice, 1540 (see page 50)

Inside cover illustrations: Michael Praetorius. Details of plates 16 (front) and 5 (back) from the *Theatrum Instrumentorum*, suppl. to *Syntagma Musicum*, vol. 2, *De Organographia* (1619)

pages 2–3: Bala. West Africa, Mandinka people, 19th century (see page 143)

pages 4–5: James D'Aquisto. Archtop guitar, 1993 (see page 177)

page 10: Johannes Vermeer. *Woman with a Lute*, ca. 1662–63. Oil on canvas. Bequest of Collis P. Huntington, 1900 (25.110.24)

page 21: William Esperance Boucher Jr. Banjo, ca. 1845 (see page 128)

The Metropolitan Museum of Art endeavors to respect copyright in a manner consistent with its nonprofit educational mission. If you believe any material has been included in this publication improperly, please contact the Editorial Department.

The Metropolitan Museum of Art
1000 Fifth Avenue
New York, New York 10028
metmuseum.org

Distributed by
Yale University Press, New Haven and London
yalebooks.com/art
yalebooks.co.uk

Cataloging-in-Publication Data is available from the Library of Congress.

ISBN 978-1-58839-562-7